Kaffe Fassett's
Heritage Quilts

20 designs from Rowan for patchwork and quilting

featuring

Judy Baldwin

Corienne Kramer

Liza Prior Lucy

Brandon Mably

Pauline Smith

A ROWAN PUBLICATION

The Taunton Press

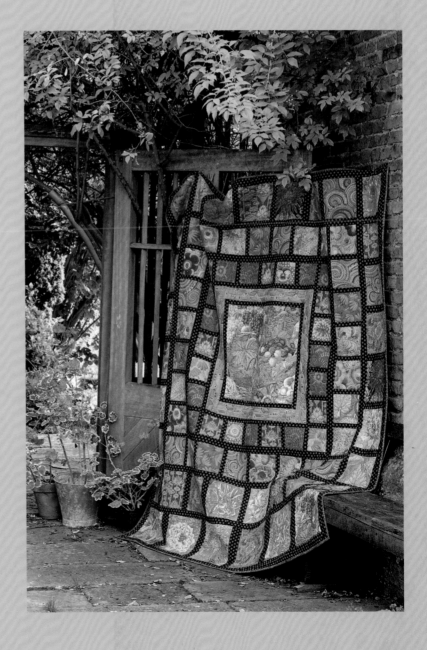

The Taunton Press
Inspiration for hands-on living®

The Taunton Press, Inc., 63 South Main Street, PO Box 5506, Newtown, CT 06470-5506
email: tp@taunton.com

First published in Great Britain in 2015 by
Rowan
Green Lane Mill
Holmfirth
West Yorkshire
England HD9 2DX

Patchwork designs	Kaffe Fassett, Liza Prior Lucy, Pauline Smith, Brandon Mably, Judy Baldwin, Corienne Kramer
Art direction/styling	Kaffe Fassett
Editor	Pauline Smith
Technical editor	Ruth Eglinton
Designer	Anne Wilson
Location photography	Debbie Patterson
Stills photography	Dave Tolson
Illustrations	Ruth Eglinton
Quilters	Judy Irish, Pauline Smith
Publishing consultant	Susan Berry

Library of Congress Cataloging-in-Publication Data in progress
ISBN 978-1-63186-155-0

Colour reproduction by XY Digital Ltd, London
Printed by KHL Printing Co Pte Ltd, Singapore

Page 1: *Red Squares* by Kaffe Fassett
Right: *Dark Wagga Wagga* by Kaffe Fassett

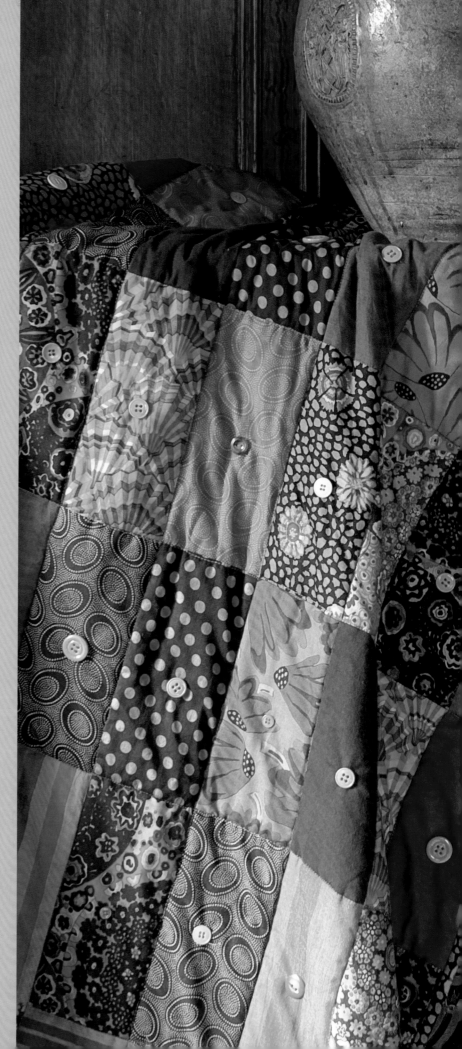

Contents

introduction

I can't say I have ever been so excitedly motivated by a project as I am by creating the quilts for this book. It is the first time I've been let loose on a gorgeous collection of antique quilts and been able to do my personal interpretation of their layouts. Some ten years ago I did a book on the Victoria & Albert Museum's collection, but there I was simply using their quilt arrangements to showcase my own updated fabrics.

The idea for this book began when I was invited by The Quilters' Guild of the British Isles to have a show at The Quilt Museum and Gallery in York. The concept for the show included my own personal 'antique quilt' collection along with a selection from The Quilters' Guild Collection. When I went to choose a few of the Museum's quilts I was so inspired by the variety and inventiveness they possessed that I decided to take the opportunity to do a book devoted to the quilts arising from the creative buzz I was getting in spades from these beauties.

In America, where I grew up, we have a reverence for folk art, such as hooked rugs, naïve painting, carved wooden objects and so on. To my mind there is no greater and more vividly eternal folk art than patchwork and quilt making. When I was trying to make a career in fine art, I was always knocked sideways by the sight of early American scrappy quilts. And when I started to knit I often based my multi-coloured creations on patterns in old quilts. So it was only a matter of time before I would start designing my own.

This book brings together my love of textile making and the ingenious discoveries of past quilt-makers – those early folk artists who continue to give us the gift of their inspired arrangements of patterned cloth. It is a great honour to be able to showcase my most recent fabric collection in the forms inspired by this outstanding collection.

I chose the antique quilts for many reasons. Sometimes it was the visual impact of the repeated patterns, sometimes the fact that they had large areas of bold design that could show off our up-scale prints. Often it was a jaunty and fresh-looking use of geometry that was easy to sew by machine and which I felt would be transformed by a different brighter palette.

I only hope the enormous fun I had playing with these new layouts both amuses you and inspires your own colour combinations.

the original quilts

Here are the 15 truly wonderful original quilts in The Quilters' Guild Collection, from which I (and members of my design team) drew inspiration for the redesigned and re-coloured quilts that follow in the Quilt Gallery. Our interpretations, often very loosely based on the originals, are made up using the latest fabrics from the Kaffe Fassett collection (see pages 16 and 17). Each original quilt on this and the following pages takes its title from The Quilters' Guild Collection, with the title and page number of my new version alongside it, so you can compare them if you wish!

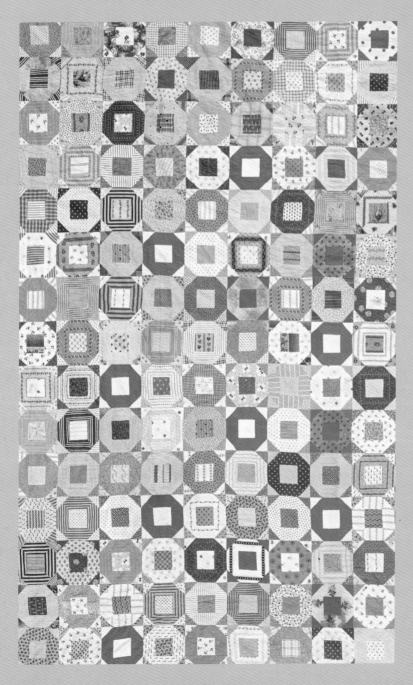

◄ *Church Window Hexagon Top, 1825–1875* (detail)
(*Pastel Donut*, page 34)
Now this is just the sort of quilt that catches my eye and delights me more and more as I discover all the playful prints within it. The first impression is a field of light pastels, punctuated with dark and red accents. Then the use of stripes among the plaids, small florals and geometrics starts to emerge. The exciting rhythm of circular forms with contrasting square centres makes a powerful field of pattern. Then the little pinwheels at the corners become a juicy small detail for the eye to play with.

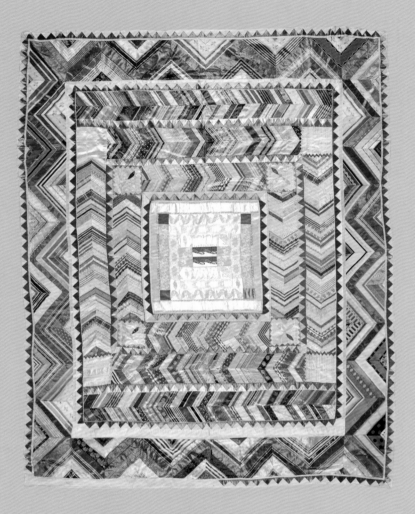

◄ **Mrs Fitz-Herbert Top, 1800–1850**
(*Candy Zigzag Ribbon*, page 32 and *Citrus Zigzag Ribbon*, page 48)
This quilt is a fashionable summer party – all the jaunty freshness of silk dresses, shawls and ribbons fluttering in a warm breeze. With quite simple means, a delightful complexity of stripes and zigzags is created. It keeps your eye roving its surface finding more and more difference in scale and tone. The palette is soft and elegant with just the right level of contrast. I love the little points in the borders.

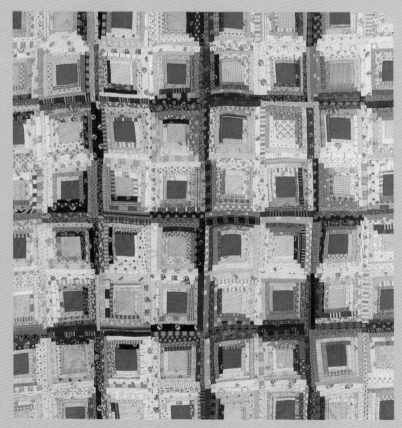

◄ **Elderton Log Cabin, 1890–1899** (detail)
(*Autumn Crosses*, page 28)
When I saw this quilt the light areas suggested crosses to me. The corners became the pink and red starting squares for each log cabin block. The fact that it appears to be the same all over, yet has an amazing variety of scrappy fabrics when studied closely, makes it magical to me. It is the strict dark and light elements that create the repetitious strength of this log cabin.

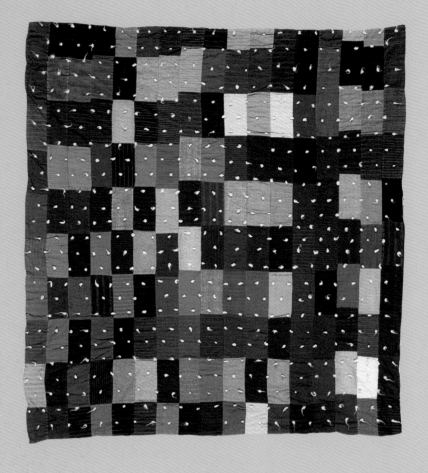

◄ Suit Wools Canadian Red Cross Quilt, 1939–1945

(*Dark Wagga Wagga*, page 18 and *Mellow Wagga Wagga*, page 56)

There is something so satisfying about rows of rectangles. I've seen many quilts with this layout, particularly in Australia, where they are called Wagga Waggas. They were essentially utilitarian quilts made by quite poor folk out of sample books of mens suiting fabrics to create warm blankets, inadvertently creating simple strong arrangements of rectangles in handsome palettes.

This one appealed to me because its dark mysterious palette and brilliant use of contrasting ties give it a ripple of movement.

Cartwright Hexagon Coverlet, 1865 ►

(*Diamond Jubilee*, page 44)

Hexagons are all the rage in the quilt world just now so this, I'm sure, will have people doing it exactly the same with elements of the original beauty. There is something elegantly exciting about the jumble of diamonds and half diamonds going in different directions in various scales. The mauve print that outlines the centre diamonds and triangles creates a secure solidity to this dance of shapes.

The wide border of small scrappy diamonds on point is delightful, leading to the bold outer border of triangles in a satisfying dark/light dramatic finish.

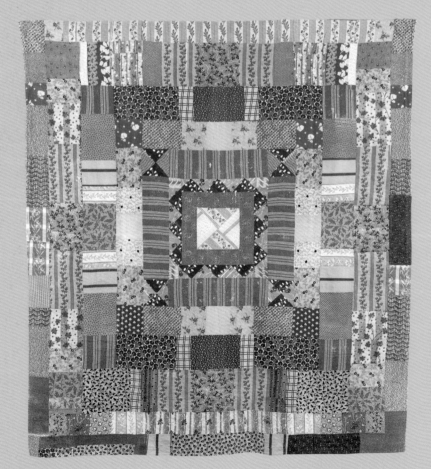

◄ Purple Frame Quilt, 1860–1870

(*Sunset Stripes*, page 30)

I liked this scrappy medallion quilt and felt it could show strong directional prints in this layout. It's the stripes and weaves created by the mirror imaging of rectangles of prints that make it dynamic. The way the piece is so complex you aren't immediately aware how structured it is. The mirror imaging is very satisfying to me on this bold scale.

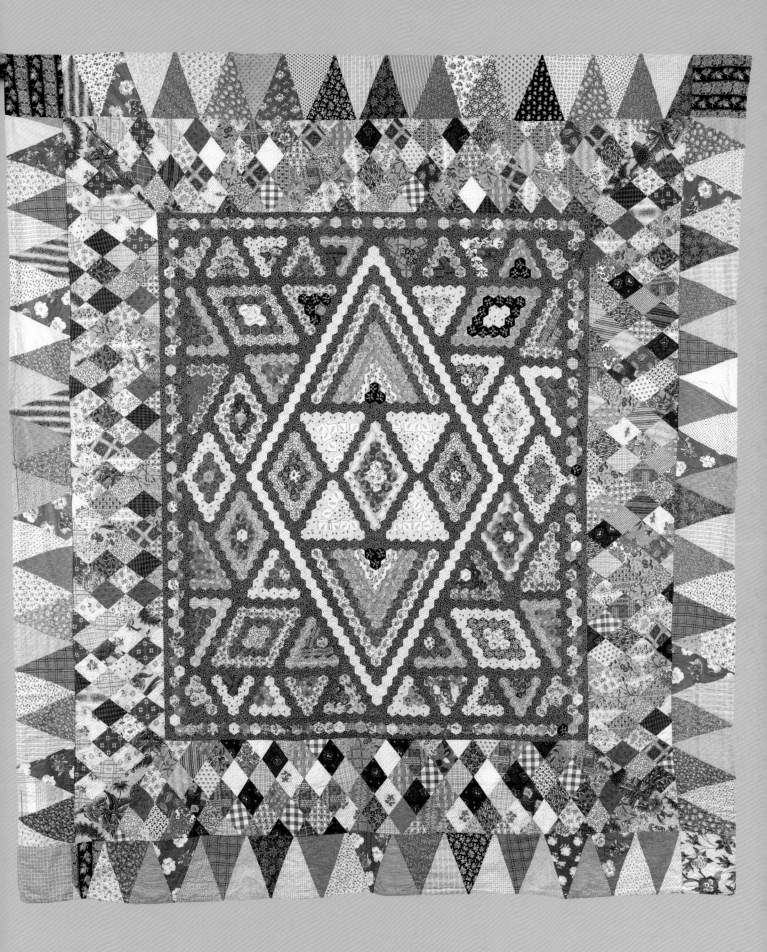

9

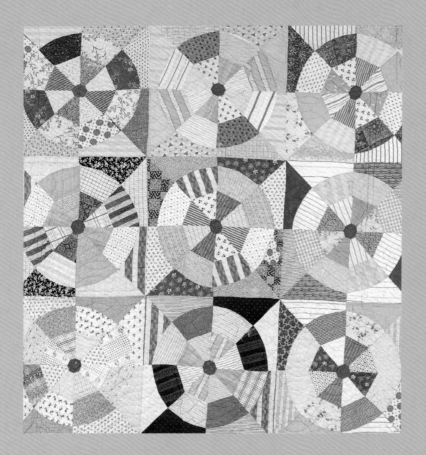

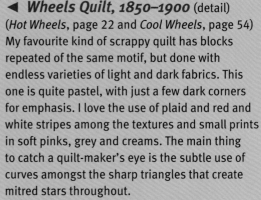

◄ *Wheels Quilt, 1850–1900* (detail)
(*Hot Wheels*, page 22 and *Cool Wheels*, page 54)
My favourite kind of scrappy quilt has blocks
repeated of the same motif, but done with
endless varieties of light and dark fabrics. This
one is quite pastel, with just a few dark corners
for emphasis. I love the use of plaid and red and
white stripes among the textures and small prints
in soft pinks, grey and creams. The main thing
to catch a quilt-maker's eye is the subtle use of
curves amongst the sharp triangles that create
mitred stars throughout.

**Thirties Small Squares Top,
1930–1939 ►**
(*Bright Squares*, page 42)
This is like confetti thrown at a party that just
happened to organize itself into squares on point.
The black and white plaid is also a great texture
with solid tones of bright around it. I love the
happy palette on the original and tried to emulate
that – when you look closely, the little flower
prints (sky blue and white or navy and pale pink)
make a jaunty note in the mix.

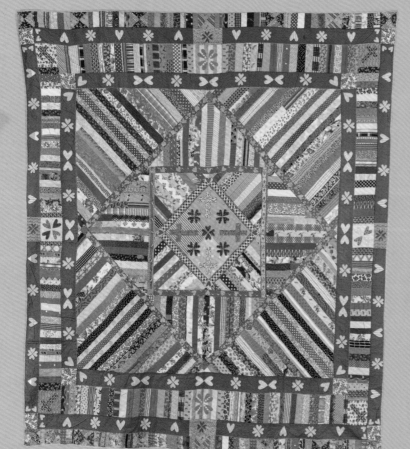

**◄ *Hearts and Crosses Coverlet,
1875–1900***
(*Organic Radiation*, page 26)
This is the quilt that started the concept of this
book flaming into life. I went with the editor of
these books, Pauline Smith, to a show of quilts
from The Quilters' Guild Collection in Preston in
2003. We were both immediately struck by the
forceful design of this quilt. Its many wonderful
prints weren't evident at first; it was the dynamic
design of radiating stripes in different directions
and the series of borders that captivated us.

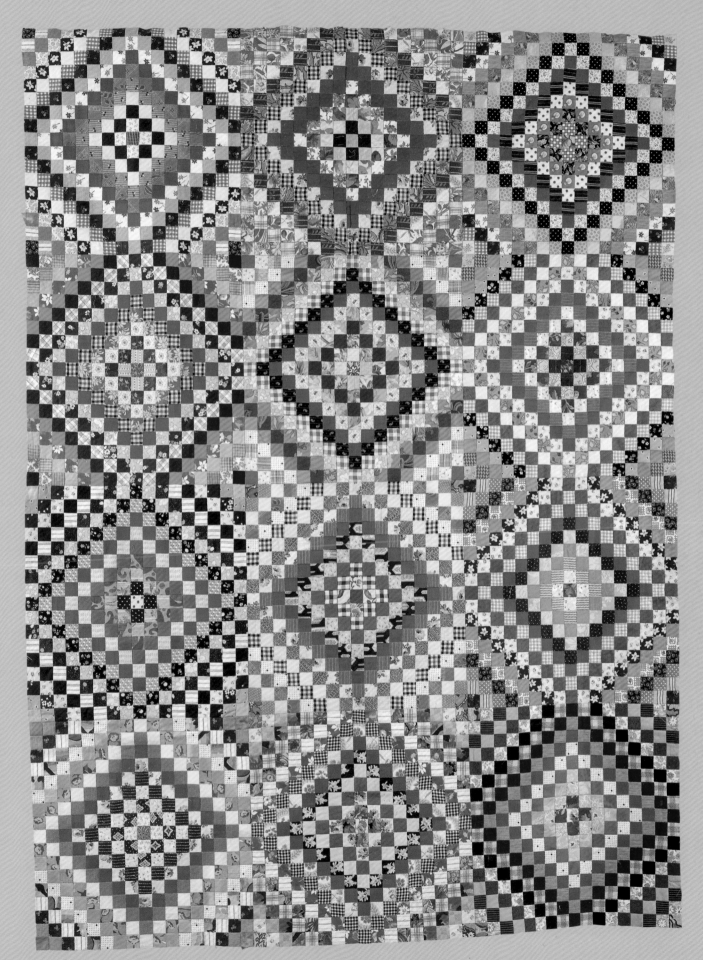

11

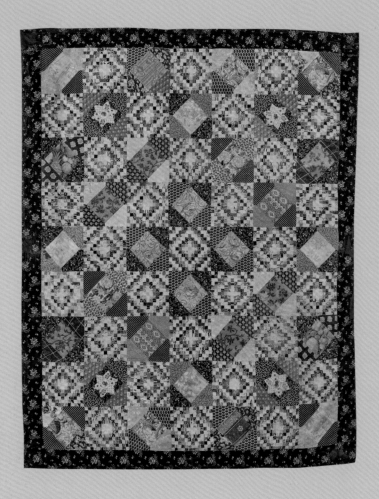

◀ Crib Coverlet, 1780–1820

(*Log Cabin Sampler*, page 36)
The charming quilt attracted me because it was such a good quilt layout for showing off my medium-size prints. I love the postage stamp squares that repeat throughout the quilt, while the prints on point create a lovely sense of scrappy variety.

Sidmouth Quilt, 1820–1840 ▶

(*Rustic Checkerboard Medallion*, page 38 and *Purple Checkerboard Medallion*, page 50)
This joyous checkerboard drew me to it because within the bold dark and light structure was slightly more complex piecing of hour glasses and squares on point.

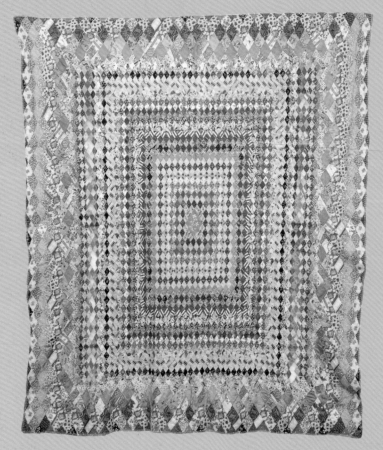

◀ Diamond Medallion Top, 1790–1859

(*Trip around the World*, page 40)
The thing that attracted me to this *Trip around the World* was not that it was made of diamonds but that I saw it could be done in simple stripes of prints to look like the diamond rows. It has a pleasing, low-contrast, light-and-dark rhythm to it.

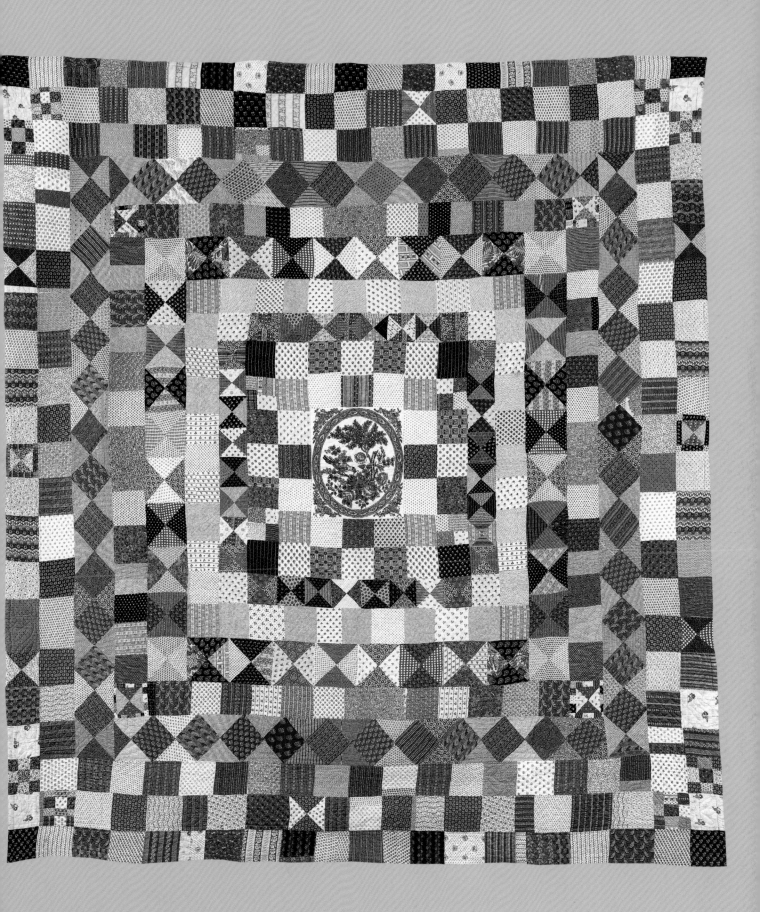

13

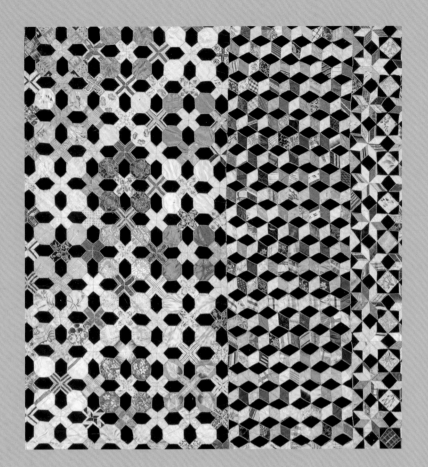

◄ *Ridehalgh Quilt, 1860–1890* (detail)
(*Snowball Crisscross*, page 46)
I was attracted to this vintage quilt because of the charming choice of fabrics. I didn't realise at first that it was arranged in groups of four snowballs in the same print. The crosses are outlined which adds such a wonderful note. The black ground gives it the appearance of an Indian carved screen.

Red Manor House Appliqué Coverlet, 1850–1859 ►
(*Red Squares*, page 20)
There is much to admire in this Bobby Dazzler display of appliquéd motifs. What struck me first was the layout of square blocks that start small and get larger each row as they progress to the outer edges. This piece has all the charm of a children's painting in its folk art rendering of motifs. The fact that these motifs sit on a consistent cream background emphasises the repeated nature of the design. The wonderful variety of prints under those squares (sashing) adds to the richness and liveliness of this gem.

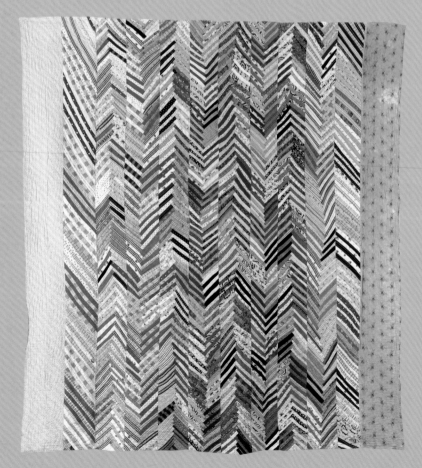

◄ *Chevron Strippy, 1880–1900*
(*Sunshine Herringbone Stripes*, page 24 and *Earthy Herringbone Stripes*, page 52)
Wow is all I could say when I first encountered this beauty. The rough masculinity of it thrilled me to the core. How slivers of printed cloth can be arranged in such a way that a wild organic life is dancing before your eyes – it's the wacky primitive placement of the repeating stripes that gets me, as well as the strong and softer uses of contrast. The zigzag that dissolved in places only adds to its charm and verve.

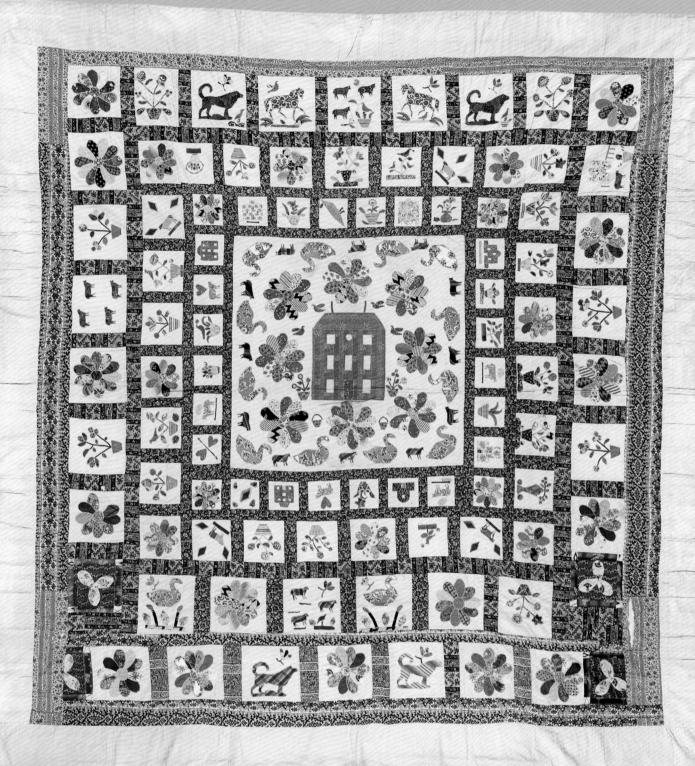

the fabrics

There are so many fabrics in the Rowan range it is impossible to show all of them on these pages. This capsule collection of current prints by Kaffe (code indicator GP), Philip Jacobs (code indicator PJ) and Brandon Mably (code indicator BM) is grouped into colour palettes. Most of the fabrics shown here have been used in the quilts in this book.

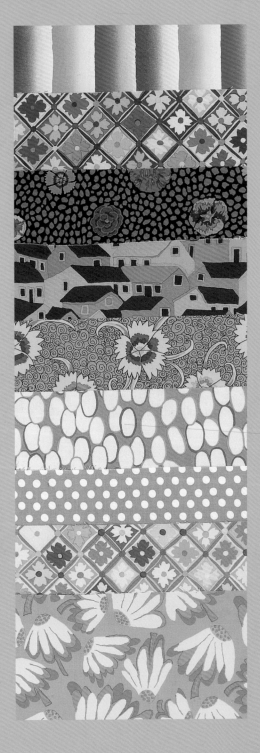

Blues (left)
GP142 Kim (blue)
GP139 Antwerp Flowers (blue)
GP59 Guinea Flower (purple)
BM47 Shanty Town (cool)
GP138 Dianthus (blue)
BM45 Labels (cool)
GP70 Spot (teal)
GP139 Antwerp Flowers (green)
BM44 Lazy Daisy (emerald)

Pastels (right)
PJ66 Curly Baskets (silver)
GP20 Paperweight (grey)
GP92 Millefiore (pastel)
GP70 Spot (china blue)
GP93 Lake Blossom (sky)
GP92 Millefiore (lilac)
GP139 Antwerp Flowers (soft)

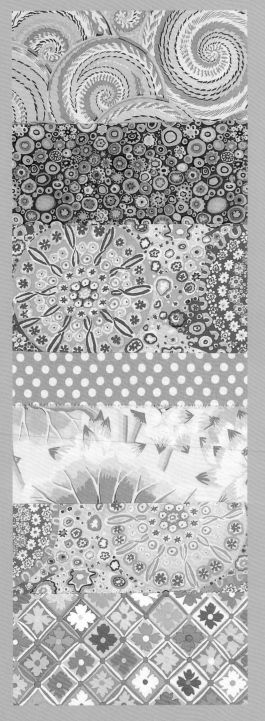

There are plenty of others in the range for you to choose from when making your quilts, including a comprehensive range of shot-cottons and woven stripes to complement the prints.

Note: If you need to make a fabric substitution, it is more important to go by the combined effect of the colour and pattern together, rather than looking for an exact colour match, say, to the background colour alone.

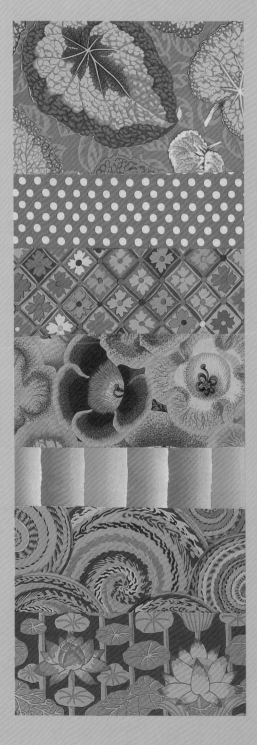

Reds (left)
PJ70 Big Leaf (pink)
GP70 Spot (tomato)
GP139 Antwerp Flowers (red)
PJ71 Gloxinias (pink)
GP142 Kim (red)
PJ66 Curly Baskets (red)
GP140 Lotus Stripe (red)

Yellows (right)
BM47 Shanty Town (ochre)
GP70 Spot (gold)
PJ55 Feathers (yellow)
GP138 Dianthus (yellow)
GP143 Paper Fans (yellow)
BM46 Victoria (citrus)
GP93 Lake Blossoms (yellow)
PJ68 Lilac (yellow)

Dark Wagga Wagga
by Kaffe Fassett

I have used my darkest prints and woven fabrics to create my Wagga Wagga, like the original *Suit Wools Quilt* on page 8. I had some slightly lighter colours included in my 'first draft' of this quilt, but opted for a dark all over look that would contrast with my sky blue buttons.

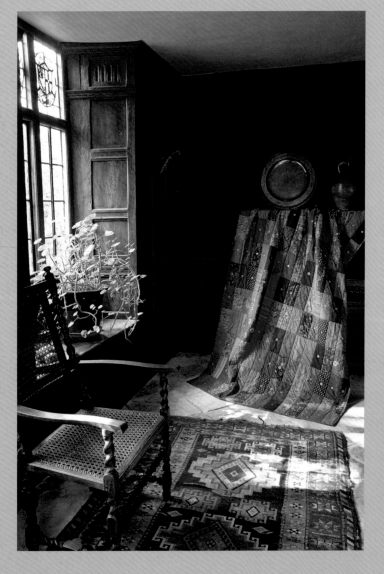

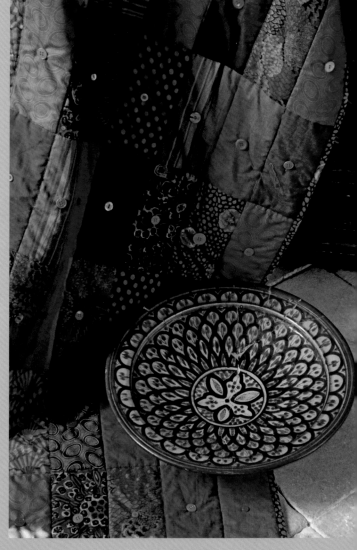

Red Squares
by Kaffe Fassett

I couldn't compete with the wonderful appliqué of the *Red Manor House Appliqué Coverlet* (page 15) in the time I had to design this quilt for this book, so I chose a palette that I hoped would create another sort of richness. By placing all the red colourways of my print collection on a black and purple background, I hoped to create a sort of oriental carpet of a quilt. Brandon Mably's Shanty Town fabric that borders the centre echoes the Red Manor House on the original and the fussy cut florals hint at the appliqué motifs.

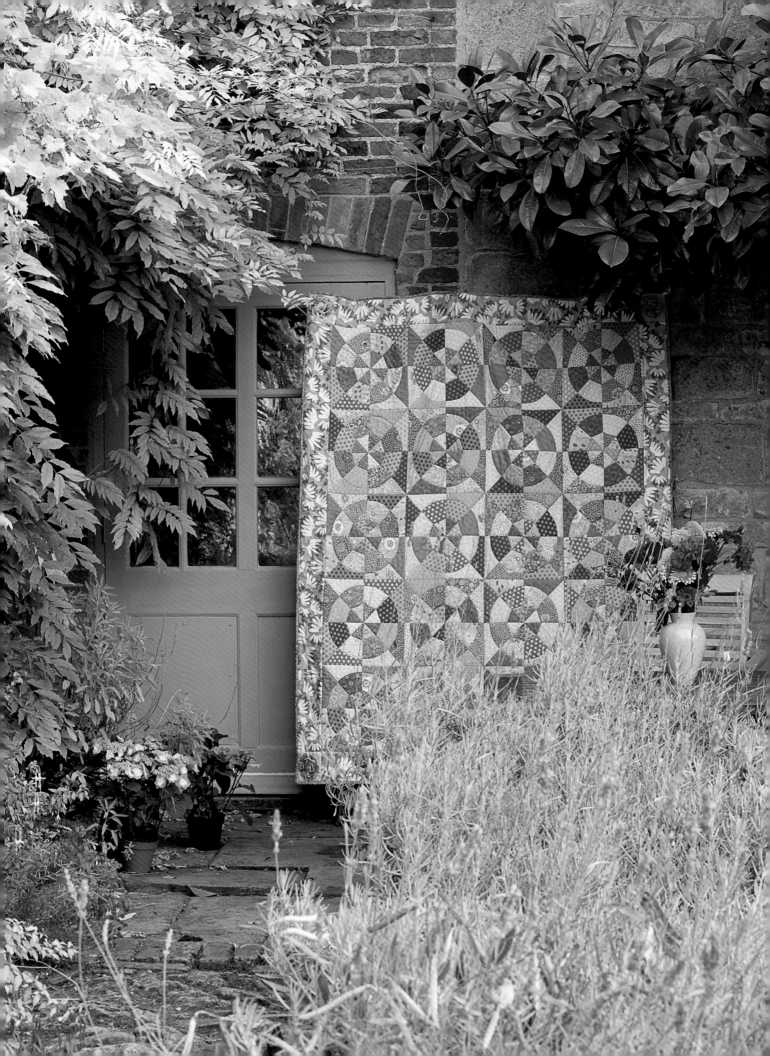

Hot wheels
by Kaffe Fassett

For my version of the *Wheels Quilt* (page 10), I chose a dusty terracotta, pink and gold palette. I loved playing with the soft contrasts and curved piecing to create this pleasing patchwork. It will be interesting to see what colours quilt makers will come up with in this pattern.

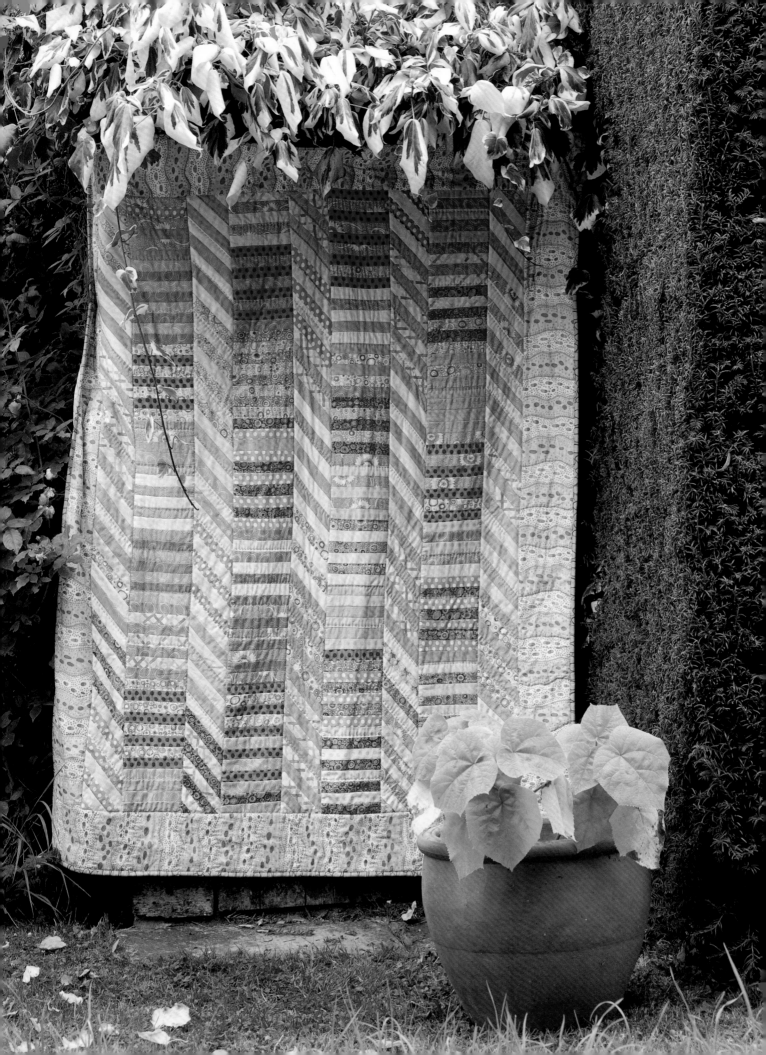

Sunshine Herringbone Stripes
by Kaffe Fassett

My version is much calmer by comparison with the original *Chevron Strippy* quilt on page 14. In part, this was to make something that is easy to give instructions for and partly because I fell in love with a happy spring palette of primroses and soft leafy greens. Mine will be easier to make but one day I will attempt the funkiness of the brilliant original.

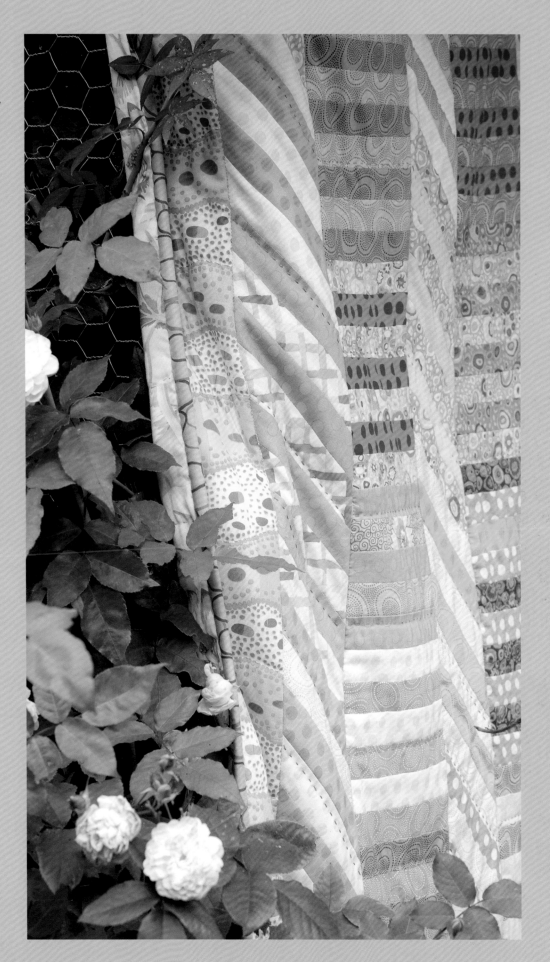

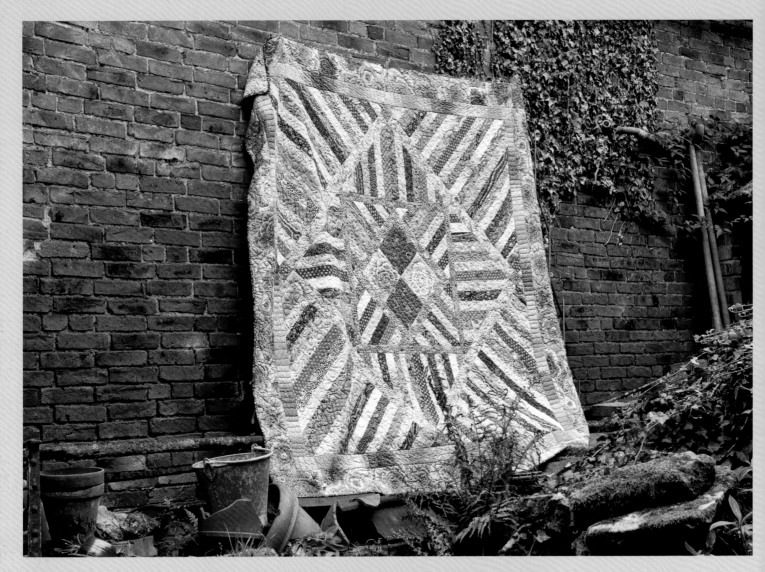

Organic Radiation
by Kaffe Fassett

We first made a version of the *Hearts and Crosses Coverlet* (page 10) in a mossy green palette and called it *Mossy Radiation*. It featured in our book, *Quilt Road*. Re-examining it for this new version I'm really moved by the dark and light rhythm of the bold stripes of print, and also how some large-scale florals are tossed into the mix.

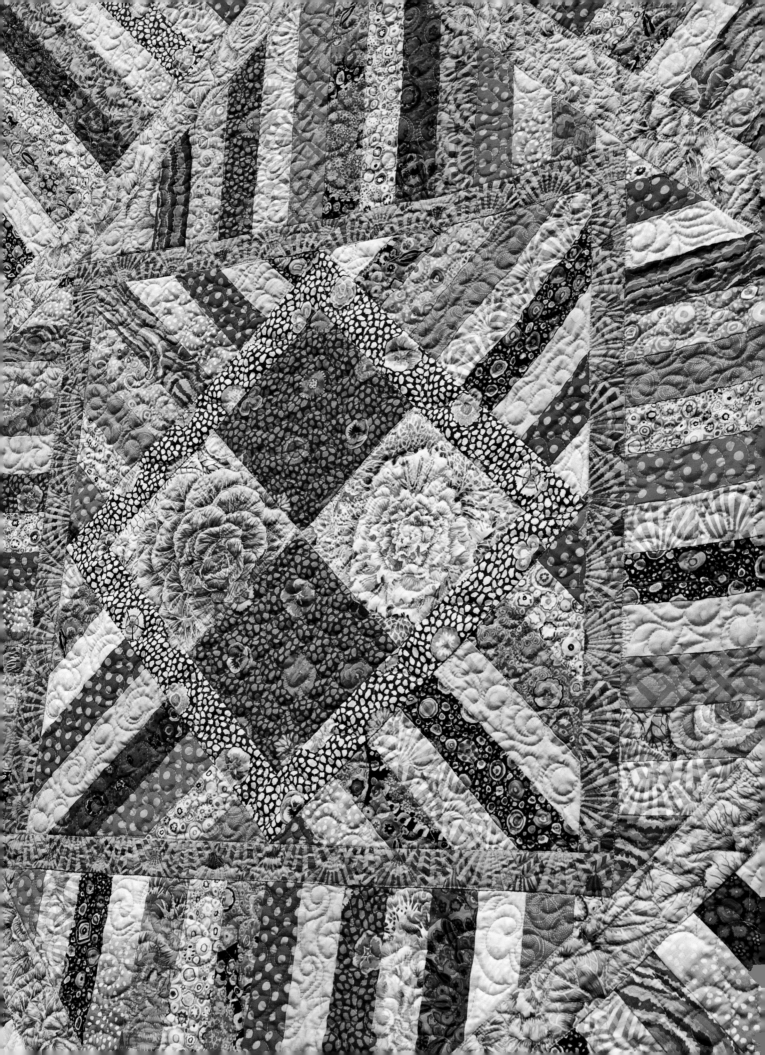

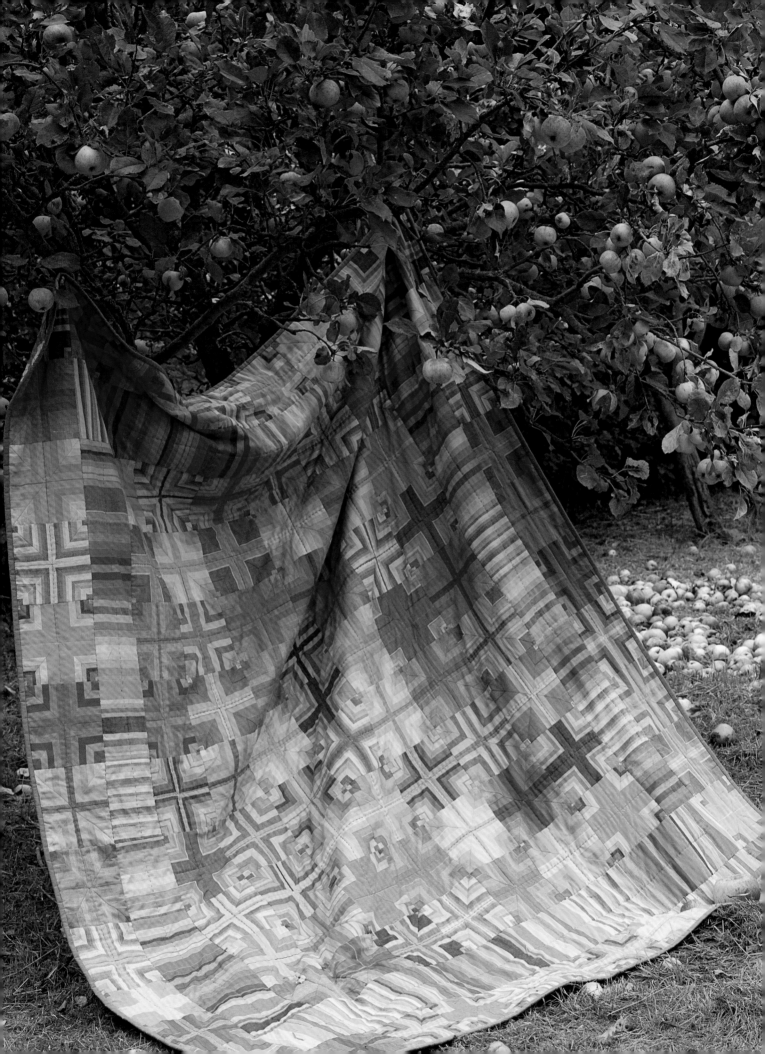

Autumn Crosses
by Kaffe Fassett

When I started on my version of the *Elderton Log Cabin* quilt (page 7) I knew from experience that we could achieve crosses by sewing the same sequence of my Indian stripe together in triangles. As we do, interesting squares are formed in the corners, creating a log cabin block effect. With that in mind, I've used four of my Stripes fabrics to create this Crosses version. The warm palette creates a harmony but is quite varied in the amount of different crosses achieved with each stripe.

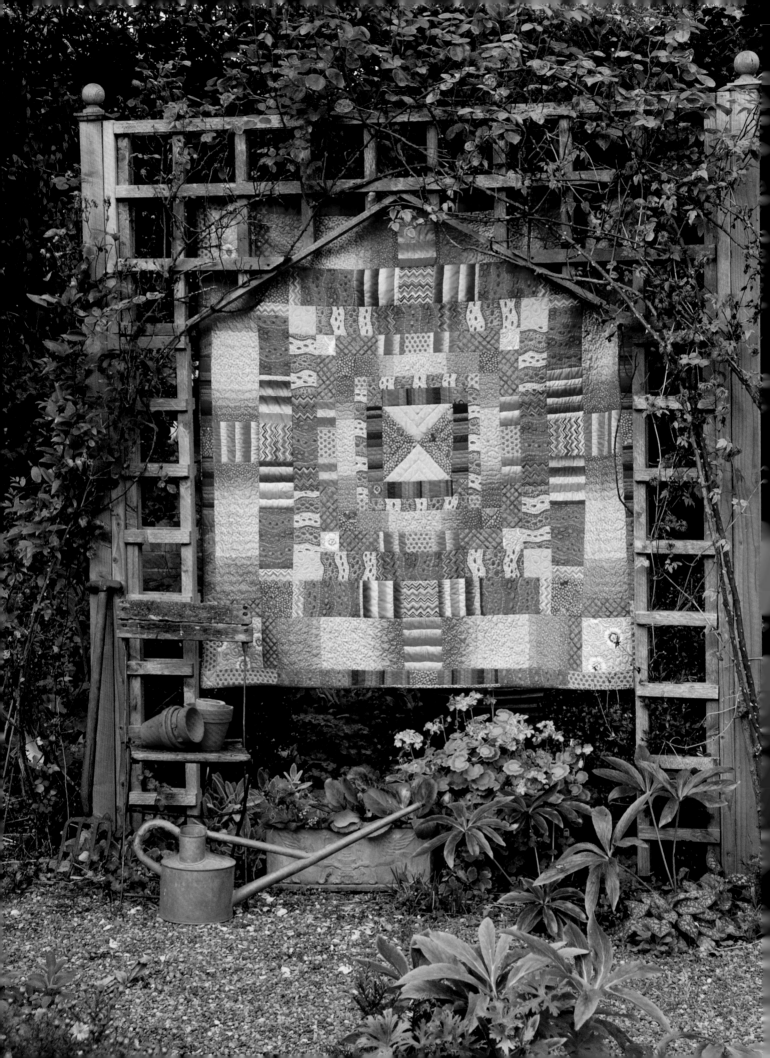

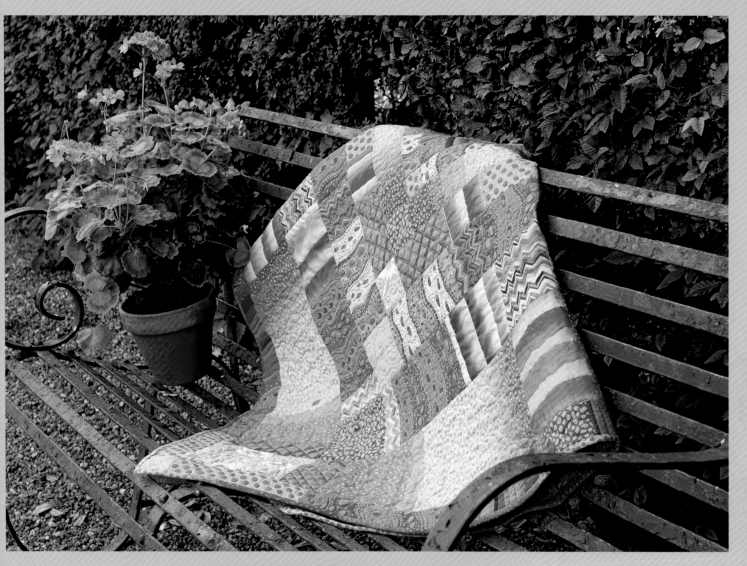

Sunset Stripes
by Kaffe Fassett

In my version of the original *Purple Frame Quilt* on page 8, I have increased the rows as they progress from the centre hour-glass shape. I also changed the browns, purples and pinks of the original to a hot, spicy red and orange, and echoed the original's cool shots of blue in my own take on it. This is the sort of easy-to-construct quilt that could be done in so many different colour moods. The mirror imaging gives any combination the authority of good design.

31

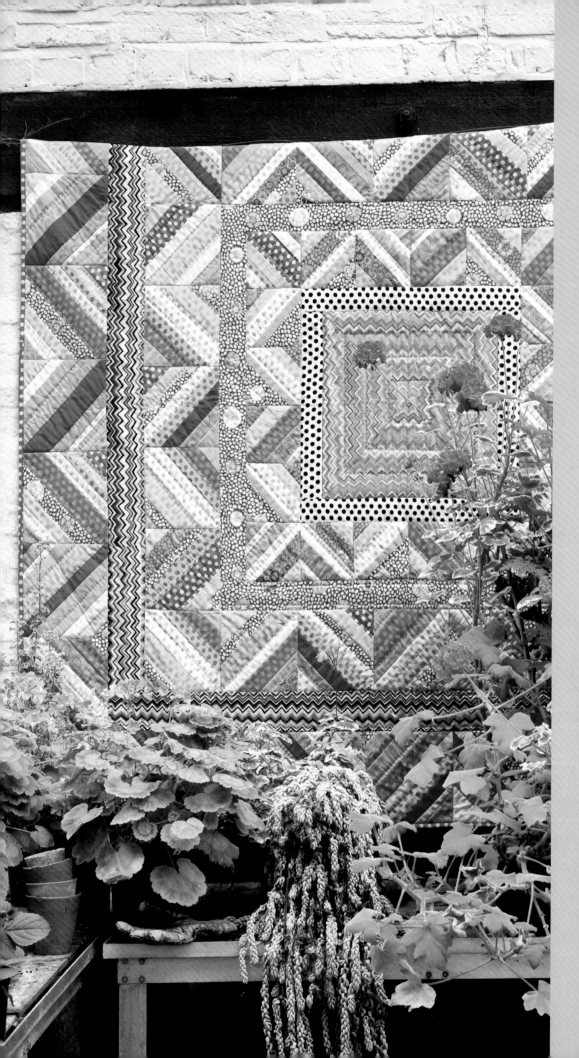

Candy Zigzag Ribbon
by Kaffe Fassett

In my version of *Mrs Fitz-Herbert Top* (page 7), I have replaced the little pointed borders with print and I have also used a brighter palette to emulate the silky sheen of the original quilt.

OVERLEAF

Pastel Donut
by Kaffe Fassett

I used the same structure as the original *Church Windows* quilt on page 6, but made my colours a little stronger with more of a checkerboard effect. I noticed on the original quilt that some fabric combinations merged together; I wanted more clarity, so went for a really pronounced contrast (which is something I don't do very often). Adding a checkerboard border kept the action going while calming it down. Philip Jacobs' Pom Pom print in a grey colourway echoed all the colours and circular shapes of the original.

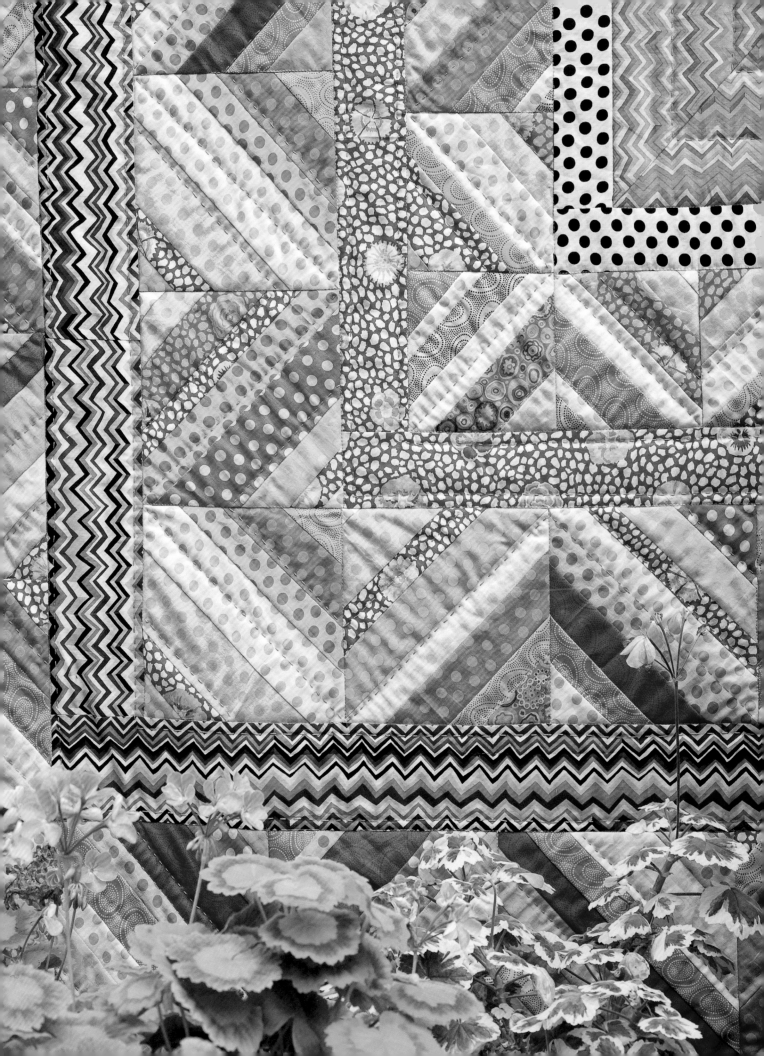

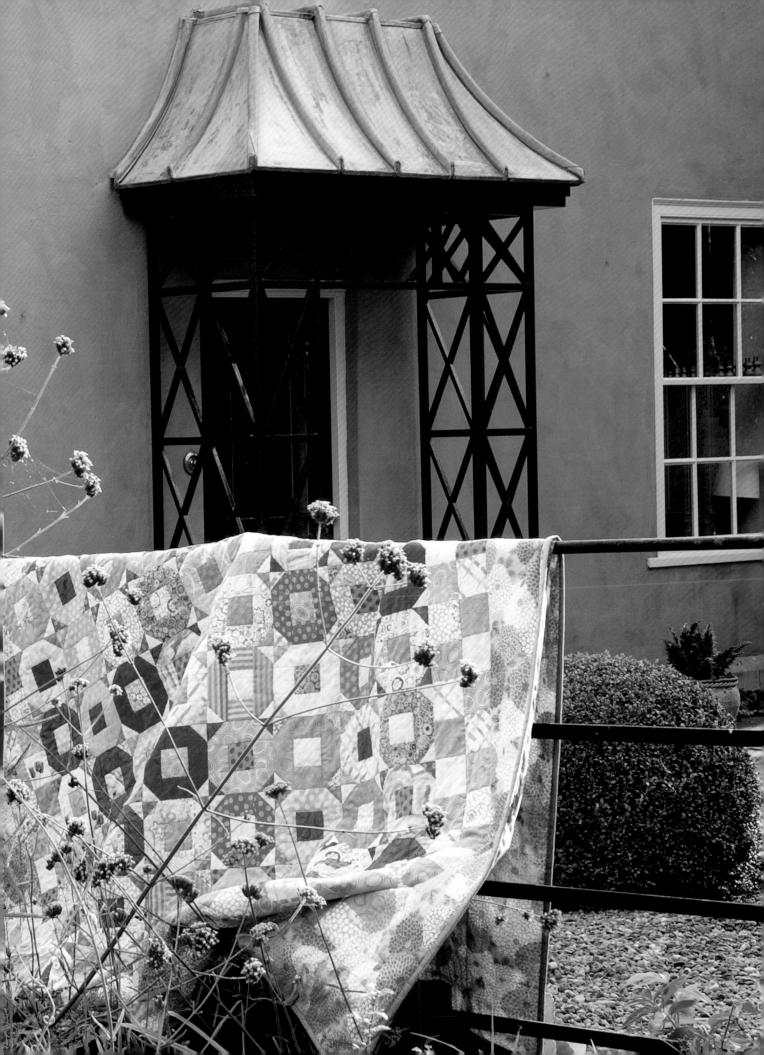

Log Cabin Sampler
by Kaffe Fassett

I have made my interpretation of the *Crib Coverlet* on page 12 a lot simpler but I think it shows our current collection of prints in their softest colourways to great advantage, which is why I call it a sampler. Only as I started to create my version did I notice the mirror imaging that is making this little gem so satisfying to contemplate. I hope some quilt makers will attempt a closer rendition of the original coverlet.

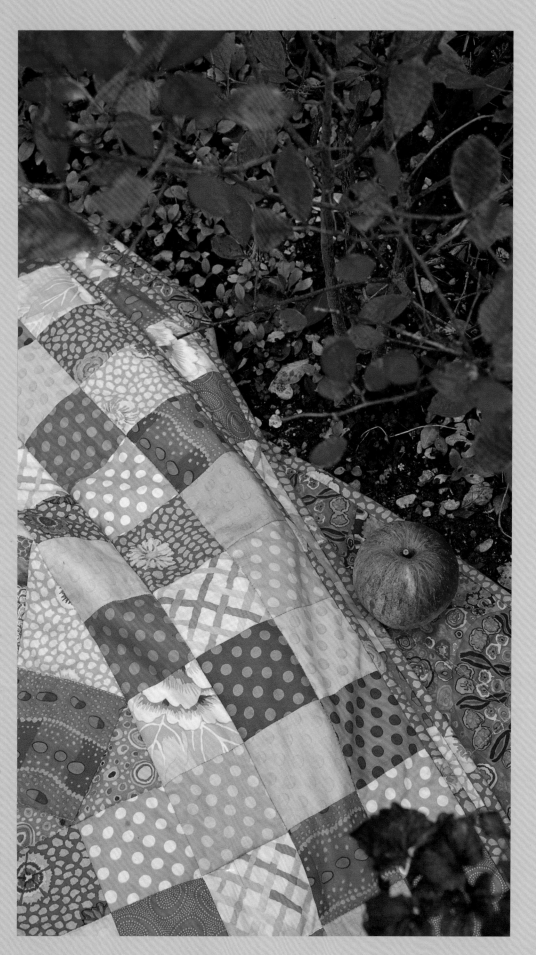

Rustic Checkerboard Medallion
by Kaffe Fassett

I love boldness and it was fun to do a version of the *Sidmouth Quilt* (page 13) that was slightly less black and white and with sunny yellows, creams and pinks in my palette. You can see that I've changed some elements but kept that all over dark/ light chalkiness. I like the way the background colours of the squares-on-point row goes diagonally instead of straight across the square as on the original. I also like Philip Jacobs' flowery print, Lilac, in soft yellows in the centre.

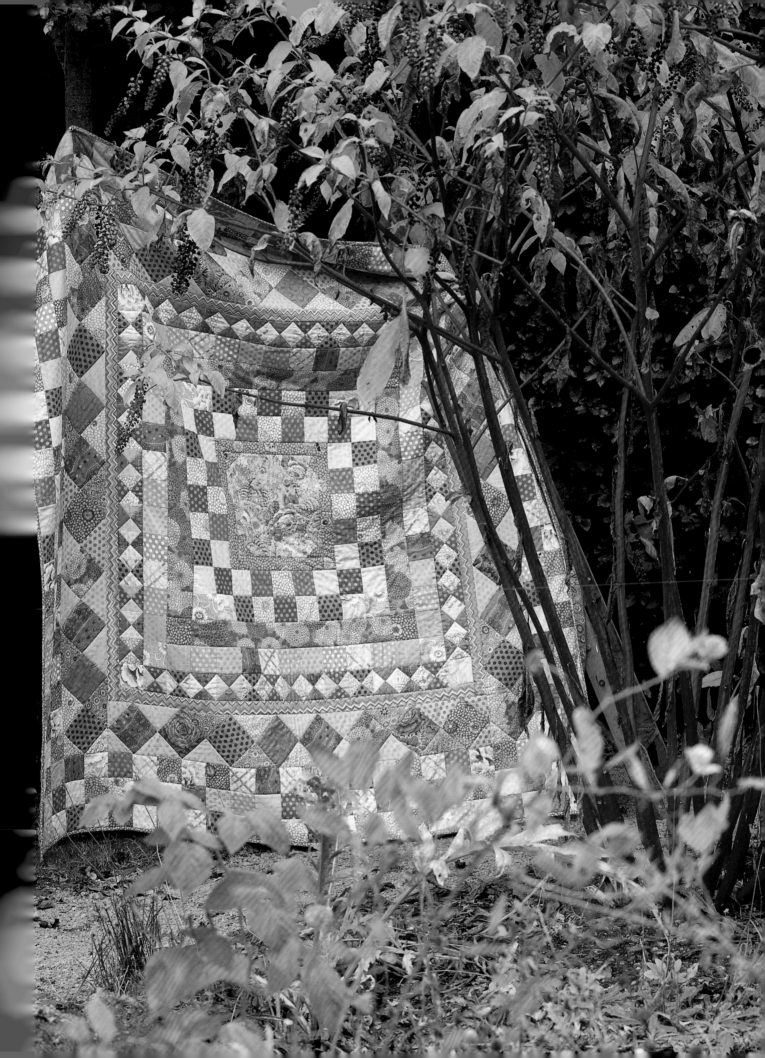

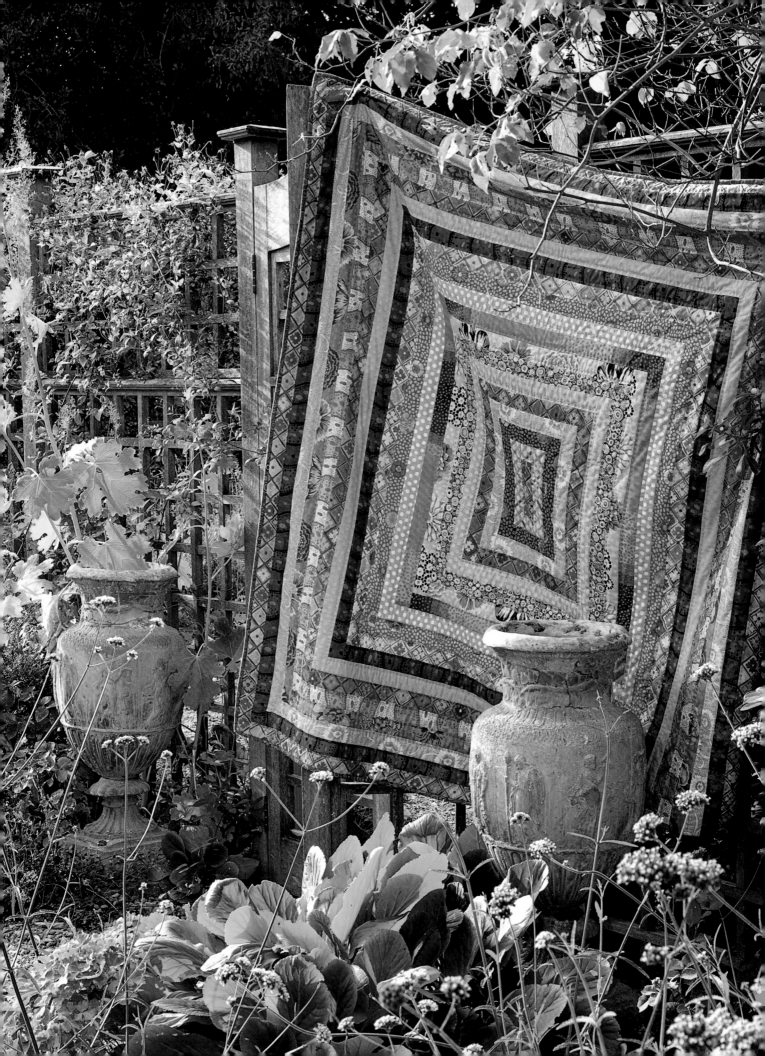

Trip around the World
by Kaffe Fassett

I like the obsessive small diamond centre giving way to many layers of diamonds at the dramatic border on the *Diamond Medallion Top* (page 12). Some of the prints are quite jazzy with stripes and up-scale motifs, but it is the solids and small textures that give them a background to glow against. At first, I tried to emulate the original's palette of beiges, browns and blues, but soon broke into my own choices of tone.

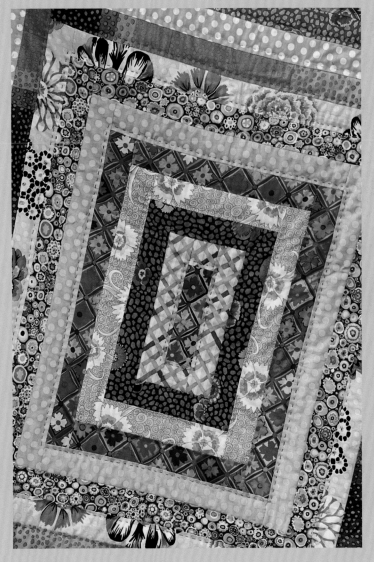

41

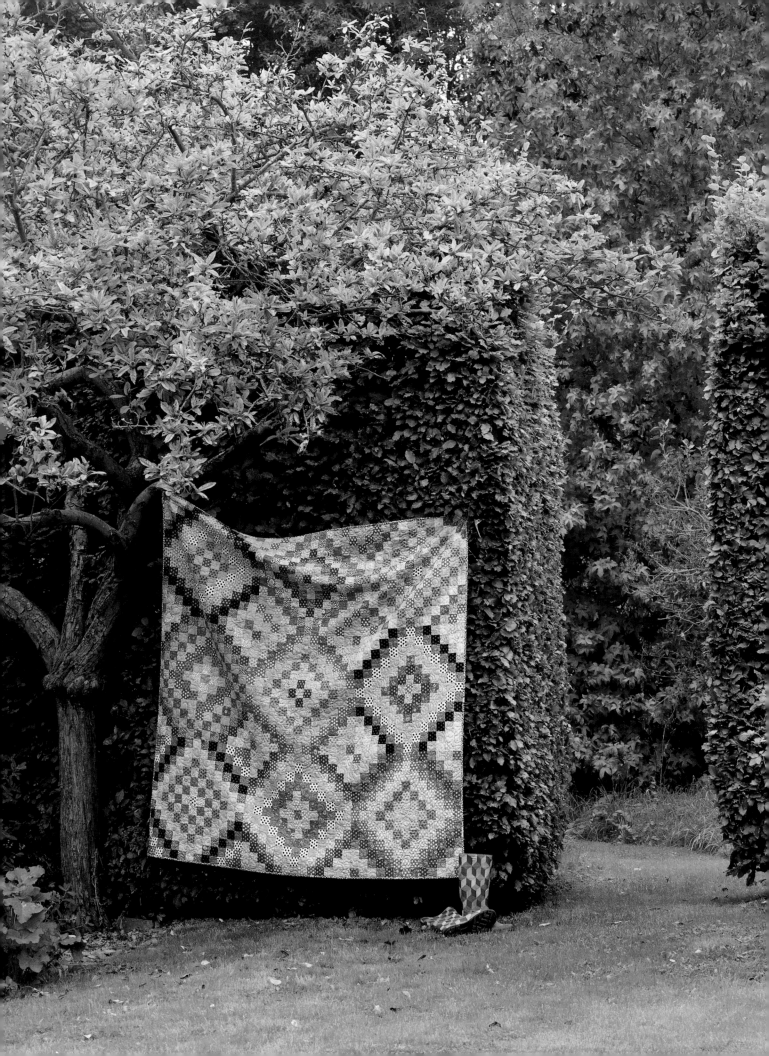

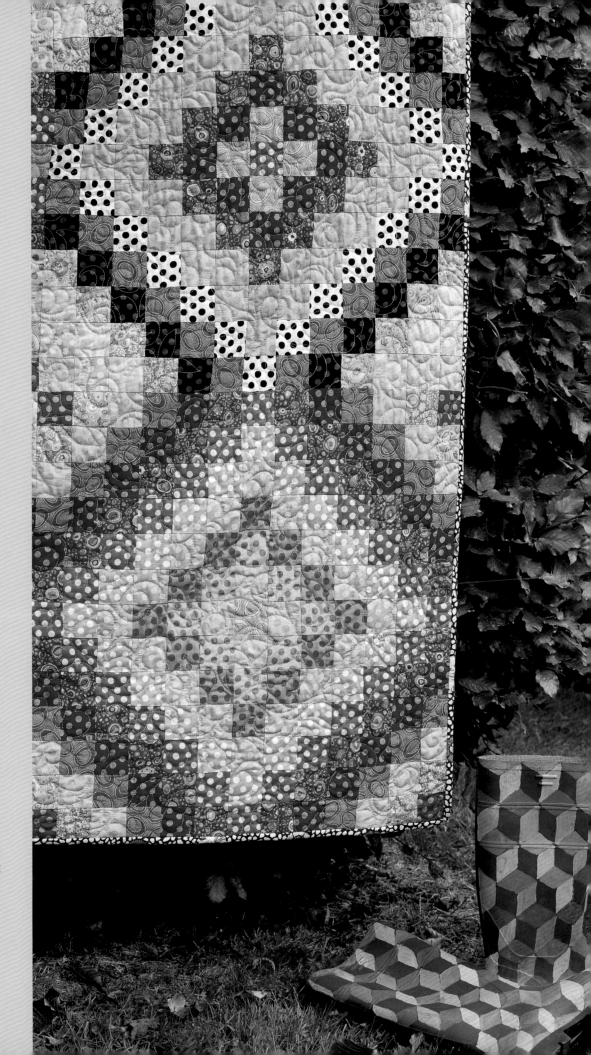

Bright Squares
by Kaffe Fassett

The inspiration for this design was the *Thirties Small Squares Top* on page 11. The most interesting thing about this design is that one builds each block separately, then when they come together a more scrappy unexpected squares on point is created. I worked a bit with my dark and light rows to make them appear more like the 'unintentional' squares, but they are still quite maverick when studied closely. It was by far the most fun to assemble and I kept it on my design wall for weeks, making the whole room look like a celebration.

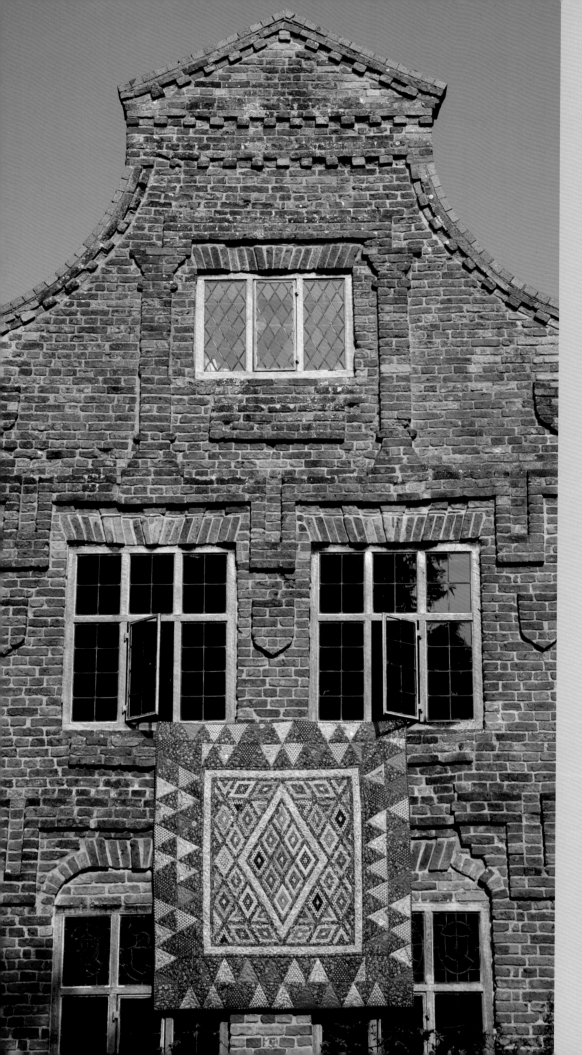

Diamond Jubilee
by Kaffe Fassett

It would have been wonderful if I had had the time to do this quilt (the *Cartwright Hexagon Coverlet* on page 9) just as it is. Instead I reduced the hexagon rows to strips so it is quicker to make while keeping the diamond dance going. This was the first of the more complex quilts to catch my eye and delights me each time I study it afresh.

OVERLEAF

Snowball Crisscross
by Kaffe Fassett

My version of the *Ridehalgh Quilt* (see page 14) uses a soft palette of tones with a misty grey blue ground. It would be interesting to find a stripe that would make the crosses appear as an outline. This version has more the feeling of a plaid in its blocks of repeated colour.

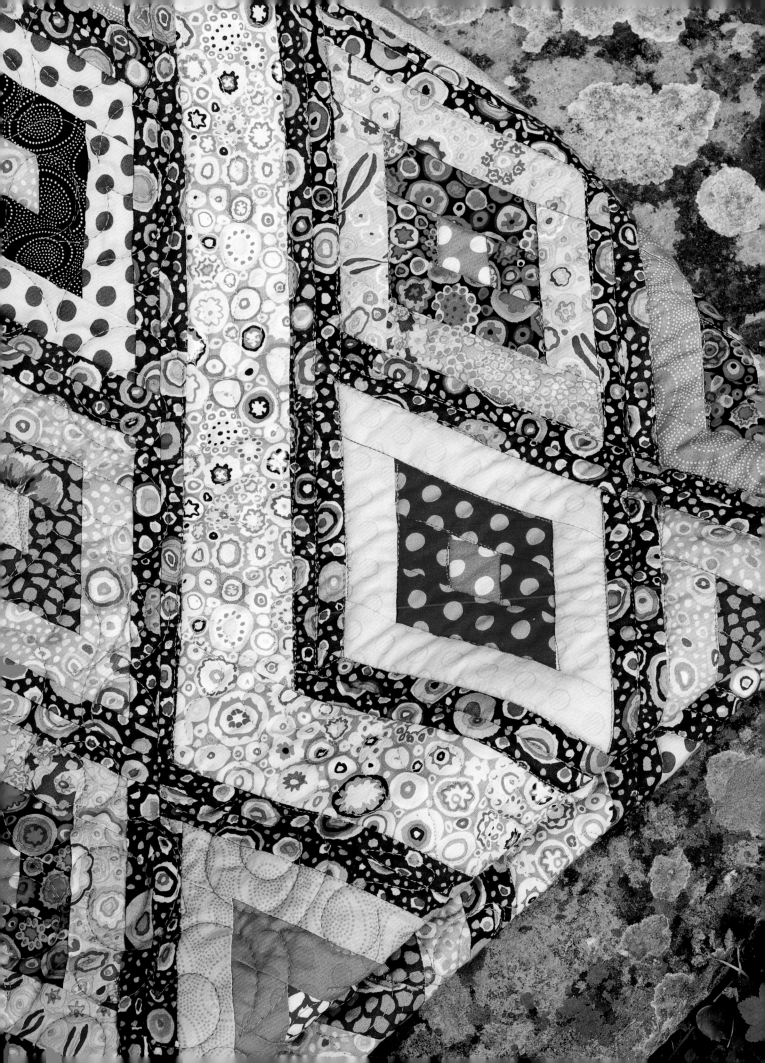

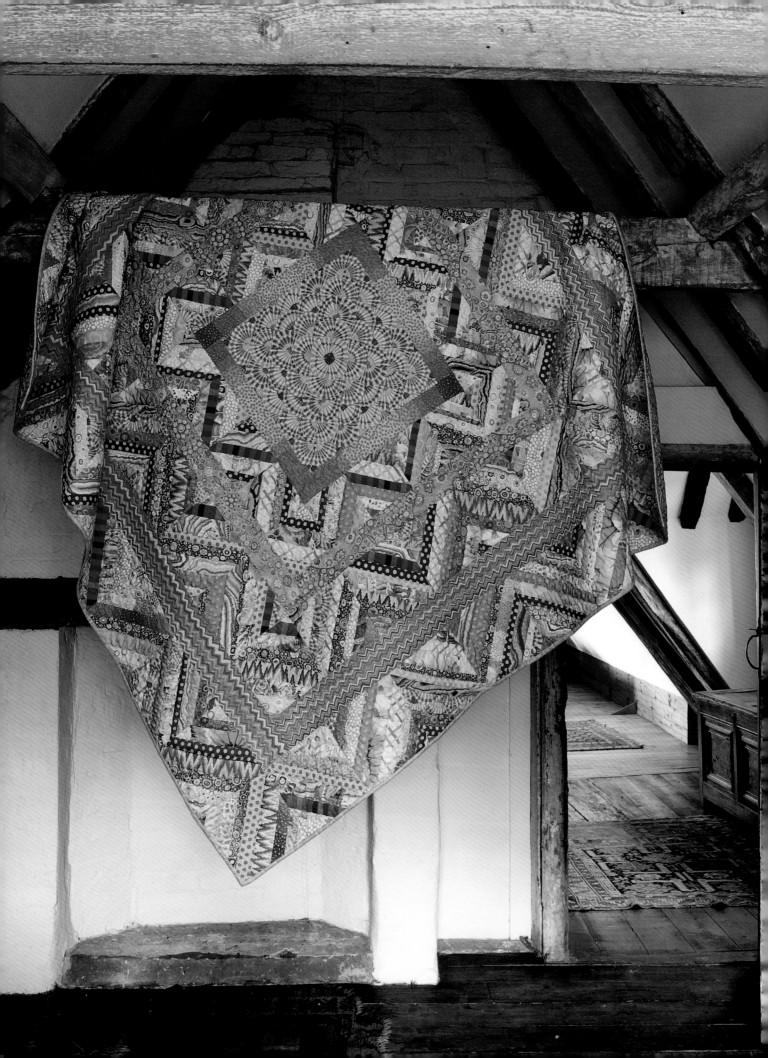

Citrus Zigzag Ribbon
by Corienne Kramer

I love the way the angles of this Elizabethan manor house attic room echo so wonderfully the jaunty chevrons in Corienne's version of the *Candy Zigzag Ribbon* quilt. I just love the way Corienne has cut the centre triangles in her version from the Yellow Paper Fans fabric to give the sewn square a kaleidoscopic effect, beautifully set off by the surrounding border in Pink Ombre.

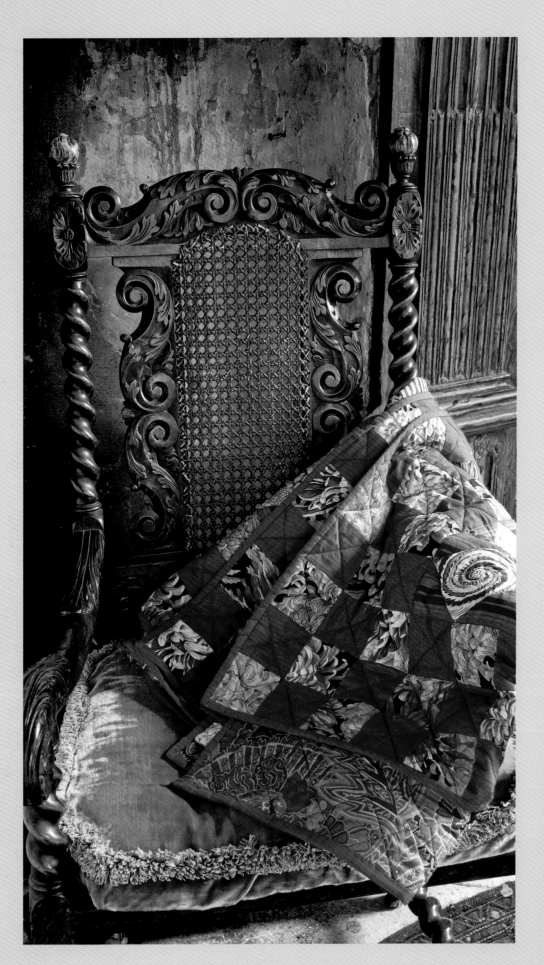

Purple Checkerboard Medallion
by Liza Prior Lucy

Liza's version of my *Rustic Checkerboard Medallion* uses a contrasting palette to create a dramatic, eye-catching quilt. Its rich plum tones and bright oranges really glow against the handsome wooden panelling and dark flagstone floors of our Elizabethan manor house location.

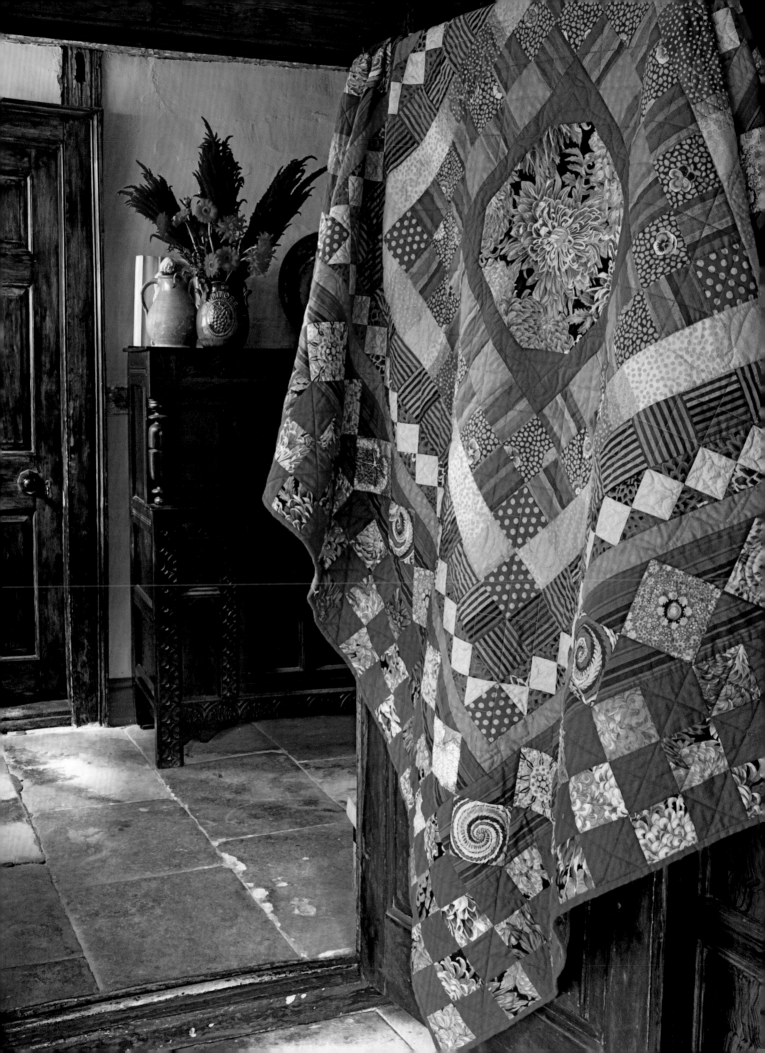

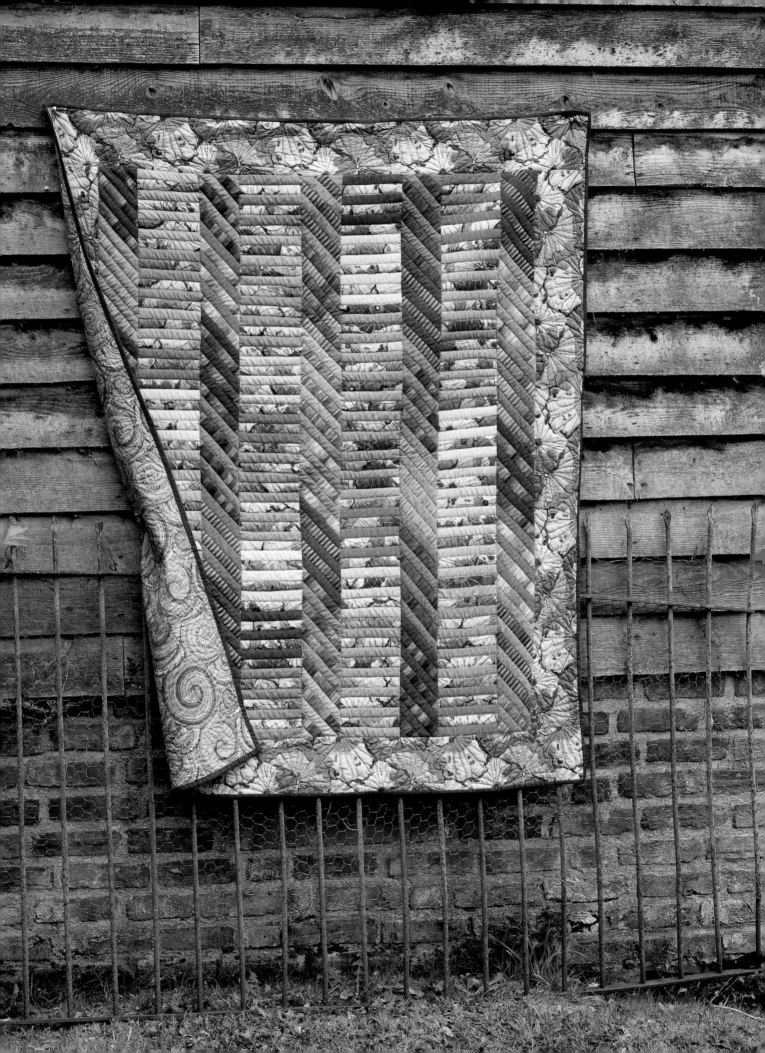

Earthy Herringbone Stripes

by Judy Baldwin

We found exactly the right place for Judy's interpretation of my *Sunshine Herringbone Stripes* quilt. The horizontal bricks and vertical iron railings echo the neat geometry of the design. In Judy's version, the choice of the Lotus Leaf fabric for the border makes a really effective contrast to the Shot Cottons and Woven Stripes. I look forward to seeing other interesting versions of this quilt on my travels!

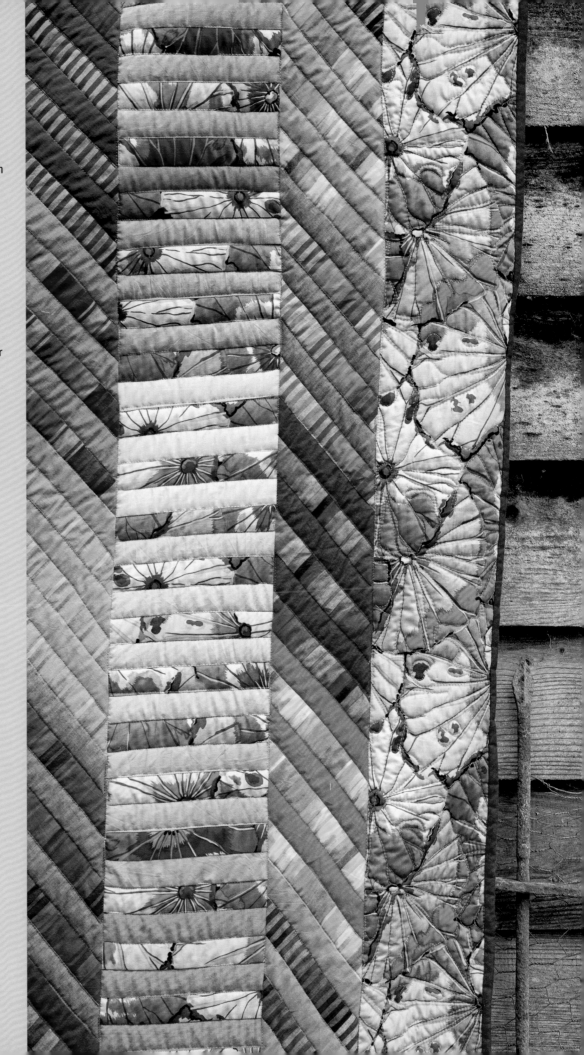

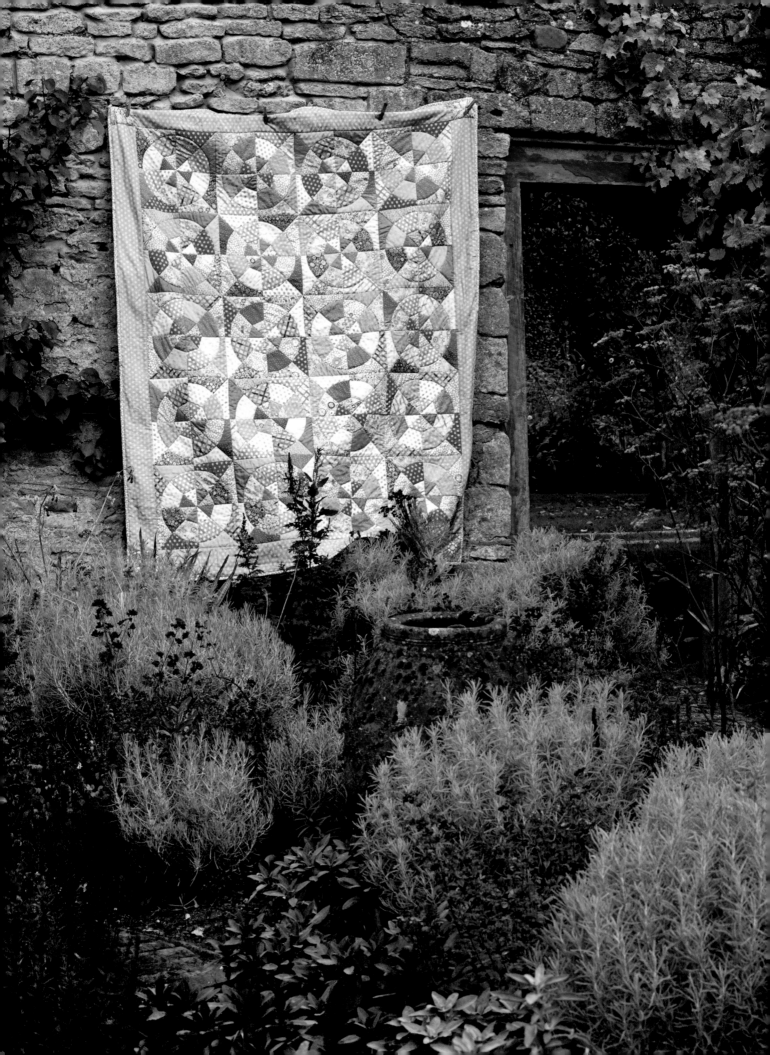

Cool Wheels
by Pauline Smith

The cool tones in Pauline's version of my *Hot Wheels* quilt sit so well in this lovely old walled herb garden with its silvery-grey foliage. Pauline particularly liked the contrasting elements in the original quilt, the splashes of darker tones, and the mirror-imaged pieces in the same prints in each block, so she used this in her version. To create a contrast to my hot palette version, she took a group of cool shades, but used my Pink Ombre fabric to add a kick.

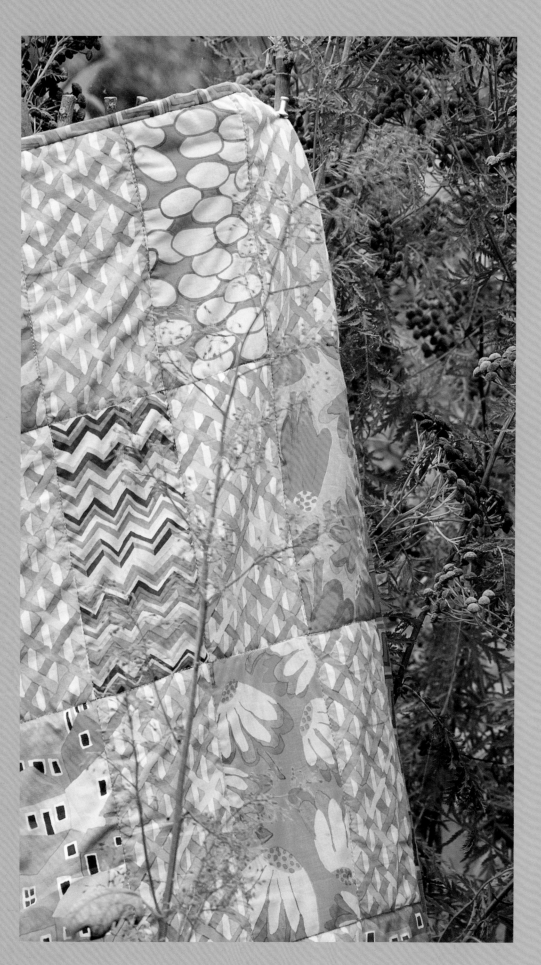

Mellow Wagga Wagga
by Brandon Mably

Brandon's lyrical version
of my *Dark Wagga Wagga*
quilt is created in a delicate
palette that complements
the soft colours of this
English garden beautifully.
Brandon's version is very
different both from my
version and the original and
has a very simple layout
even a novice could manage.
The layout showcases his
latest range of prints, the
alternate blocks being in his
Candy Mad Plaid.

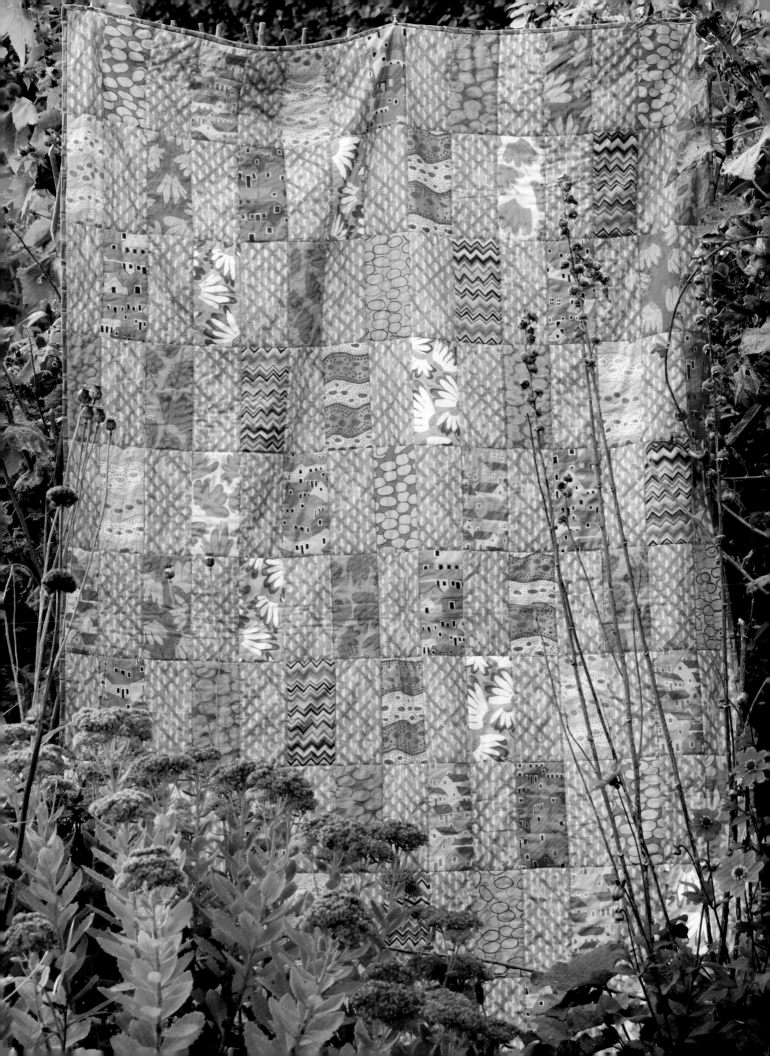

dark wagga wagga *

Kaffe Fassett

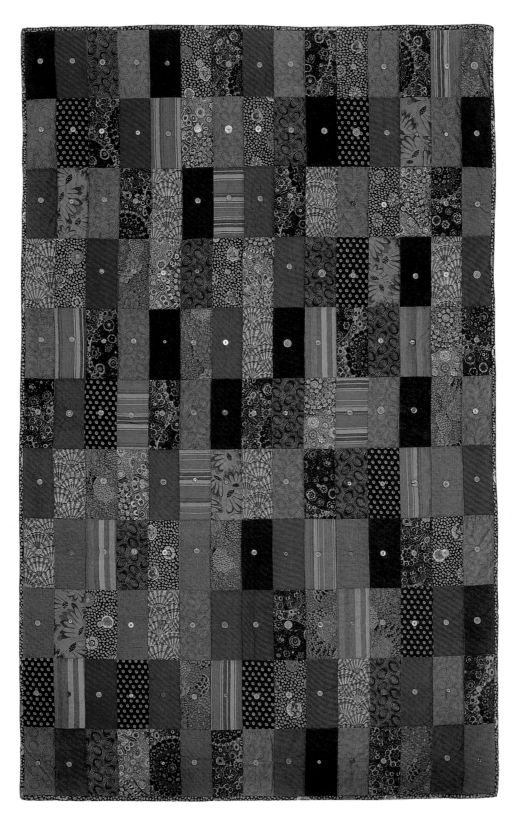

This very straightforward quilt is made using a single rectangle (Template G). The rich dark background is studded with little jewel-like buttons.

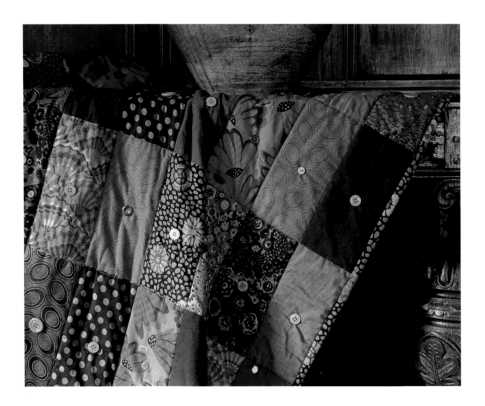

SIZE OF QUILT
The finished quilt will measure approx. 52½in x 82½in (133.25cm x 209.5cm).

MATERIALS
Patchwork Fabrics
LAZY DAISY
Charcoal	BM44CC	¼yd (25cm)

GUINEA FLOWER
Purple	GP59PU	⅜yd (35cm)

SPOT
Black	GP70BK	⅜yd (35cm)

ABORIGINAL DOTS
Charcoal	GP71CC	⅝yd (60cm)
Chocolate	GP71CO	⅜yd (35cm)

MILLEFIORE
Blue	GP92BL	⅜yd (35cm)
Dark	GP92DK	⅝yd (60cm)

ORIENTAL TREES
Maroon	GP129MR	⅜yd (35cm)

PAPER FANS
Teal	GP143TE	⅜yd (35cm)

SHOT COTTON
Thunder	SC06	½yd (45cm)
Bordeaux	SC54	⅜yd (35cm)
Coal	SC63	½yd (45cm)
Blue Jeans	SC100BJ	⅜yd (35cm)

WOVEN BROAD STRIPE
Blue	WBS BL	⅜yd (35cm)

WOVEN EXOTIC STRIPE
Mallard	WES ML	⅜yd (35cm)

Backing Fabric 5¼yd (4.8m)
We suggest these fabrics for backing
WOVEN EXOTIC STRIPE Parma, WES PM
WOVEN BROAD STRIPE Blue, WBS BL

Binding
GUINEA FLOWER
Purple	GP59PU	⅝yd (60cm)

Batting
60in x 90in (152.5cm x 228.5cm)

Quilting thread and buttons
Toning machine quilting thread and 165 small toning buttons.

Templates

G

CUTTING OUT
Please note that the Stripe fabrics are cut differently to all the other fabrics to achieve the different stripe directions.
Template G STRIPE FABRICS Cut an 8in (20.25cm) strip across the width of the fabric in WBS BL and WES ML. Cut 8in x 4in (20.25cm x 10.25cm) rectangles using the template as a guide. Cut 6 rectangles in WES ML and 5 in WBS BL with the stripes running vertically down the length of the rectangles. Then cut 4 rectangles in WES ML with the stripes running horizontally across the width of the rectangles. Total 15 rectangles.
Template G ALL OTHER FABRICS Cut 4in (10.25cm) strips across the width of the fabric, each strip will give you 5 rectangles per full width. Cut 20 rectangles in GP71CC, GP92DK, 15 in SC06, 14 in SC63, 10 in GP59PU, GP71CO, GP129MR, GP143TE, SC54, 9 in GP70BK, SC100BJ, 8 in GP92BL and 5 in BM44CC. Total 150 rectangles.

Binding Cut 7 strips 2½in (6.5cm) wide across the width of the fabric in GP59PU.

Backing Cut 1 piece 40in x 90in (101.5cm x 228.5cm) and 1 piece 21in x 90in (53.25cm x 228.5cm) in backing fabric.

MAKING THE QUILT
Use a ¼in (6mm) seam allowance throughout. Refer to the quilt assembly diagram for fabric placement. Lay out all the rectangles as shown in the quilt assembly diagram. Join the rectangles into 11 rows of 15 rectangles. Join the rows, pressing the seam allowances in opposite directions for each row, to complete the quilt centre.

FINISHING THE QUILT
Press the quilt top. Seam the backing pieces using a ¼in (6mm) seam allowance to form a piece approx. 60in x 90in (152.5cm x 228.5cm). Layer the quilt top, batting and backing and baste together (see page 148). Using toning machine quilting thread stitch in the ditch throughout the quilt, then sew a button in the centre of each rectangle. Trim the quilt edges and attach the binding (see page 149).

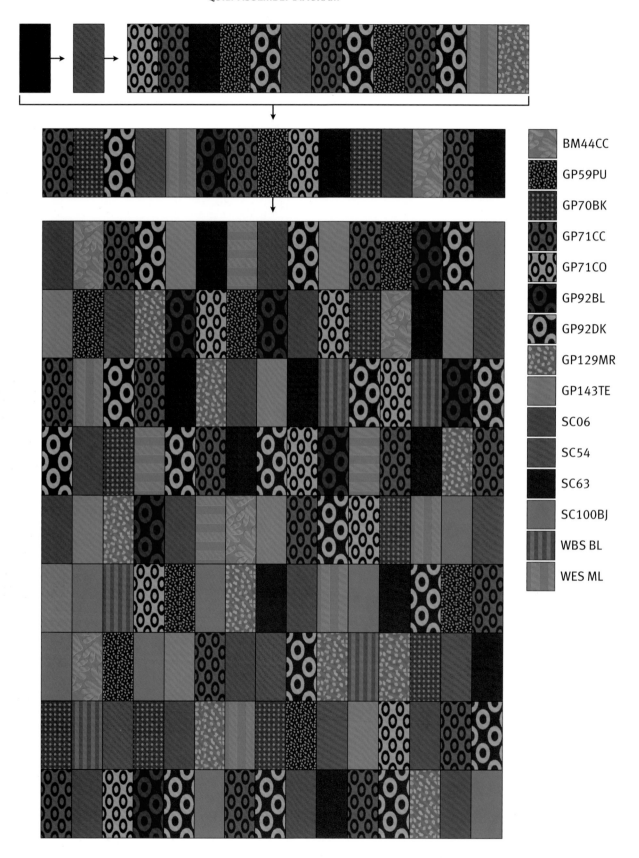

BM44CC

GP59PU

GP70BK

GP71CC

GP71CO

GP92BL

GP92DK

GP129MR

GP143TE

SC06

SC54

SC63

SC100BJ

WBS BL

WES ML

red squares **

Kaffe Fassett

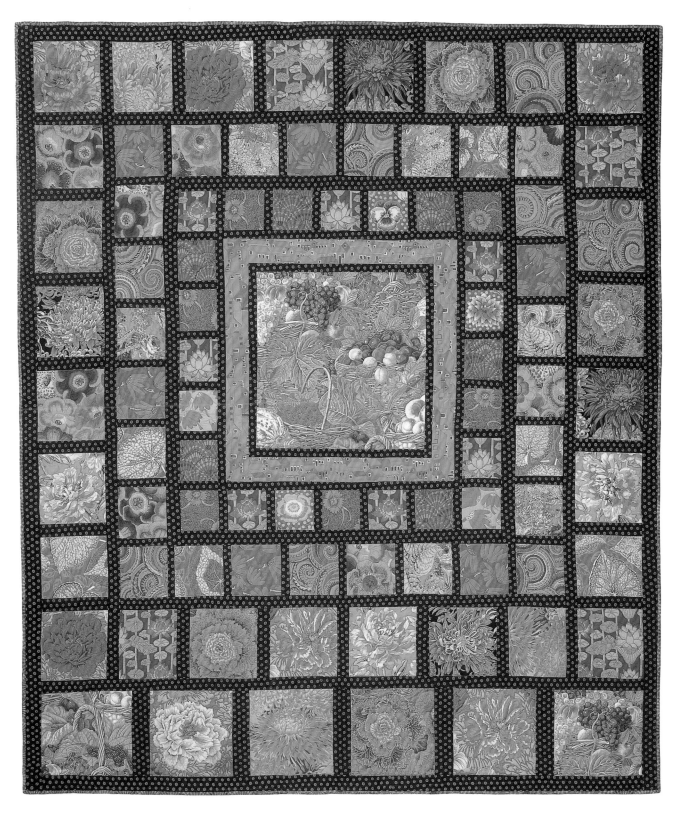

All the shapes for this unusual medallion style quilt are cut to specified sizes and we have not provided any templates. Please read the cutting instructions carefully as the sizes of borders and sashing vary depending on position in the layout. Several of the fabrics are fussy cut to focus on the large blooms in the designs. The quilt is built in a series of simple and pieced borders around a large fussy cut panel. The centre panel is surrounded with 3 simple borders, Borders 1, 2 and 3. Border 4 is pieced of squares (Square A) interspaced with sashing strips, followed by simple Border 5. Border 6 is pieced of squares (Square B) interspaced with sashing strips and is surrounded with simple Border 7. Border 8 is pieced of squares (Square C) and rectangles (Rectangle D) interspaced with sashing strips. Next the top outer border is added, followed by a sashing strip on the bottom of the quilt. Then a bottom row of squares (Square E) and rectangles (Rectangle F) interspaced with sashing strips is added, followed by the bottom outer border. Then finally the side outer borders to complete the quilt.

SIZE OF QUILT
The finished quilt will measure approx.
76in x 87in (193cm x 221cm).

MATERIALS
Patchwork Fabrics
LAZY DAISY

| Pink | BM44PK | ¼yd (25cm) |
| Red | BM44RD | ¼yd (25cm) |

BIG BLOOMS

| Red | GP91RD | ¼yd (25cm)* |

DIANTHUS

| Red | GP138RD | ¼yd (25cm) |

LOTUS STRIPE

| Red | GP140RD | ½yd (45cm)* |

PAPER FANS

| Red | GP143RD | ¼yd (25cm) |

JAPANESE CHRYSANTHEMUM

| Pink | PJ41PK | ½yd (45cm)* |
| Red | PJ41RD | ⅜yd (35cm)* |

BRASSICA

| Red | PJ51RD | ¾yd (70cm)* |

BROCADE PEONY

| Red | PJ62RD | ¾yd (70cm)* |

CURLY BASKETS

| Red | PJ66RD | ½yd (45cm) |

MARKET BASKET

| Red | PJ67RD | 1yd (90cm)* |

LILAC

| Red | PJ68RD | ¼yd (25cm) |

TREE PEONY

| Orange | PJ69OR | ½yd (45cm)* |

BIG LEAVES

| Pink | PJ70PK | ½yd (45cm) |

GLOXINIAS

| Pink | PJ71PK | ½yd (45cm) |

*Extra fabric allowed for fussy cutting.

Border and Sashing Fabrics
SHANTY TOWN

| Red | BM47RD | ⅜yd (35cm) |

SPOT

| Black | GP70BK | 2¾yd (2.5m) |

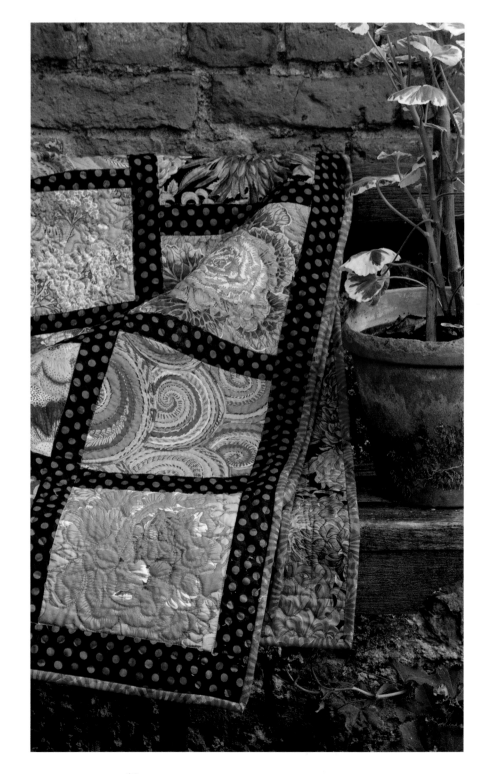

62

Backing Fabric 6⅛yd (5.6m)
We suggest these fabrics for backing
JAPANESE CHRYSANTHEMUM Red, PJ41RD
BRASSICA Red, PJ51RD

Binding
PAPER FANS
Red GP143RD ¾yd (70cm)

Batting
84in x 95in (213.25cm x 241.25cm)

Quilting thread
Toning machine quilting thread

Cut Shapes

A B C D

E F

CUTTING OUT
Our usual strip cutting method is not
appropriate in this case as so many of
the fabrics are fussy cut to feature the
blooms in the fabric designs, refer to
the photograph for help with this. We
recommend marking out the all the
shapes required onto each fabric to
ensure a good fit before fussy cutting,
especially the Centre Panel.

Shape Sizes
Centre Panel Cut 20in x 20in (50.75cm x
50.75cm)
Square A for Border 4 Cut 5in x 5in
(12.75cm x 12.75cm)
Square B for Border 6 Cut 6¼in x 6¼in
(16cm x 16cm)
Square C for Border 8 Cut 8½in x 8½in
(21.5cm x 21.5cm)
Rectangle D for Border 8 Cut 8½in x
7¼in (21.5cm x 18.5cm)
Square E for Bottom Row Cut 10in x 10in
(25.5cm x 25.5cm)
Rectangle F for Bottom Row Cut 11¼in x
10in (28.5cm x 25.5cm)

Fabric BM44PK Cut 2 x A
Fabric BM44RD Cut 6 x B
Fabric GP91RD Cut 3 x A
Fabric GP138RD Cut 6 x A
Fabric GP140RD Fussy cut with the
stripes vertical 7 x A, 2 x C and 2 x D
Fabric GP143RD Cut 6 x A
Fabric PJ41PK Fussy cut 2 x D and 1 x E
Fabric PJ41RD Fussy cut 4 x C
Fabric PJ51RD Fussy cut 4 x C and 1 x E
Fabric PJ62RD Fussy cut 5 x C and 2 x E
Fabric PJ66RD Cut 6 x B, 1 x C and 1 x D
Fabric PJ67RD Fussy cut the Centre Panel
to feature a basket and 2 x F
Fabric PJ68RD Cut 6 x B
Fabric PJ69OR Fussy cut 3 x C
Fabric PJ70PK 4 x B and 2 x D
Fabric PJ71PK Cut 6 x B, 1 x C and 1 x D
Total 24 x Square A, 28 x Square B, 20 x
Square C, 8 x Rectangle D, 4 x Square E
and 2 x Rectangle F.

Border 2 Cut 3 strips 3in (7.5cm) wide
across the width of the fabric, join as
necessary and cut 2 borders 3in x 22in
(7.5cm x 56cm) for the quilt top and
bottom and 2 borders 3in x 27in (7.5cm x
68.5cm) in BM47RD.
Border 1 Cut 3 strips 1½in (3.75cm)
wide across the width of the fabric, join
as necessary and cut 2 borders 1½in x
20in (3.75cm x 50.75cm) for the quilt top
and bottom and 2 borders 1½in x 22in
(3.75cm x 56cm) in GP70BK.
Border 3 Cut 3 strips 1½in (3.75cm)
wide across the width of the fabric, join
as necessary and cut 2 borders 1½in x
27in (3.75cm x 68.5cm) for the quilt top
and bottom and 2 borders 1½in x 29in
(3.75cm x 73.75cm) in GP70BK.
Border 4 Sashing Strips Cut 3 strips
1½in (3.75cm) wide across the width of
the fabric, cut 24 sashing strips 1½in x
5in (3.75cm x 12.75cm) in GP70BK.
Border 5 Cut 4 strips 2½in (6.25cm)
wide across the width of the fabric, join
as necessary and cut 2 borders 2½in x
38in (6.25cm x 96.5cm) for the quilt top
and bottom and 2 borders 2½in x 42in
(6.25cm x 106.75cm) in GP70BK.
Border 6 Sashing Strips Cut 5 strips
1½in (3.75cm) wide across the width of
the fabric, cut 28 sashing strips 1½in x
6¼in (3.75cm x 16cm) in GP70BK.
Border 7 Cut 6 strips 2in (5cm) wide
across the width of the fabric, join as
necessary and cut 2 borders 2in x 53½in

(5cm x 136cm) for the quilt top and
bottom and 2 borders 2in x 56½in (5cm x
143.5cm) in GP70BK.
Border 8 Sashing Strips Cut 7 strips 2in
(5cm) wide across the width of the fabric,
cut 28 sashing strips 2in x 8½in (5cm x
21.5cm) in GP70BK.
Bottom Sashing Strip Cut 2 strips 2in
(5cm) wide across the width of the fabric,
join as necessary and cut 1 sashing
strip 2in x 72½in (5cm x 184.25cm) in
GP70BK.
Bottom Row Sashing Strips Cut 2 strips
3in (7.5cm) wide across the width of the
fabric, cut 5 sashing strips 3in x 10in
(7.5cm x 25.5cm) in GP70BK.
Outer Border Cut 8 strips 2½in (6.25cm)
wide across the width of the fabric, join
as necessary and cut 2 borders 2½in x
72½in (6.25cm x 184.25cm) for the quilt
top and bottom and 2 borders 2½in x
87½in (6.25cm x 222.25cm) in GP70BK.

Binding Cut 9 strips 2½in (6.5cm)
wide across the width of the fabric in
GP143RD.

Backing Cut 2 pieces 40in x 95in
(101.5cm x 241.25cm), 2 pieces 40in
x 5in (101.5cm x 12.75cm) and 1 piece
16in x 5in (40.5cm x 12.75cm) in backing
fabric.

MAKING THE QUILT
Borders 1–5
Use a ¼in (6mm) seam allowance
throughout. Refer to the quilt assembly
diagrams for fabric placement. Take care
to add the borders in the numbered order
shown in the quilt assembly diagrams.
Take the centre panel in PJ67RD and add
border 1, top and bottom first, then the
sides. Add borders 2, then 3 in the same
sequence as shown in quilt assembly
diagram 1.

Border 4 is pieced using 24 A squares
interspaced with sashing strips. Piece
the top and bottom border, each of 5 A
squares and 6 sashing strips, add to the
quilt centre, then piece the side borders,
each with 7 A squares and 6 sashing
strips and add to the quilt sides. Add
Border 5, top and bottom first, then sides
as shown in quilt assembly diagram 1.

QUILT ASSEMBLY DIAGRAM 1

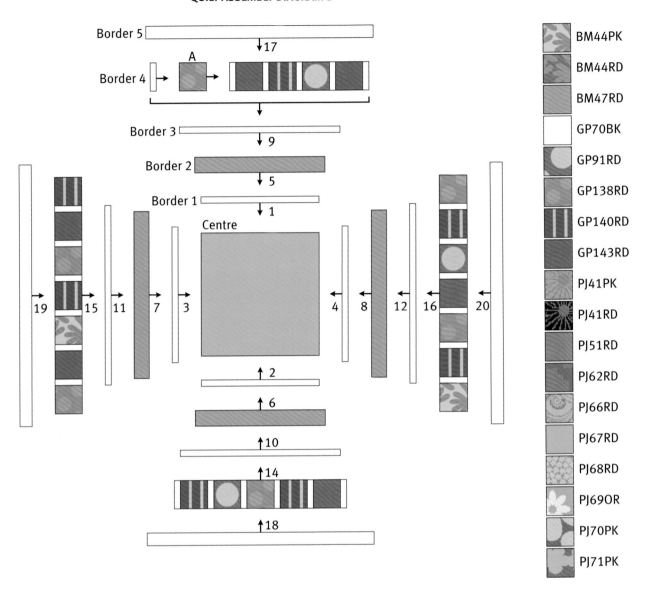

BM44PK
BM44RD
BM47RD
GP70BK
GP91RD
GP138RD
GP140RD
GP143RD
PJ41PK
PJ41RD
PJ51RD
PJ62RD
PJ66RD
PJ67RD
PJ68RD
PJ69OR
PJ70PK
PJ71PK

MAKING THE QUILT

Borders 6-8 and the Bottom Row

Border 6 is pieced using 28 B squares interspaced with sashing strips. Piece the top and bottom border, each of 6 B squares and 7 sashing strips, add to the quilt centre, then piece the side borders, each with 8 B squares and 7 sashing strips and add to the quilt sides as shown in quilt assembly diagram 2. Add Border 7, top and bottom first, then sides.

Border 8 is pieced using 20 C squares and 8 D rectangles interspaced with sashing strips. Refer to quilt assembly

diagram 2 for the layout of these shapes. Piece the top and bottom borders as shown and add to the quilt top and bottom, then piece the sides and add to the quilt sides.

Next add only the top outer border, then the bottom sashing strip. The Bottom Row is pieced using 4 E squares, 2 F rectangles and the bottom row sashing strips, refer to quilt assembly diagram 2 for the layout of these shapes and piece as shown. Add the bottom outer border to the quilt bottom, then the side outer borders to complete the quilt.

FINISHING THE QUILT

Press the quilt top. Seam the backing pieces using a ¼in (6mm) seam allowance to form a piece approx. 84in x 95in (213.25cm x 241.25cm). Layer the quilt top, batting and backing and baste together (see page 148). Free motion quilt gently curving lines in all the sashing and borders and follow the floral designs in the squares and rectangles using toning machine quilting thread. Trim the quilt edges and attach the binding (see page 149).

QUILT ASSEMBLY DIAGRAM 2

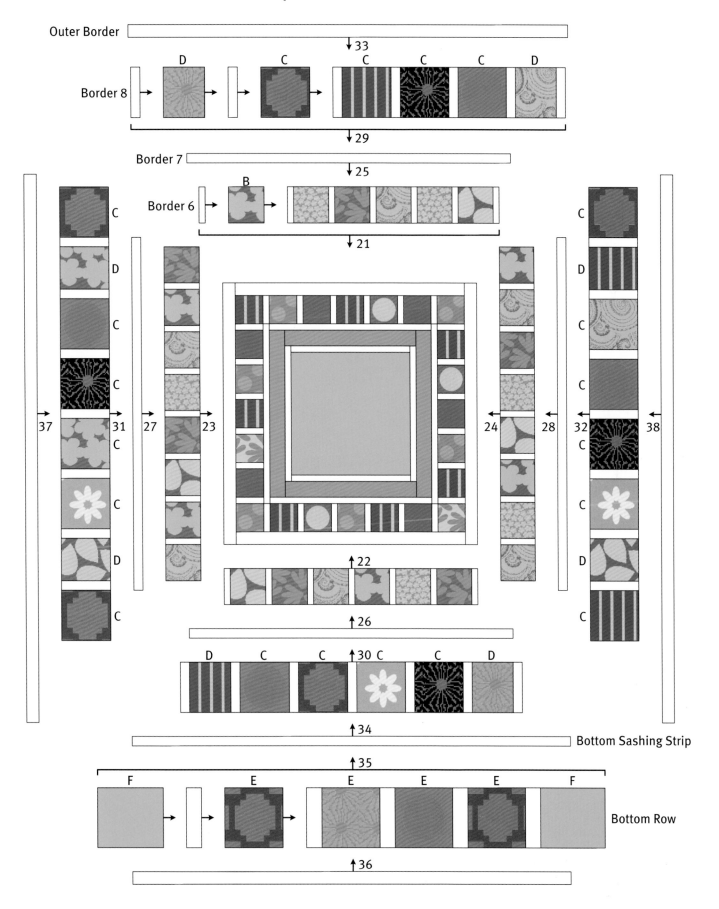

Outer Border

Border 8

33

29

Border 7

25

Border 6

B

21

37 31 27 23

C D C C C C D C

24 28 32 38

C D C C C C D C

22

26

D C C 30 C C D

34

Bottom Sashing Strip

35

F E E E E F

Bottom Row

36

hot wheels ✱✱✱

Kaffe Fassett

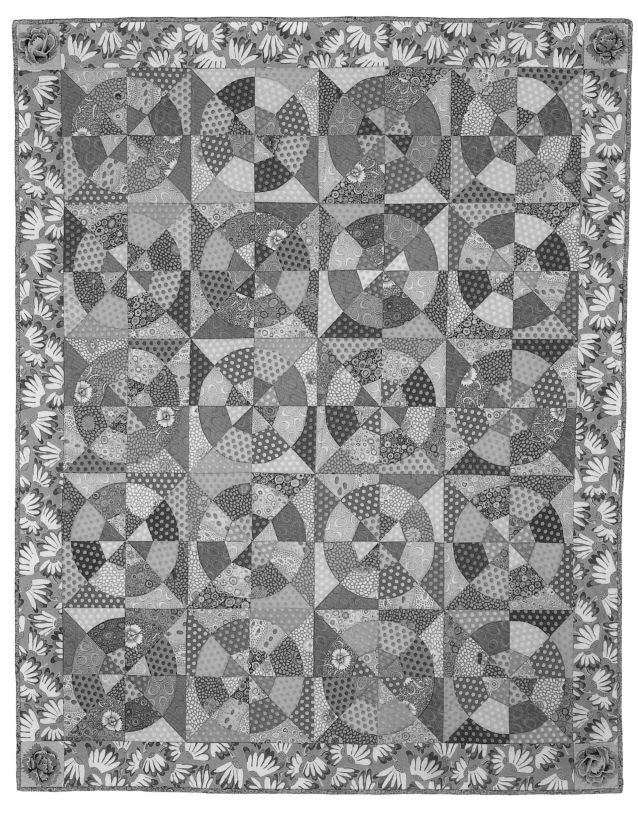

The 'wheels' blocks in this quilt are made using 2 curved edge patch shapes (Templates R and T & Reverse T) and a triangle (Template S). The template R and S shapes form the wheel and the Template T & reverse T shape forms the background. The blocks finish to 12½in (31.75cm). The blocks are straight set into rows and surrounded with a simple border with corner posts (cut to size).

SIZE OF QUILT
The finished quilt will measure approx.
59in x 71½in (149.75cm x 181.5cm)

MATERIALS
Patchwork Fabrics
VICTORIA
Citrus	BM46CT	⅜yd (35cm)

ROMAN GLASS
Pink	GP01PK	¼yd (25cm)
Red	GP01RD	⅛yd (15cm)

PAPERWEIGHT
Gold	GP20GD	¼yd (25cm)
Grey	GP20GY	¼yd (25cm)
Pink	GP20PK	¼yd (25cm)

GUINEA FLOWER
Apricot	GP59AP	¼yd (25cm)
Mauve	GP59MV	¼yd (25cm)
Grey	GP59GY	¼yd (25cm)
Pink	GP59PK	½yd (45cm)

SPOT
Fuchsia	GP70FU	⅛yd (15cm)
Gold	GP70GD	⅜yd (35cm)
Grape	GP70GP	⅜yd (35cm)
Hydrangea	GP70HY	⅜yd (35cm)
Ice	GP70IC	¼yd (25cm)
Lavender	GP70LV	⅛yd (15cm)
Magenta	GP70MG	⅜yd (35cm)
Orange	GP70OR	¼yd (25cm)
Peach	GP70PH	⅜yd (35cm)
Red	GP70RD	¼yd (25cm)
Soft Blue	GP70SF	⅛yd (15cm)

ABORIGINAL DOTS
Lilac	GP71LI	⅛yd (15cm)
Mint	GP71MT	⅜yd (35cm)
Purple	GP71PU	⅜yd (35cm)
Red	GP71RD	⅜yd (35cm)

DIANTHUS
White	GP138WH	¼yd (25cm)

Border Fabrics
LAZY DAISY
Blue	BM44BL	1yd (90cm)

BIG BLOOMS
Duck Egg	GP91DE	¼yd (25cm)

Backing Fabric 4yd (3.7m)
We suggest these fabrics for backing
GUINEA FLOWER Purple, GP59PU
PAPERWEIGHT Gypsy, GP20GS

Binding
PAPERWEIGHT
Pink	GP20PK	⅝yd (60cm)

Batting
67in x 79in (170.25cm x 200.5cm)

Quilting thread
Toning machine quilting thread

Templates

R S T & Rev. T

CUTTING OUT
Cut the fabric in the order stated, trim and use leftover strips for later templates. Cutting layouts are provided for all the templates to show how to get the maximum pieces per full row.

Template R Cut 3½in (9cm) strips across the width of the fabric. Each strip will give you 10 patches per full row, see the cutting layout for template R. Cut 14 in GP138WH, 12 in GP70PH, 10 in GP59PK, GP70GD, GP70GP, GP70MG, GP71RD, 8 in BM46CT, GP59AP, GP59GY, GP70HY, 6 in GP20GD, GP20GY, GP70OR, GP71LI, GP71MT, GP71PU, 4 in GP01RD, GP20PK, GP70RD, 2 in GP59MV and GP70IC. Total 160 patches.

Template T & Reverse T Be sure to open out the fabric strips when cutting Template T and Reverse T patches! If you leave them folded and cut 2 layers you will end up with the wrong shapes. Cut 3¼in (8.25cm) strips across the width of the fabric. Each strip will give you 7 patches per full row, see the cutting layout for template T & Reverse T. With the template right side up cut 14 in GP59PK, 10 in GP70MG, GP71PU, 8 in GP70GP, 6 in GP20GY, GP20PK, GP70IC, GP71RD, 4 in GP59AP, GP70OR, GP70RD, 2 in GP70GD and GP70PH. Total 82 patches. Now reverse the template by flipping it over and with the wrong side up cut 12 in GP70HY, 10 in BM46CT, GP71MT, 8 in GP01PK, GP59GY, GP70GD, 6 in GP20GD, GP59MV, GP70PH and 4 in GP70LV. Total 78 Patches. Please note that the numbers of Template T & Reverse T patches are unequal as 2 of the shapes (cut in GP70GD) are used wrong side facing in the quilt.

Template S Cut 3¼in (8.25cm) strips across the width of the fabric. Each strip will give you 28 patches per full row, see the cutting layout for template S. Cut 20 in GP59PK, 14 in GP70FU, GP70GD, 12 in GP71MT, GP71RD, 10 in GP01PK, GP20GD, GP70HY, 8 in GP70LV, GP71PU, 6 in GP70MG, GP71LI, 4 in GP20GY, GP59MV, GP70GP, GP70IC, GP70RD, 2 in BM46CT, GP20PK, GP70PH, GP70SF and GP138WH. Total 160 triangles.

Borders Cut 6 strips 5in (12.75cm) wide across the width of the fabric in BM44BL, Join as necessary and cut 2 borders 5in x 63in (12.75cm x 160cm) for the quilt sides and 2 borders 5in x 50½in (12.75cm x 128.25cm) for the quilt top and bottom.

Border Corner Posts Fussy cut 4 squares 5in x 5in (12.75cm x 12.75cm) in GP91DE centring on the blooms as shown in the photograph.

Cutting Layout for Template R

Cutting Layout for Template S

Cutting Layout for Template T

Binding Cut 7 strips 2½in (6.5cm) wide across the width of the fabric in GP20PK.

Backing Cut 2 pieces 40in x 67in (101.5cm x 170.25cm) in backing fabric.

MAKING THE BLOCKS

In some cases the wrong side of the fabric was used as Kaffe wanted a softer look, we have marked the quilt assembly diagram with small white circles to show the position of these fabrics.

Use a ¼in (6mm) seam allowance throughout and refer to the quilt assembly diagram for fabric placement, you will notice that the fabrics are alternated in a dark/light combination as illustrated in block assembly diagrams a, b and c. Make a second set for templates R and T & Reverse T, this time using the sewing lines. Mark your patches with the sewing lines and register marks with a washable marker pen or pencil.

Lay out all the pieces for the first block, first stitch the template S triangles to the template R patches as shown in block assembly diagram a. Then add the background template T & Reverse T patches as shown in diagram b. Match with the Template T and Reverse T patch on top and the Template R beneath and use 3 pins along the length of the curve. The curves in these blocks are gentle and should not be difficult to ease gently into place as you sew. When stitching the curved seams start sewing with a backstitch ¼in (6mm) from the raw edge and finish ¼in (6mm) short of the raw edge and backstitch to secure. Finger press the pieces as you go, towards the dark fabric, this will help with matching at the junctions, but wait to press the seams with your iron until the block is complete. Sew the 8 sections that make up the block, then join into 4 squares as shown in diagram c. Join the squares as shown

in diagram d, the finished block is shown in diagram e. Make a total of 20 blocks.

MAKING THE QUILT

Lay out the blocks as shown in the quilt assembly diagram. Join into 5 rows of 4 blocks. Join the rows to complete the quilt centre. Add the side borders to the quilt centre. Join a corner post to each end of the top and bottom borders and join to the quilt centre to complete the quilt.

FINISHING THE QUILT

Press the quilt top. Seam the backing pieces using a ¼in (6mm) seam allowance to form a piece approx. 67in x 79in (170.25cm x 200.5cm). Layer the quilt top, batting and backing and baste together (see page 148). Using toning machine quilting thread stitch in the ditch throughout the quilt. Trim the quilt edges and attach the binding (see page 149).

BLOCK ASSEMBLY DIAGRAMS

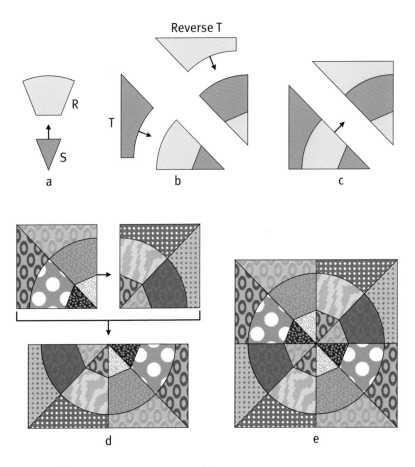

QUILT ASSEMBLY DIAGRAM

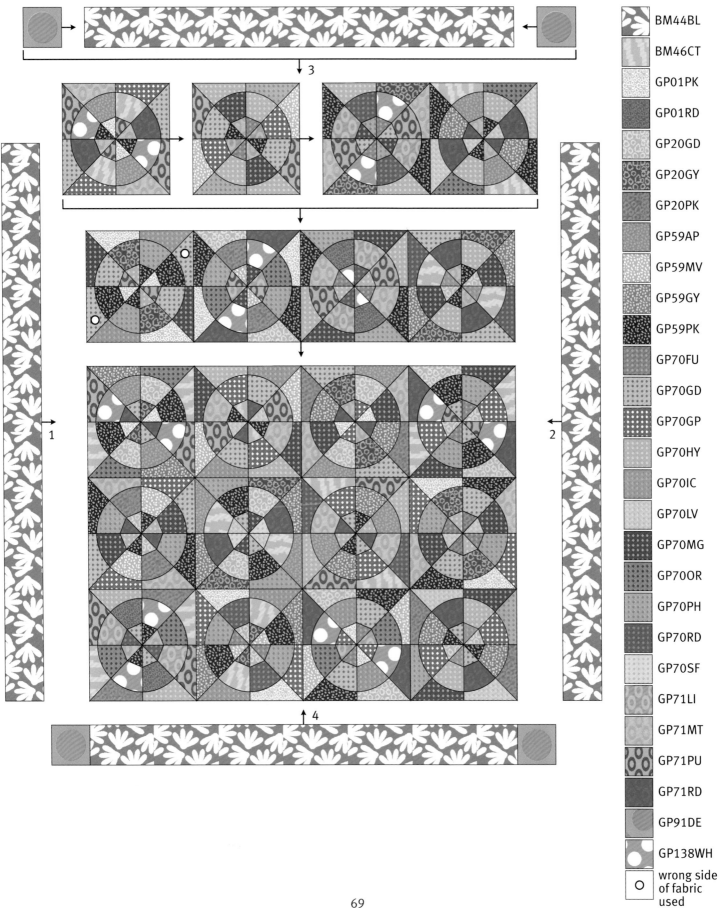

BM44BL
BM46CT
GP01PK
GP01RD
GP20GD
GP20GY
GP20PK
GP59AP
GP59MV
GP59GY
GP59PK
GP70FU
GP70GD
GP70GP
GP70HY
GP70IC
GP70LV
GP70MG
GP70OR
GP70PH
GP70RD
GP70SF
GP71LI
GP71MT
GP71PU
GP71RD
GP91DE
GP138WH

O wrong side
of fabric
used

sunshine herringbone stripes **

Kaffe Fassett

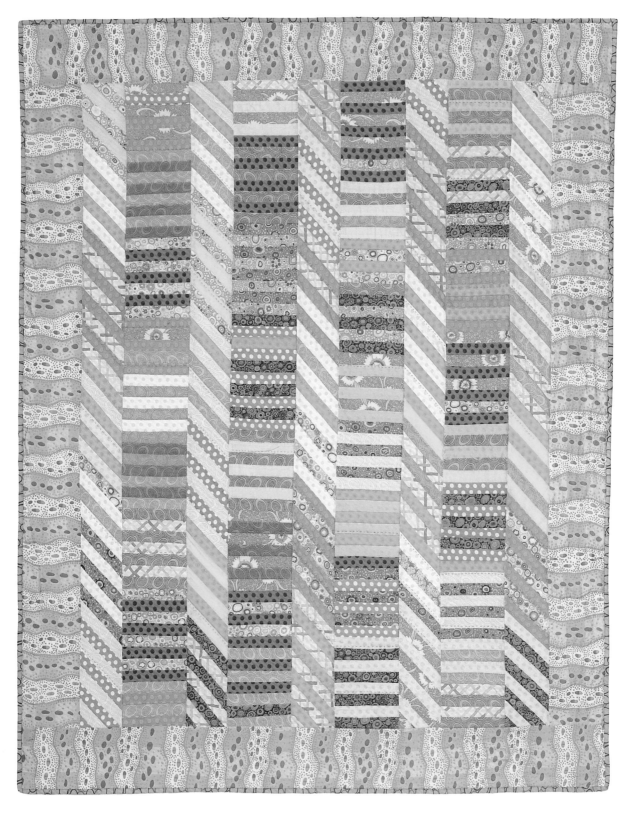

This quilt is pieced in columns. The diagonal columns are pieced from cut strips onto a paper foundation using the 'stitch and flip' method. It's very easy and the paper is really only to keep the pieced column in shape as you stitch. The only template provided is for a small triangle (Template L) which is used in the top right of the diagonal column to set the correct angle for the subsequent strips. The straight columns are pieced, again from cut strips. The quilt centre is then surrounded with a simple border.

SIZE OF QUILT
The finished quilt will measure approx. 55 in x 68 in (139.75cm x 172.75cm).

MATERIALS
Please note, we used Paperweight Paprika in the original quilt, this colourway had been discontinued so Kaffe suggested Paperweight Pink (GP20PK) which he says will work even better! We have coloured the diagrams and specified the fabric accordingly.

Patchwork Fabrics
MAD PLAID
Red	BM37PT	³/₈yd (35cm)

ROMAN GLASS
| Gold | GP01GD | ¼yd (25cm) |
| Pink | GP01PK | ¼yd (25cm) |

PAPERWEIGHT
| Gold | GP20GD | ¼yd (25cm) |
| Pink | GP20PK | ¼yd (25cm) |

SPOT
Apple	GP70AL	⅛yd (15cm)
China Blue	GP70CI	¼yd (25cm)
Orange	GP70OR	¼yd (25cm)
Peach	GP70PH	³/₈yd (35cm)
Pond	GP70PO	³/₈yd (35cm)
Soft Blue	GP70SF	¼yd (25cm)
Sprout	GP70SR	³/₈yd (35cm)

ABORIGINAL DOTS
Cantaloupe	GP71CA	⅛yd (15cm)
Gold	GP71GD	¼yd (25cm)
Ivory	GP71IV	¼yd (25cm)
Leaf	GP71LF	⅛yd (15cm)
Lilac	GP71LI	¼yd (25cm)

DIANTHUS
| Yellow | GP138YE | ¼yd (25cm) |

SHOT COTTON
| Lemon | SC34 | ¼yd (25cm) |

Border Fabric
VICTORIA
| Citrus | BM46CT | 1¼yd (1.15m) |

Backing Fabric 3¾yd (3.4m)
We suggest these fabrics for backing
LAKE BLOSSOMS Yellow, GP93YE
THOUSAND FLOWERS Yellow, GP144YE

Binding
LABELS
| Ochre | BM45OC | ⁵/₈yd (60cm) |

Batting
63in x 76in (160cm x 193cm).

Quilting thread
Toning perlé embroidery threads.

You will also need
A roll of thin drawing paper from which to cut 5 rectangles 4½in x 57½in (11.5cm x 146cm) for foundations.

Template

L

CUTTING OUT
Template L Cut 3 in GP71IV, 1 in GP71GD and 1 in SC34. Total 5 Triangles.
Diagonal Columns Cut 1½in (3.75cm) strips across the width of the fabric, each strip will give you 5 rectangles per full width. Cut 1½in x 8in (3.75cm x 20.25cm) rectangles. Cut 27 in GP70PH, 26 in BM37PT, GP70SR, 20 in GP70PO, 18 in GP70SF, 17 in GP71IV, 12 in GP70CI, SC34, 10 in GP20GD, GP71GD, 8 in GP01PK, GP20PK, 7 in GP138YE, 5 in GP71CA, and 4 in GP01GD. Total 210 rectangles.
Straight Columns Cut 1½in (3.75cm) strips across the width of the fabric, each strip will give you 6 rectangles per full width. Cut 1½in x 6½in (3.75cm x 16.5cm) rectangles. Cut 26 in GP70OR, 22 in GP71LI, 19 in GP138YE, 18 in GP20PK, 15 in GP71GD, 13 in GP01GD, GP20GD, GP70CI, 11in GP70AL, GP70PO, 10 in GP01PK, GP71LF, 9 in GP37PT, GP70PH, SC34, 6 in GP70SF, GP71IV, 5 in GP71CA and 3 in GP70SR. Total 228 rectangles.
Borders Cut 6 strips 6in (15.25cm) wide across the width of the fabric in BM46CT. Join as necessary and cut 2 borders 6in x 57½in (15.25cm x 146cm) for the quilt sides and 2 borders 6in x 55½in (15.25cm x 141cm) for the quilt top and bottom.

Binding Cut 7 strips 2½in (6.5cm) across the width of the fabric in BM45OC.

Backing Cut 1 piece 40in x 76in (101.5cm x 193cm) and 1 piece 37in x 76in (94cm x 193cm) in backing fabric.

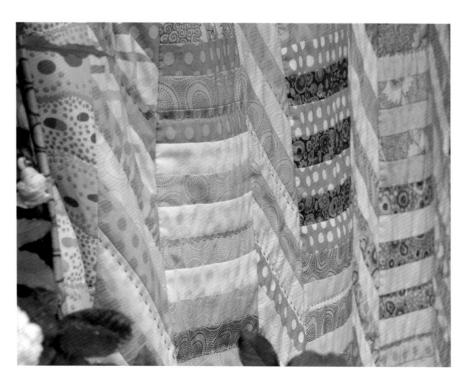

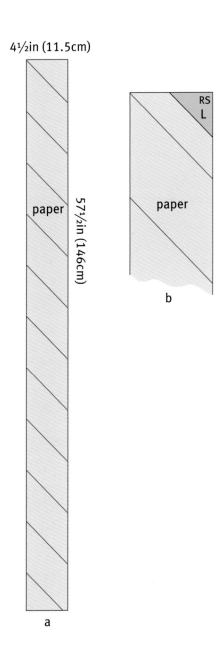

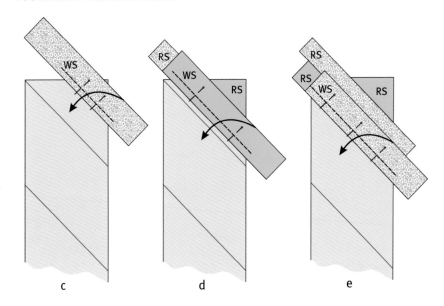

MAKING THE DIAGONAL COLUMNS

Use a ¼in (6mm) seam allowance throughout and refer to the quilt assembly diagram for fabric placement. Cut 5 rectangles of paper 4½in x 57½in (11.5cm x 146cm) this includes a ¼in (6mm) seam allowance. Mark lines at 45 degrees on the paper as shown in foundation piecing diagram a. These are just guides to keep the angles correct as you progress so the exact position is not important, only the angle.

Set your sewing machine to a very short stitch, this will perforate the paper well, and make stripping it off the fabrics

easier later. Start by placing a template L triangle in the top right of the first paper right side up, match the raw edge of the fabric triangle with the edge of the paper as shown in diagram b. Take the 1st rectangle and place it right sides together with the template L triangle. Make sure that the rectangle will completely cover the paper when it is stitched and flipped open. You can check this by pinning along the sewing line and flipping the rectangle open before you stitch. Stitch using an accurate ¼in seam allowance through the fabrics and paper as shown in diagram c. Flip the rectangle open and press using a dry iron.

Take the 2nd rectangle and match right sides together to the 1st rectangle stitch, flip open and press as shown in diagram d. Repeat this process with the 3rd rectangle as shown in diagram e. When all the paper is covered trim away the excess fabric from around the paper. Make 5 diagonal columns. Do not remove the papers until the quilt is complete, this will keep the columns from stretching or distorting.

MAKING THE QUILT

Piece the 4 straight columns as shown in the quilt assembly diagram, then alternate with the diagonal columns and join to complete the quilt centre. Add the side, then top and bottom borders and finally remove the foundation papers.

FINISHING THE QUILT

Press the quilt top. Seam the backing pieces using a ¼in (6mm) seam allowance to form a piece approx. 63in x 76in (160cm x 193cm). Layer the quilt top, batting and backing and baste together (see page 148). Using toning perlé embroidery threads quilt every 3rd or 4th row in a falling zigzag from top left to bottom right across the quilt. Trim the quilt edges and attach the binding (see page 149).

Pauline says:
When I pieced the original quilt I used a paper template for the diagonal columns, but I didn't actually stitch the fabrics to the paper, it was just used as a guide to keep the column straight and trim. This meant that the columns were very stretchy and difficult to handle as all the edges were on the bias! The foundation 'stitch and flip' method will eliminate all the problems.

QUILT ASSEMBLY DIAGRAM

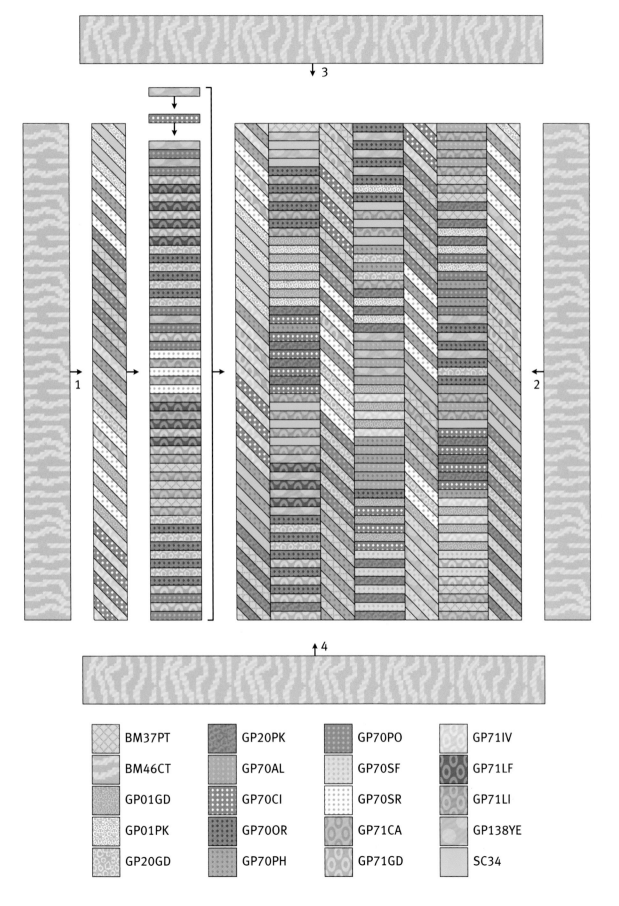

	BM37PT		GP20PK		GP70PO		GP71IV
	BM46CT		GP70AL		GP70SF		GP71LF
	GP01GD		GP70CI		GP70SR		GP71LI
	GP01PK		GP70OR		GP71CA		GP138YE
	GP20GD		GP70PH		GP71GD		SC34

organic radiation ***

Kaffe Fassett

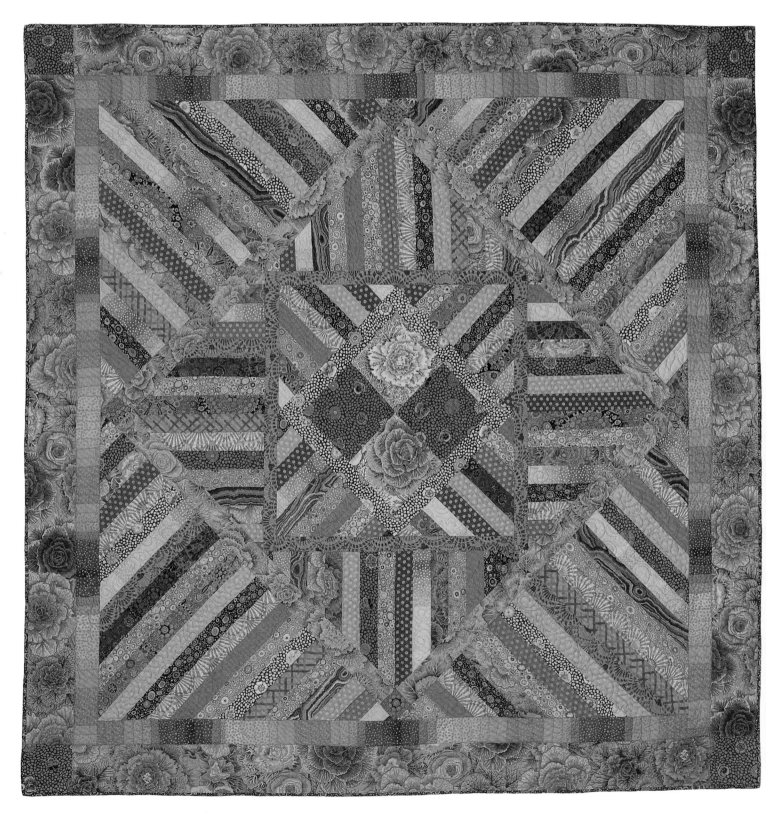

This stunning quilt is built, medallion style, around a large 4–patch block pieced using 1 square (Large Square) which is cut to size. The block is then surrounded by a series of 8 borders, 5 simple (2 with corner posts) and 3 sections of pieced triangles. Border 1 is simple, the next is the 1st pieced triangle section. The pieced triangle sections are made by stitching cut strips into a row, the triangles are then cut from the resulting row. This is surrounded by simple border 2. Next is the 2nd pieced triangle section, which is followed by border 3 which has corner posts (Template J). The 3rd pieced triangle section is then added followed by simple border 4 and simple border 5 which has corner posts (Template K).

SIZE OF QUILT
The finished quilt will measure approx. 83¼ in x 83¼ in (211.5cm x 211.5cm).

MATERIALS
The quantities given are generous to allow for choice in fabric placement in the pieced triangle sections, see below for details.

Patchwork Fabrics
MAD PLAID
Red	BM37RD	¼yd (25cm)

ROMAN GLASS
Byzantine	GP01BY	⅜yd (35cm)
Gold	GP01GD	¼yd (25cm)

PAPERWEIGHT
Sludge	GP20SL	⅜yd (35cm)

GUINEA FLOWER
Brown	GP59BR	½yd (45cm)
Green	GP59GN	½yd (45cm)

SPOT
Ice	GP70IC	⅝yd (60cm)
Magenta	GP70MG	⅜yd (35cm)
Red	GP70RD	⅜yd (35cm)

ABORIGINAL DOTS
Purple	GP71PU	¼yd (25cm)

MILLEFIORE
Brown	GP92BR	¼yd (25cm)
Red	GP92RD	¼yd (25cm)

OMBRE
Green	GP117GN	¾yd (70cm)
Moss	GP117MS	½yd (45cm)

JUPITER
Brown	GP131BR	¼yd (25cm)
Red	GP131RD	¼yd (25cm)

PAPER FANS
Ochre	GP143OC	½yd (45cm)
Vintage	GP143VN	½yd (45cm)

BRASSICA
Brown	PJ51BR	1¾yd (1.6m)
Green	PJ51GN	¼yd (25cm)
Grey	PJ51GY	½yd (45cm)
Red	PJ51RD	⅜yd (35cm)

Backing Fabric 6⅜yd (5.8m)
We suggest these fabrics for backing
BRASSICA Grey, PJ51GY
SERPENTINE Dark, GP145DK

Binding
ROMAN GLASS
Byzantine	GP01BY	¾yd (70cm)

Batting
91in x 91in (231.25cm x 231.25cm).

Quilting thread
Toning machine quilting thread.

Templates

J K Large Square

CUTTING OUT
Only 3 fabrics are not included in the pieced triangles, these are Ombre Green (GP117GN), Brassica Grey (PJ51GY) and Green (PJ51GN). For all other fabrics cut the stated pieces for templates and borders first, then use the leftover fabrics for the pieced triangles.

Large Square Cut 8in (20.25cm) strips across the width of the fabric. Cut 8in x 8in (20.25cm x 20.25cm) squares. Cut 2 in GP59BR and PJ51GN.

Template J Cut 4 in GP92BR.

Template K Cut 4 in GP59BR.

Border 1 Cut 2 strips 2½in x 15½in (6.25cm x 39.25cm) and 2 strips 2½in x 19½in (6.25cm x 49.5cm) in GP59GN.

Border 2 Cut 2 strips 2in x 27⅜in (5cm x 69.5cm) and 2 strips 2in x 30⅜in (5cm x 77.25cm) in GP143OC.

Border 3 Cut 5 strips 3in (7.75cm) wide across the width of the fabric, join as necessary and cut 4 borders 3in x 42¾in (7.75cm x 108.5cm) in PJ51GY.

Border 4 Cut 7 strips 3¼in (8.25cm) wide across the width of the fabric, join as necessary and cut 2 strips 3¼in x 67¼in (8.25cm x 170.75cm) and 2 strips 3¼in x 72¾in (8.25cm x 184.75cm) in GP117GN.

Border 5 Cut 8 strips 6in (15.25cm) wide across the width of the fabric, join as necessary and cut 4 strips 6in x 72¾in x (15.25cm x 184.75cm) in PJ51BR.

Pieced Triangles Cut the remaining fabrics into 2½in (6.5cm) strips and piece to form rows.

1st Pieced Triangles Cut a total of 26 strips 2½in x 10¾in (6.5cm x 27.25cm).

2nd Pieced Triangles Cut a total of 36 strips 2½in x 16½in (6.5cm x 42cm).

3rd Pieced Triangles Cut a total of 52 strips 2½in x 25in (6.5cm x 63.5cm). Strips can be joined to prevent waste.

Binding Cut 9 strips 2½in (6.5cm) across the width of the fabric in GP01BY.

Backing Cut 2 pieces 40in x 91in (101.5cm x 231.25cm), 2 pieces 40in x 11in (101.5cm x 28cm) and 1 piece 11in x 11in (28cm x 28cm) in backing fabric.

QUILT ASSEMBLY DIAGRAM 1

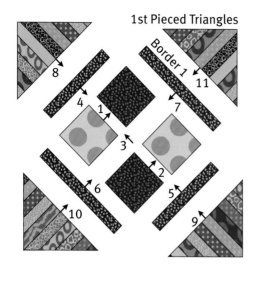

1st Pieced Triangles

Border 1

8 4 1 11 7 3 2 6 5 10 9

QUILT ASSEMBLY DIAGRAM 2

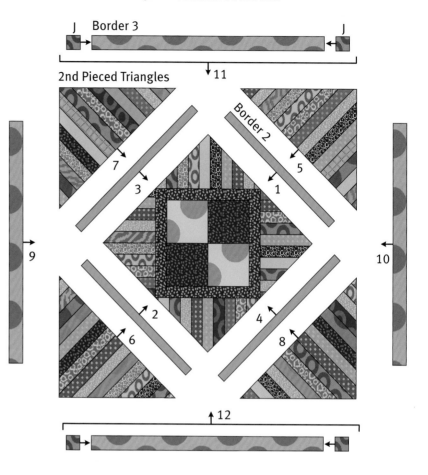

J Border 3 J

11

2nd Pieced Triangles

Border 2

7 3 5 1 9 2 6 4 8 10

12

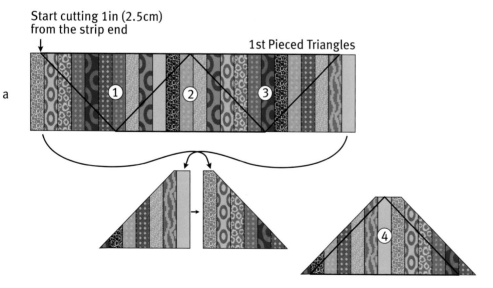

a

Start cutting 1in (2.5cm) from the strip end

1st Pieced Triangles

① ② ③ ④

MAKING THE QUILT

Use a ¼in (6mm) seam allowance throughout and refer to the quilt assembly diagram for fabric placement. Piece the 4 patch centre block as shown in quilt assembly diagram 1, add simple border 1 in the order indicated. Next piece the strips for the 1st triangle section into a row as shown in diagram a. The exact position of the fabrics is not important, just choose a pleasing selection and an overall alternating light/ dark order. Start cutting 1in (2.5cm) in from the end of the strip. Make 45 degree cuts to make right angled triangles. Cut 3 triangles (1, 2 & 3), then join the leftover section as shown in the diagram and cut the final triangle (4). The triangles will be slightly oversized and the edges will be slightly stretchy as they are cut on the bias, so handle carefully. Join them to the quilt centre in the order shown in diagram a. Trim to a generous ¼in (6mm) OUTSIDE the corners of border 1.

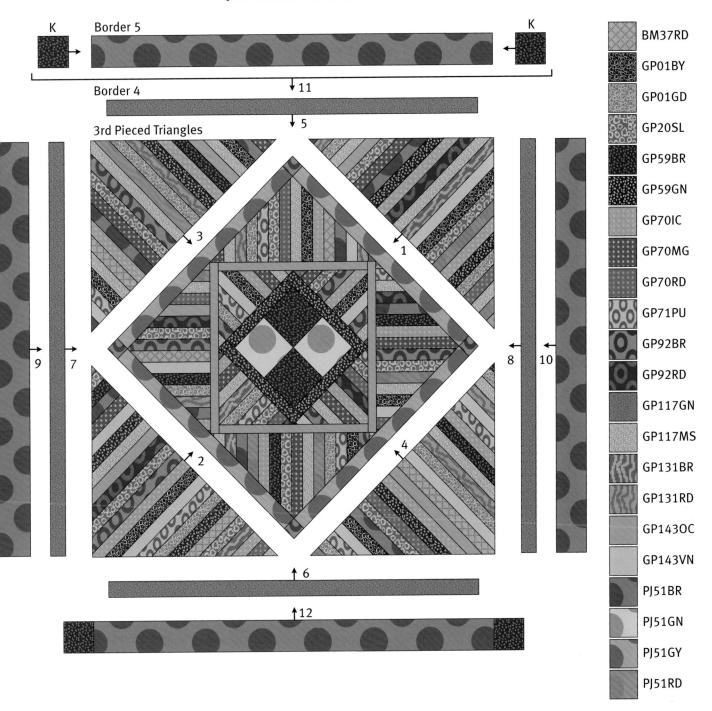

K
Border 5
K

Border 4
↓ 11
↓ 5

3rd Pieced Triangles

→ 3
1 ↖

→ 9 → 7
8 ← ← 10

↗ 2
↖ 4

↑ 6
↑ 12

BM37RD
GP01BY
GP01GD
GP20SL
GP59BR
GP59GN
GP70IC
GP70MG
GP70RD
GP71PU
GP92BR
GP92RD
GP117GN
GP117MS
GP131BR
GP131RD
GP143OC
GP143VN
PJ51BR
PJ51GN
PJ51GY
PJ51RD

Join border 2 to the quilt centre as shown in quilt assembly diagram 2. Piece and cut the strips for the 2nd triangle section in the same way as the 1st triangle section. Join the sections to the quilt centre and trim to a generous ¼in (6mm) OUTSIDE the corners of border 2. Join border 3 to the quilt centre as shown in quilt assembly diagram 2. Piece and cut the strips for the 3rd triangle section as before. Join to the quilt centre and trim

to a generous ¼in (6mm) OUTSIDE the corners of border 3.

Finally join borders 4 and 5 in the order shown in quilt assembly diagram 3.

FINISHING THE QUILT
Press the quilt top. Seam the backing pieces using a ¼in (6mm) seam allowance to form a piece approx. 91in x 91in (231.25cm x 231.25cm). Layer the

quilt top, batting and backing and baste together (see page 148). Using a toning machine quilting thread, quilt in the ditch around the centre 4 patch squares and all the simple borders. Free motion quilt in the pieced triangle sections in an organic pattern. You can also follow the fabric designs in the simple borders to give the quilt texture. Trim the quilt edges and attach the binding (see page 149).

autumn crosses **

Kaffe Fassett

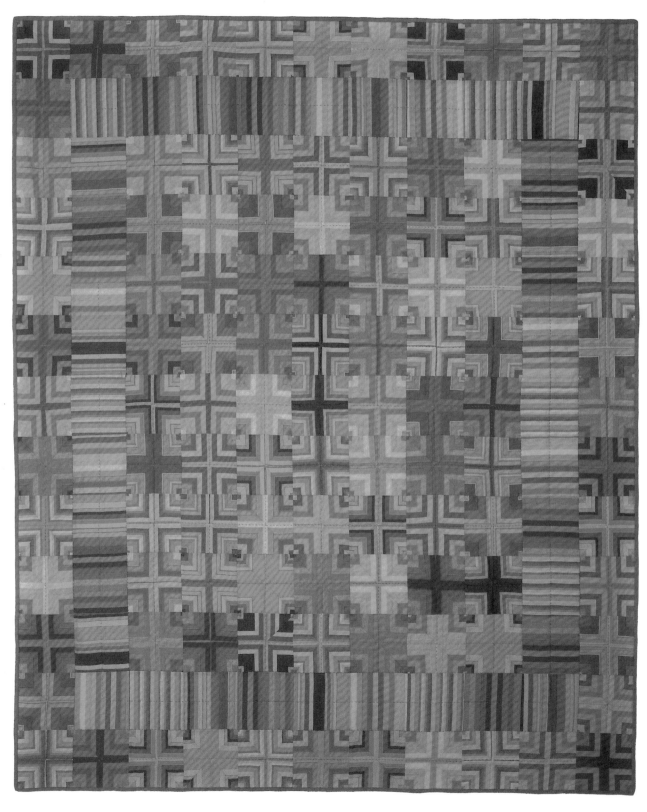

Only 4 fabrics are used to produce the myriad of different blocks in this striking quilt. It is great fun to make and we have allowed plenty of fabric for you to experiment and play with the technique to produce your own unique version. The blocks are cleverly made by carefully cutting identical sets of squares (Template Y) from the striped fabrics. From 8 identical squares 2 very different 'cross' blocks are produced (see block sewing diagrams f and g for examples). These blocks are straight set into rows to complete the centre of the quilt. The centre is then surrounded with an inner border made with a second square (Template Z). Finally an outer border of 'cross' blocks is added to complete the quilt.

SIZE OF QUILT
The finished quilt will measure approx. 66in x 78in (167.75cm x 198cm).

MATERIALS
Patchwork Fabrics
WOVEN BROAD STRIPE

Bliss	WBS BS	$2\frac{3}{8}$yd (2.2m)
Watermelon	WBS WL	$2\frac{3}{8}$yd (2.2m)

WOVEN MULTI STRIPE

Lime	WMS LM	$1\frac{3}{8}$yd (1.3m)

WOVEN ROMAN STRIPE

Arizona	WRS AR	$2\frac{3}{4}$yd (2.5m)

Backing Fabric 5yd (4.6m)
We suggest these fabrics for backing
LAZY DAISY Emerald, BM44EM
DREAM Moss, GP148MS

Binding
SHOT COTTON

Pea Soup	SC91	$\frac{5}{8}$yd (60cm)

Batting
74in x 86in (188cm x 218.5cm)

Quilting thread
Perlé embroidery threads in strong autumn colours

Templates

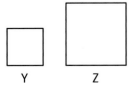

Y Z

CUTTING OUT
Cut the fabrics in the order stated, accurate cutting of the striped fabrics is very important to the design. Open out the fabrics and cut 1 layer at a time. The majority of the Template Y fabric for the 'cross' blocks is cut down the length of the fabric. Please read the whole cutting and piecing instruction to ensure you understand the process before starting. We suggest cutting and stitching a set of Template Y squares in each fabric to see how the blocks turn out before cutting all the fabric, that way you can plan the cutting to achieve variety in your blocks.
Template Z Cut $6\frac{1}{2}$in (16.5cm) strips across the width of the fabric. Each strip will give you 6 squares per full width. Cut 11 in WRS AR, 10 in WBS WL, 8 in WBS BS and 7 in WMS LM. Total 36 squares.
Template Y First cut 32in (81.25cm) x the width of the fabric sections. Cut 2 in WBS BS, WBS WL, WRS AR and 1 in WMS LM. Cut $3\frac{7}{8}$in (9.75cm) strips down the length of the fabric, the strips must follow the stripe exactly, so that when squares are cut they are all identical. From each strip cut 8 identical $3\frac{7}{8}$in (9.75cm) squares, this makes 1 set, keep

them together. You can cut 10 strips down the length of each fabric section but we have allowed extra fabric so you only need to cut 8 strips down the length from each section, this way you can choose to feature particular stripe combinations. In this way cut 16 sets of squares in WBS BS, WRS AR, 13 sets in WBS WL and 7 in WMS LM. You will have extra fabric in WRS AR, from this cut 3 strips $3\frac{7}{8}$in (9.75cm) wide across the width of the fabric. From these strips fussy cut 2 more sets of 8 identical $3\frac{7}{8}$in (9.75cm) squares to make a total of 18 sets in WRS AR.

Binding Cut 8 strips $2\frac{1}{2}$in (6.5cm) wide across the width of the fabric in SC91.

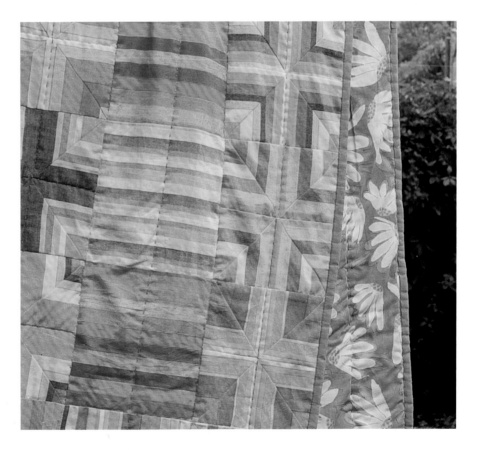

BLOCK SEWING DIAGRAMS

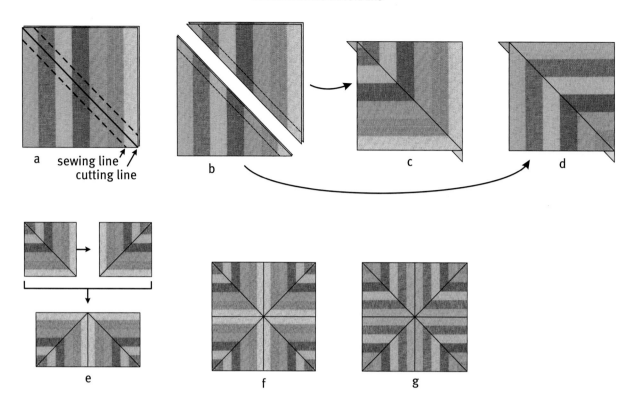

a sewing line
 cutting line

b

c

d

e

f

g

Backing Cut 1 piece 40in x 86in (101.5cm x 218.5cm) and 1 piece 35in x 86in (89cm x 218.5cm) in backing fabric.

MAKING THE CROSS BLOCKS

Use a ¼in (6mm) seam allowance throughout. The method given will make 2 very different cross blocks from 1 set of 8 identical squares.

Take 2 identical squares of fabric and place one on top of the other, matching the stripes and the edges accurately (the woven stripe fabrics are all reversible, so don't worry about finding the right and wrong side!). Mark a diagonal line from corner to corner with a soft pencil or washable marker, this will be the cutting line. Stitch the squares ¼in (6mm) from both sides of the cutting line as shown in sewing diagram a. We have coloured the block sewing diagrams with a scan of a section of WBS BS to show a true representation of how a block comes together.

Cut along the marked cutting line to separate the 2 pieced squares, press the seam allowance to one side as shown in diagram b. This produces 2 very different

pieced squares as shown in diagrams c and d.

Stitch the other 6 identical squares in the same way to make 6 more pieced squares. Arrange the pieced squares into 2 blocks and piece as shown in diagram e. The 2 finished blocks can be seen in diagrams f and g. Make 36 blocks in WRS AR, 32 in WBS BS, 25 in WBS WL and 14 in WMS LM. Total 107 blocks.

MAKING THE QUILT

Refer to the quilt assembly diagram for block placement. Lay out the centre blocks and join into 9 rows of 7 blocks, join the rows to complete the quilt centre. Stitch template Z squares into 2 side inner borders of 9 squares each with the stripe running as shown in the quilt assembly diagram and join to the quilt sides. Make 2 inner borders again with 9 squares in each and add to the quilt top and bottom as shown. The outer border is pieced from cross blocks. Piece 2 side outer borders each with 11 cross blocks and add to the quilt sides. Piece the top and bottom borders, again with 11 cross blocks each and add to the quilt top and bottom to complete the quilt.

QUILTING DIAGRAM

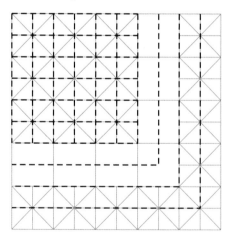

FINISHING THE QUILT

Press the quilt top. Seam the backing pieces using a ¼in (6mm) seam allowance to form a piece approx. 74in x 86in (188cm x 218.5cm). Layer the quilt top, batting and backing and baste together (see page 148). Hand quilt as shown in the quilting diagram using perlé embroidery threads in strong autumn colours. Trim the quilt edges and attach the binding (see page 149).

80

QUILT ASSEMBLY DIAGRAM

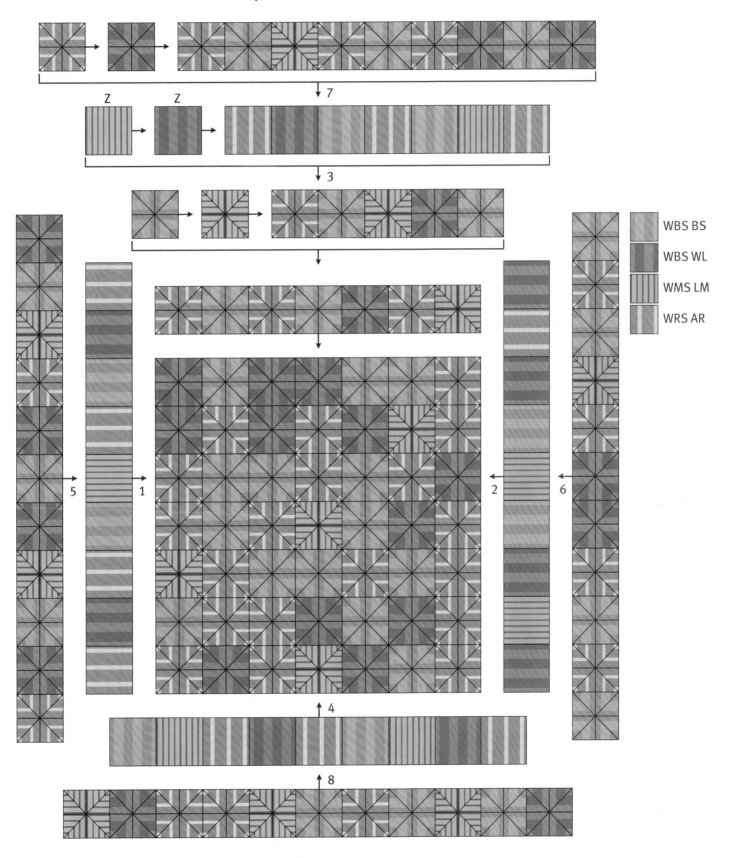

WBS BS
WBS WL
WMS LM
WRS AR

sunset stripes **

Kaffe Fassett

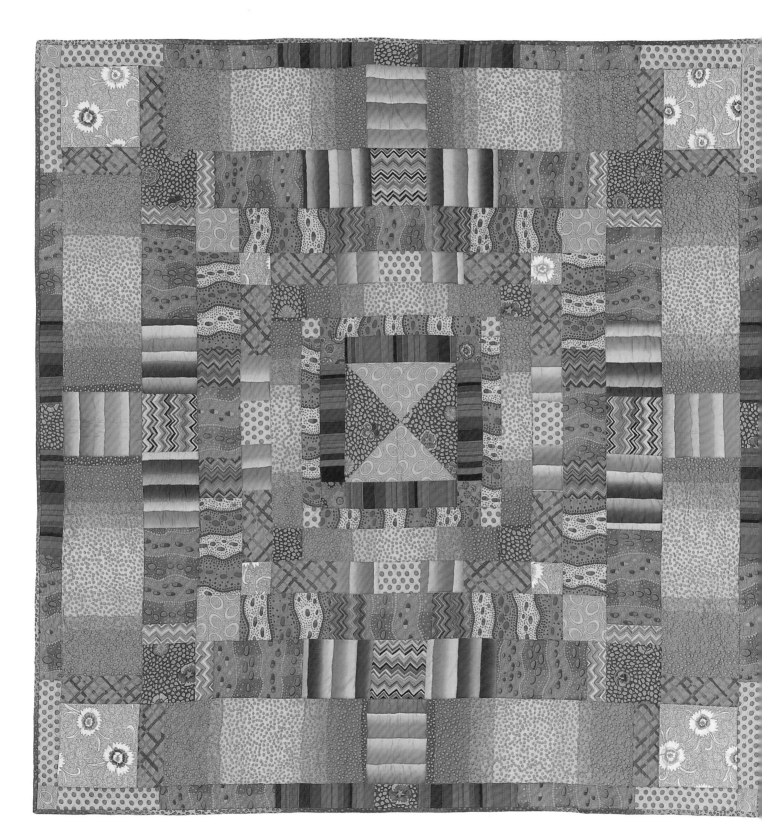

This medallion style quilt is built in a series of borders around a central hourglass block which is pieced using a triangle (Template H). The centre is then surrounded with a series of 8 borders which are pieced using various sizes of squares and rectangles all of which are cut to size. The quilt is symmetrical with the design mirrored both horizontally and vertically.

SIZE OF QUILT
The finished quilt will measure approx. 59in x 59in (149.75cm x 149.75cm).

MATERIALS
Patchwork Fabrics
MAD PLAID
Red	BM37RD	⅜yd (35cm)

ZIGZAG
Multi	BM43MU	¼yd (25cm)
Pink	BM43PK	⅛yd (15cm)
Warm	BM43WM	⅛yd (15cm)

VICTORIA
Antique	BM46AN	⅜yd (35cm)
Hot	BM46HT	⅝yd (60cm)

GUINEA FLOWER
Pink	GP59PK	⅜yd (35cm)

SPOT
Gold	GP70GD	¼yd (25cm)

ABORIGINAL DOTS
Lime	GP71LM	¼yd (25cm)

MILLEFIORE
Tomato	GP92TM	⅛yd (15cm)

OMBRE
Pink	GP117PK	1⅛yd (1m)

DIANTHUS
Turquoise	GP138TQ	¼yd (25cm)

KIM
Blue	GP142BL	¼yd (25cm)
Red	GP142RD	¼yd (25cm)

WOVEN ROMAN STRIPE
Blood Orange	WRS BO	¼yd (25cm)

Backing Fabric 4yd (3.7m)
We suggest these fabrics for backing
MILLEFIORE Tomato, GP92TM
VICTORIA Antique, BM46AN

Binding
OMBRE
Blue	GP117BL	⅝yd (60cm)

Batting
67in x 67in (170.25cm x 170.25cm)

Quilting thread
Toning machine quilting thread

Templates

H

CUTTING OUT
Our normal strip cutting method is not appropriate for this quilt as it would be very wasteful. Cut only the shapes you need and leave the remaining fabric in the largest pieces possible for subsequent cutting. When cutting striped fabrics in almost all cases the stripes run parallel to the short side of the rectangles, the exception is GP142RD in Border 7. The BM43 Zigzag fabrics are cut depending on position, so please check the diagrams and photograph for stripe direction.
Template H Cut 2 triangles in GP59PK and GP71LM using the template as a guide. Make sure the long side of each triangle is aligned with the straight grain of the fabric.
Border 1 Cut 4 squares 2½in x 2½in (6.25cm x 6.25cm) in GP92TM and 4 rectangles 2½in x 9½in (6.25cm x 24.25cm) in WRS BO.
Border 2 Cut 4 squares 2in x 2in (5cm x 5cm) in GP70GD and 4 rectangles 2in x 13½in (5cm x 34.25cm) in BM46AN.
Border 3 Cut 4 squares 3in x 3in (7.5cm x 7.5cm) in GP59PK and 4 rectangles 3in x 16½in (7.5cm x 42cm) in GP117PK.
Border 4 Cut 4 squares 3in x 3in (7.5cm x 7.5cm) in GP138TQ, 8 rectangles 3in x 5¾in (7.5cm x 14.5cm) in BM37RD, 8 rectangles 3in x 4in (7.5cm x 10.25cm) in GP142RD and 4 rectangles 3in x 4in (7.5cm x 10.25cm) in GP70GD.
Border 5 Cut 4 squares 4in x 4in (10.25cm x 10.25cm) in GP71LM, 8 rectangles 4in x 8in (10.25cm x 20.25cm) in BM46AN, 8 rectangles 4in x 3½in (10.25cm x 9cm) in BM43WM and 4 rectangles 4in x 5½in (10.25cm x 14cm) in BM46HT.
Border 6 Cut 4 squares 5in x 5in (12.75cm x 12.75cm) in BM43MU and GP59PK, 8 rectangles 5in x 2in (12.75cm x 5cm) in BM43PK, 8 rectangles 5in x 8in (12.75cm x 20.25cm) in BM46HT and 8 rectangles 5in x 5¾in (12.75cm x 14.5cm) in GP142BL.

Border 7 Cut 4 squares 7in x 7in (17.75cm x 17.75cm) in GP138TQ, 8 rectangles 7in x 2¾in (17.75cm x 7cm) in BM37RD, 8 rectangles 7in x 16¾in (17.75cm x 42.5cm) in GP117PK and 4 rectangles 7in x 5½in (17.75cm x 14cm) in GP142RD.
Border 8 Cut 4 squares 2½in x 2½in (6.25cm x 6.25cm) in GP71LM, 8 rectangles 2½in x 9¼in (6.25cm x 23.5cm) in BM46HT, 8 rectangles 2½in x 9in (6.25cm x 22.75cm) in GP70GD, WRS BO and 4 rectangles 2½in x 4in (6.25cm x 10.25cm) in GP59PK.

Binding Cut 7 strips 2½in (6.5cm) wide across the width of the fabric in GP117BL.

Backing Cut 1 piece 40in x 67in (101.5cm x 170.25cm) and 1 piece 28in x 67in (71cm x 170.25cm) in backing fabric.

MAKING THE QUILT
Centre Block and Borders 1–3
Use a ¼in (6mm) seam allowance throughout. Refer to the quilt assembly diagrams for fabric placement. Start by making the centre hourglass block as shown in quilt assembly diagram 1. Next add border 1, sides first, then

add a corner square to each end of the remaining 2 borders and add to the top and bottom of the centre block as shown in quilt assembly diagram 1. Borders 2 and 3 are added in the same way.

MAKING THE QUILT
Borders 4–8
Arrange the rectangles for Border 4 as shown in quilt assembly diagram 2. Add the sides to the quilt centre, then add a corner square to each end of the remaining 2 pieced borders and add to the top and bottom of the quilt centre. Borders 5, 6, 7 and 8 are pieced and added to the quilt centre in the same way.

FINISHING THE QUILT
Press the quilt top. Seam the backing pieces using a ¼in (6mm) seam allowance to form a piece approx. 67in x 67in (170.25cm x 170.25cm). Layer the quilt top, batting and backing and baste together (see page 148). Stitch in the ditch throughout the quilt using toning machine quilting thread then free motion quilt following the fabric designs to create additional texture. Trim the quilt edges and attach the binding (see page 149).

QUILT ASSEMBLY DIAGRAM 1

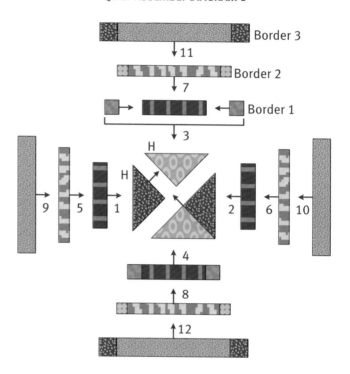

QUILT ASSEMBLY DIAGRAM 2

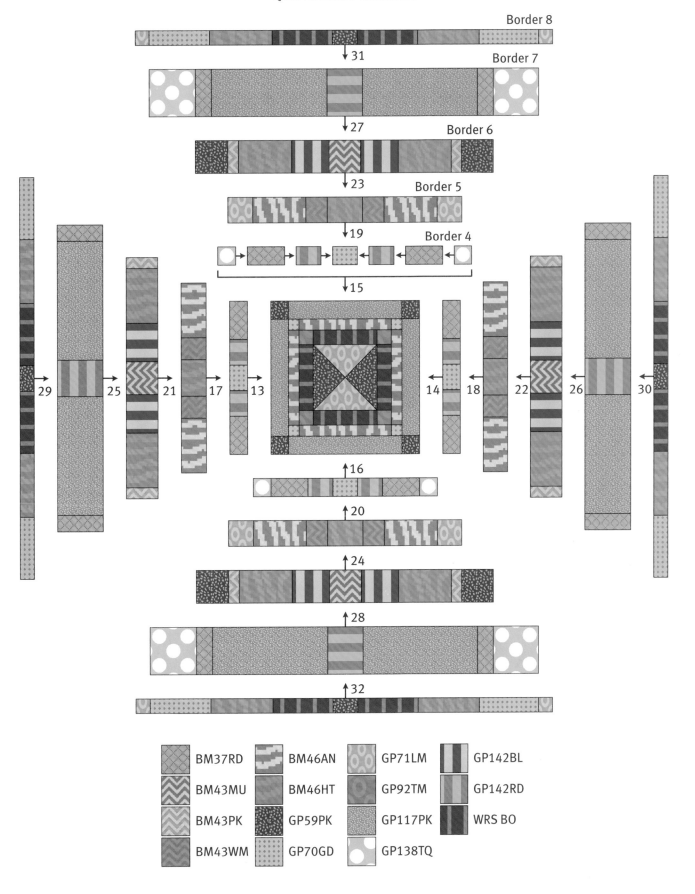

Border 8

Border 7

Border 6

Border 5

Border 4

	BM37RD		BM46AN		GP71LM		GP142BL
	BM43MU		BM46HT		GP92TM		GP142RD
	BM43PK		GP59PK		GP117PK		WRS BO
	BM43WM		GP70GD		GP138TQ		

candy zigzag ribbon **

Kaffe Fassett

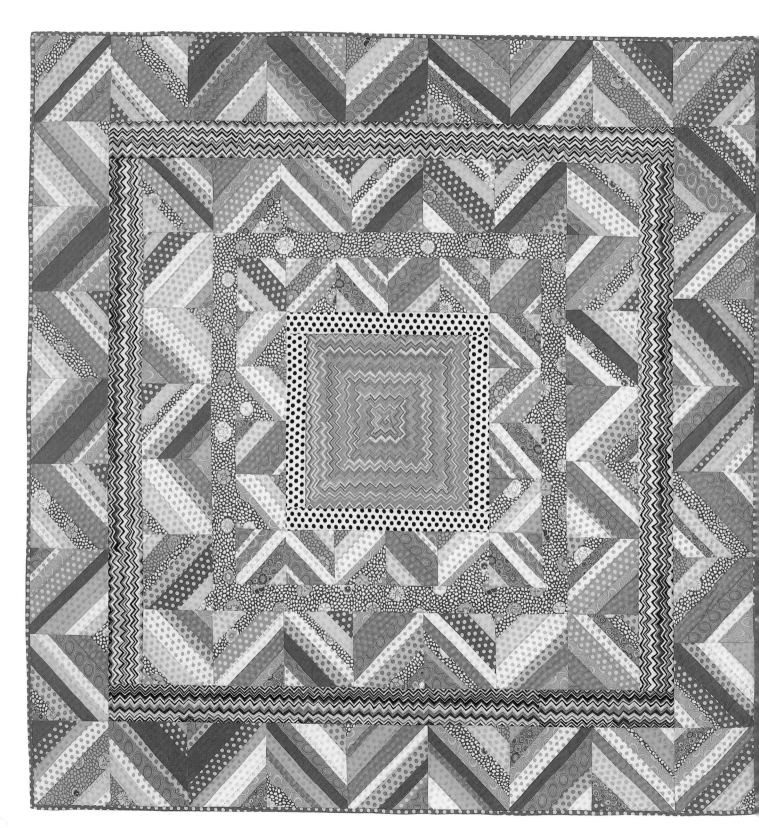

This medallion style quilt is built in a series of borders around a central hourglass block. The hourglass block is pieced by using a triangle (Triangle, cut to size). The centre is then surrounded with Border 1 which is a simple border. Border 2 consists of square pieced blocks (Small Square) which are cut to size from pieced strip sets. Border 3 is a simple border, followed by Border 4 which consists of square pieced blocks (Medium Square) again cut to size from pieced strip sets. Border 5 is simple, followed by Border 6, which consists of square pieced blocks (Large Square) again cut to size from pieced strip sets. It would be almost impossible to re-create this quilt exactly, so we suggest using the photograph and diagrams as a guide to fabric combinations, but don't be tied to Kaffe's version, enjoy making your own combinations!

SIZE OF QUILT
The finished quilt will measure approx. 72in x 72in (183cm x 183cm).

MATERIALS
Centre Block Fabric
ZIGZAG
| Pink | BM43PK | ⅝yd (60cm) |

Strip Set Fabrics
PAPERWEIGHT
| Pink | GP20PK | ⅜yd (35cm) |

GUINEA FLOWER
| Apricot | GP59AP | ½yd (45cm) |
| Blue | GP59BL | ⅞yd (80cm) |
(includes Border 3)

SPOT
Apple	GP70AL	⅜yd (35cm)
Fuchsia	GP70FU	½yd (45cm)
Gold	GP70GD	½yd (45cm)
Grape	GP70GP	⅜yd (35cm)
Lavender	GP70LV	⅜yd (35cm)
Magnolia	GP70MN	½yd (45cm)
Peach	GP70PH	½yd (45cm)
Sky	GP70SK	½yd (45cm)
Yellow	GP70YE	½yd (45cm)

ABORIGINAL DOTS
Delft	GP71DF	½yd (45cm)
Lilac	GP71LI	⅜yd (35cm)
Lime	GP71LM	⅜yd (35cm)
Red	GP71RD	½yd (45cm)

Border Fabrics
ZIGZAG
| White | BM43WH | ¾yd (70cm) |
GUINEA FLOWER
| Blue | GP59BL | see above |
SPOT
| White | GP70WH | ¼yd (25cm) |

Backing Fabric 4¾yd (4.35m)
We suggest these fabrics for backing
BROCADE PEONY Natural, PJ62NL
LAZY DAISY Grey, BM44GY

Binding
SPOT
| Grape | GP70GP | ⅝yd (60cm) |

Batting
80in x 80in (203.25cm x 203.25cm)

Quilting thread
Light blue perlé embroidery thread

Templates

Triangle Small Square

Medium Square Large Square

CUTTING OUT
Cut the fabric in the order stated to prevent waste. Make templates using template plastic to make cutting the strip sets easier.

Triangle Make a template by cutting a 12¼in (31cm) square of paper and cutting it in half diagonally, this makes the Triangle template. Cut 2 strips 8¾in (22.25cm) across the width of the fabric in BM43PK. Each strip will give you 3 triangles per full width. Align the long side of the triangle template with the cut edge of the fabric strip and cut 4 triangles, this will ensure the zigzags in the fabric pattern run in the correct direction.

Border 1 Cut 2 strips 2½in (6.25cm) wide across the width of the fabric, cut 2 borders 2½in x 16½in (6.25cm x 42cm) and 2 borders 2½in x 20½in (6.25cm x 52cm) in GP70WH.

Border 3 Cut 4 strips 3in (7.5cm) wide across the width of the fabric, cut 2 borders 3in x 30½in (7.5cm x 77.5cm) and 2 borders 3in x 35½in (7.5cm x 90.25cm) in GP59BL. Reserve leftover fabric for Strip Sets.

Border 5 Cut 6 strips 4in (10.25cm) wide across the width of the fabric, join as necessary and cut 2 borders 4in x 49½in (10.25cm x 125.75cm) and 2 borders 4in x 56½in (10.25cm x 143.5cm) in BM43WH.

Strip Sets The strip set fabrics are cut across the full width of the fabric at various widths ranging from 1in (2.5cm) up to 2¾in (7cm) in ¼in (6mm) increments.

Binding Cut 8 strips 2½in (6.5cm) wide across the width of the fabric in GP70GP.

Backing Cut 2 pieces 40in x 80in (101.5cm x 203.25cm) in backing fabric.

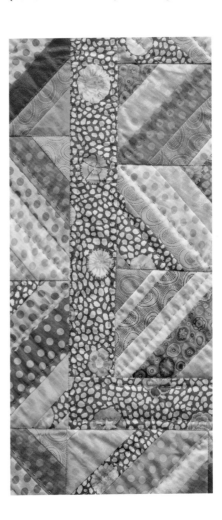

CUTTING DIAGRAM

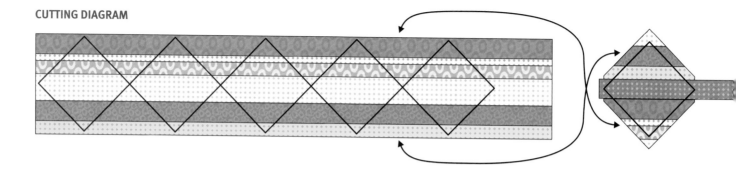

MAKING THE PIECED BLOCKS

Use a ¼in (6mm) seam allowance throughout and use the photograph and diagrams as a guide to fabric combinations, but this quilt is meant to be an adventure, so take the idea on your own journey!

Small Square Make a plastic template 5½in x 5½in (14cm x 14cm). Make up strip sets 8in (20.25cm) deep (to the raw edge). Press the strip sets and cut squares aligning the template as shown in the cutting diagram. Use the offcuts by adding an extra strip (or 2) in the middle and cutting more squares as indicated in the diagram. Cut a total of 20 Small Squares.

Medium Square Make a plastic template 7½in x 7½in (19cm x 19cm). Make up strip sets 11in (28cm) deep (to the raw edge). Using the same technique as before cut a total of 24 Medium Squares.

Large Square Make a plastic template 8½in x 8½in (21.5cm x 21.5cm). Make up strip sets 12½in (31.75cm) deep (to the raw edge). Using the same technique as before cut a total of 32 Large Squares.

MAKING THE QUILT

Make the hourglass block centre as shown in quilt assembly diagram 1. Add border 1, sides first, then top and bottom. For Border 2 make 2 borders of 4 small pieced blocks for the quilt sides aligning the diagonals to form a zigzag as shown in quilt assembly diagram 1 and join to the quilt centre. Make 2 borders of 6 small pieced blocks and add to the quilt top and bottom, again aligning the diagonals as shown and join to the quilt centre.

Add Border 3, sides first, then top and bottom as shown in quilt assembly diagram 2. For Border 4 make 2 borders of 5 medium pieced blocks for the quilt sides aligning the diagonals as shown in

QUILT ASSEMBLY DIAGRAM 1

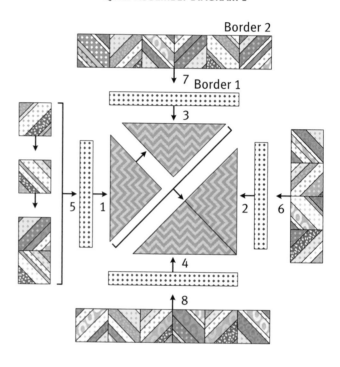

quilt assembly diagram 2 and join to the quilt centre. Make 2 borders of 7 medium pieced blocks and add to the quilt top and bottom, again aligning the diagonals as shown and join to the quilt centre. Add Border 5 sides first, then top and bottom. Finally for Border 6 make 2 borders of 7 large pieced blocks for the quilt sides aligning the diagonals as shown in quilt assembly diagram 2 and join to the quilt centre. Make 2 borders of 9 large pieced blocks and add to the quilt top and bottom to complete the quilt.

FINISHING THE QUILT

Press the quilt top. Seam the backing pieces using a ¼in (6mm) seam allowance to form a piece approx. 80in x 80in (203.25cm x 203.25cm). Layer the quilt top, batting and backing and

baste together (see page 148). Hand quilt using pale blue perlé embroidery thread. Quilt the centre hourglass block with 3 squares spaced equally from the centre out. Quilt the small pieced blocks with 2 or 3 lines running parallel with the seams, the medium pieced blocks with 3 or 4 lines and the large blocks with 4 or 5 lines. Finally quilt each simple border with a line ¼in (6mm) offset from each seam. Trim the quilt edges and attach the binding (see page 149).

QUILT ASSEMBLY DIAGRAM 2

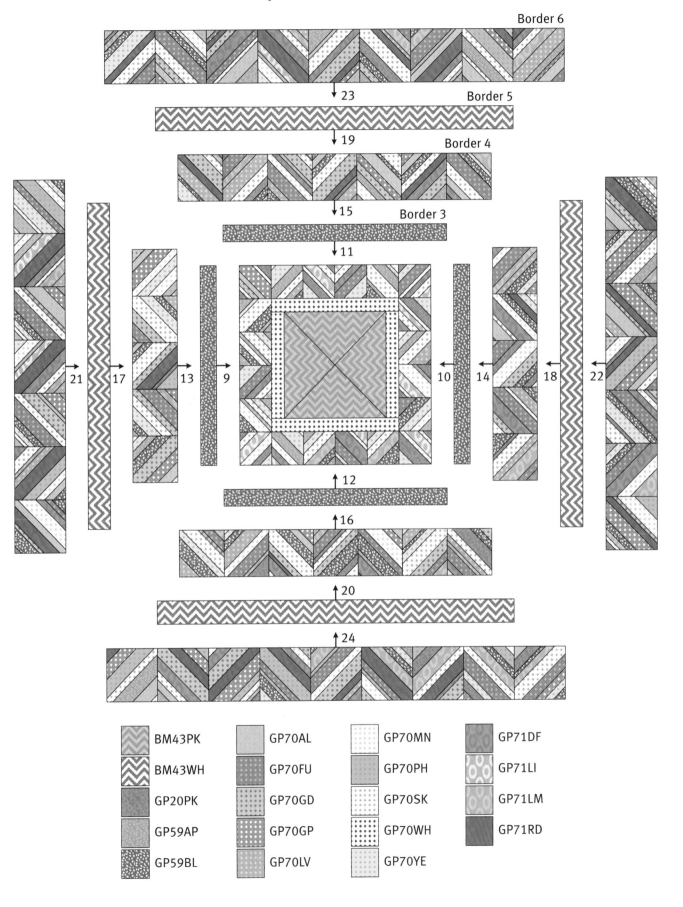

Border 6

Border 5

Border 4

Border 3

	BM43PK		GP70AL		GP70MN		GP71DF
	BM43WH		GP70FU		GP70PH		GP71LI
	GP20PK		GP70GD		GP70SK		GP71LM
	GP59AP		GP70GP		GP70WH		GP71RD
	GP59BL		GP70LV		GP70YE		

89

pastel donut **

Kaffe Fassett

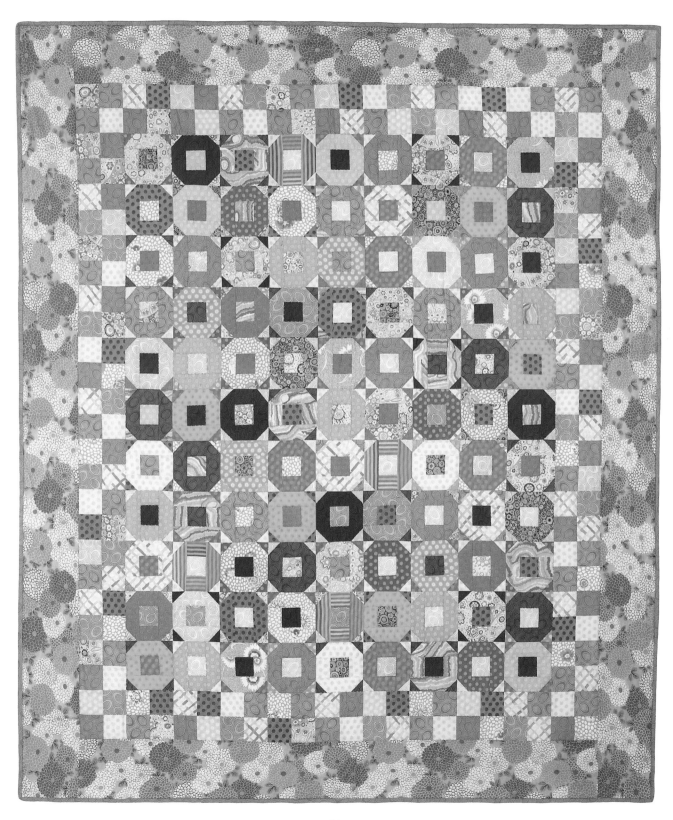

The 'Donut' blocks which make up the centre of this quilt are made using a square (Template M) and 2 rectangles (Templates U and V) which are pieced to form a square block. 4 small squares (Template W) are then placed over the corners of the pieced block and stitched diagonally, trimmed and flipped back to replace the corners of the pieced block. The 'Donut' blocks are straight set into rows and then surrounded with a pieced inner border which consists of a double row of checkerboard squares (Template J). The quilt is then finished with a simple outer border.

SIZE OF QUILT
The finished quilt will measure approx. 66in x 76in (167.75cm x 193cm).

MATERIALS
Patchwork and Inner Border Fabrics
MAD PLAID
Pastel BM37PT ⅜yd (35cm)
PAPERWEIGHT
Lime GP20LM ⅛yd (15cm)
Algae GP20AL ¼yd (25cm)
GUINEA FLOWER
Mauve GP59MV ⅜yd (35cm)
Turquoise GP59TQ ⅛yd (15cm)
SPOT
Fuchsia GP70FU ⅜yd (35cm)
Hydrangea GP70HY ⅛yd (15cm)
Lavender GP70LV ¼yd (25cm)
Mint GP70MT ¼yd (25cm)
Orange GP70OR ½yd (45cm)
Pond GP70PO ¼yd (25cm)
Peach GP70PH ¼yd (25cm)
Red GP70RD ¼yd (25cm)
Soft Blue GP70SF ½yd (45cm)
Taupe GP70TA ¼yd (25cm)
ABORIGINAL DOTS
Cream GP71CM ¼yd (25cm)
Delft GP71DF ½yd (45cm)
Lilac GP71LI ⅜yd (35cm)
Mint GP71MT ¼yd (25cm)
Pumpkin GP71PN ⅜yd (35cm)
Plum GP71PL ⅜yd (35cm)
Taupe GP71TA ⅜yd (35cm)
MILLEFIORE
Grey GP92GY ¼yd (25cm)
Lilac GP92LI ½yd (25cm)
JUPITER
Stone GP131ST ⅜yd (35cm)
DIANTHUS
Turquoise GP138TQ ⅛yd (15cm)

WOVEN CATERPILLAR STRIPE
Sprout WCS SR ¼yd (25cm)

Outer Border Fabric
JOY
Mauve PJ60MV 1⅜yd (1.3m)

Backing Fabric 5yd (4.6m)
We suggest these fabrics for backing
ABORIGINAL DOTS Taupe, GP71TA
MILLEFIORE Grey, GP92GY

Binding
ABORIGINAL DOTS
Taupe GP71TA ⅝yd (60cm)

Batting
74in x 84in (188cm x 213.5cm)

Quilting thread
Toning hand quilting thread

Templates

M U V W J

CUTTING OUT
Cut the fabrics in the order stated, reserve leftover strips and trim for later templates to ensure you will have sufficient fabric and prevent waste.
Outer Border Cut 7 strips 6in (15.25cm) wide across the width of the fabric, join as necessary and cut 2 borders 6in x 76½in (15.25cm x 194.25cm) for the quilt sides and 2 borders 6in x 55½in (15.25cm x 141cm) for the quilt top and bottom and in PJ60MV.
Template J Cut 3in (7.5cm) strips across the width of the fabric. Each strip will give you 13 squares per full width. Cut 29 in GP71DF, 26 in BM37PT, 24 in GP71TA, 20 in GP70SF, GP71LI, 15 in GP70OR, 14 in GP92LI, 12 in GP59MV, 8 in GP70HY and GP71MT. Total 176 squares.
Template M Cut 2½in (6.25cm) strips across the width of the fabric. Each strip will give you 16 squares per full width. Cut 17 in GP71CM, 14 in GP71PL, 11 in GP70TA, 7 in GP70OR, GP92LI, 6 in GP20AL, GP131ST, 5 in GP71LI, 4 in GP59MV, GP70FU, GP71DF, GP71MT, GP71PN, 3 in GP70MT and GP92GY. Total 99 squares.

Template V Fabric WCS SR only fussy cut 8 rectangles 2in x 5½in (5cm x 14cm) with the stripes running down the length (see the photograph for help with this). For all other fabrics cut 2in (5cm) strips across the width of the fabric. Each strip will give you 7 rectangles per full width. Cut 2in x 5½in (5cm x 14cm) rectangles, cut 14 in GP70PO, 12 in GP70PH, GP71PN, GP71TA, GP131ST, 10 in GP70FU, GP92LI, 8 in BM37PT, GP70LV, GP70RD, GP71DF, GP71PL, GP138TQ, 6 in GP20AL, GP59MV, GP59TQ, GP70MT, GP70OR, GP70SF, GP70TA, 4 in GP20LM, GP71LI, GP71MT, GP92GY and 2 in GP71CM. Total 198 rectangles.
Template U Fabric WCS SR only fussy cut 8 rectangles 2in x 2½in (5cm x 6.25cm) with the stripes running down the length (see the photograph for help with this). For all other fabrics cut 2in (5cm) strips across the width of the fabric. Each strip will give you 7 rectangles per full width. Cut 2in x 2½in (5cm x 6.25cm) rectangles, cut 14 in GP70PO, 12 in GP70PH, GP71PN, GP71TA, GP131ST, 10 in GP70FU, GP92LI, 8 in BM37PT, GP70LV, GP70RD, GP71DF, GP71PL, GP138TQ, 6 in GP20AL, GP59MV, GP59TQ, GP70MT, GP70OR, GP70SF, GP70TA, 4 in GP20LM, GP71LI, GP71MT, GP92GY and 2 in GP71CM. Total 198 rectangles.
Template W Cut 1¾in (4.5cm) strips across the width of the fabric. Each strip will give you 22 squares per full width. Cut 52 in GP70SF, 40 in GP70FU, GP71PN, 28 in GP70RD, GP92LI, 24 in GP71MT, 20 in GP70LV, GP71CM, GP71DF, GP71PL, 16 in GP59MV, GP70OR, GP70TA, 12 in BM37PT, GP70PO, GP131ST, 8 in GP20AL, GP70MT and 4 in GP71LI. Total 396 squares.

Binding Cut 8 strips 2½in (6.5cm) wide across the width of the fabric in GP71TA.

Backing Cut 1 piece 40in x 84in (101.5cm x 213.5cm) and 1 piece 35in x 84in (89cm x 213.5) in backing fabric.

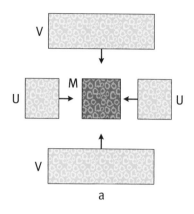

a

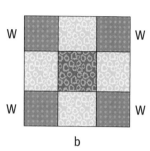

b

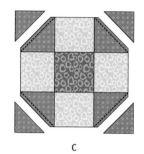

c

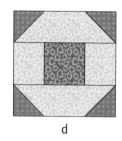

d

MAKING THE BLOCKS

Use a ¼in (6mm) seam allowance throughout and refer to the quilt assembly diagram for fabric combinations. The 'Donut' blocks are made up with either a dark middle and corners and a light 'ring' or the opposite, with a light middle and corners and a dark ring. The blocks are alternated throughout the quilt so that you always have 2 opposite light and dark triangles at the junctions of the blocks.

First piece a template M centre with template U and V rectangles (in the same fabric) as shown in block assembly diagram a. Take 4 template W squares and place one square, right sides together onto each corner of the pieced block, matching the edges carefully as shown in block assembly diagram b. Stitch diagonally across the small squares as shown in diagram c. Trim the corners to a ¼in (6mm) seam allowance and press the corners out (diagram d). Make 99 blocks.

MAKING THE QUILT

Lay out the blocks as shown in the quilt assembly diagram making sure the block corners alternate as described above. Join into 11 rows of 9 blocks then join the rows to complete the quilt centre. Piece the inner border using template J squares. Make 2 sections of 2 x 22 squares and add to the sides of the quilt and then 2 sections of 2 x 22 squares and add to the quilt top and bottom as shown in the quilt assembly diagram. Finally add the outer border, top and bottom first, then the sides to complete the quilt.

FINISHING THE QUILT

Press the quilt top. Seam the backing pieces using a ¼in (6mm) seam allowance to form a piece approx. 74in x 84in (188cm x 213.5cm). Layer the quilt top, batting and backing and baste together (see page 148). Hand quilt in the ditch using toning thread to outline the block centres, corner triangles and the outer border seam. Trim the quilt edges and attach the binding (see page 149).

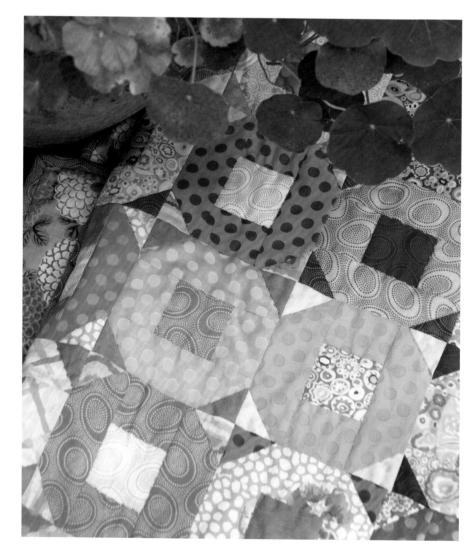

QUILT ASSEMBLY
DIAGRAM

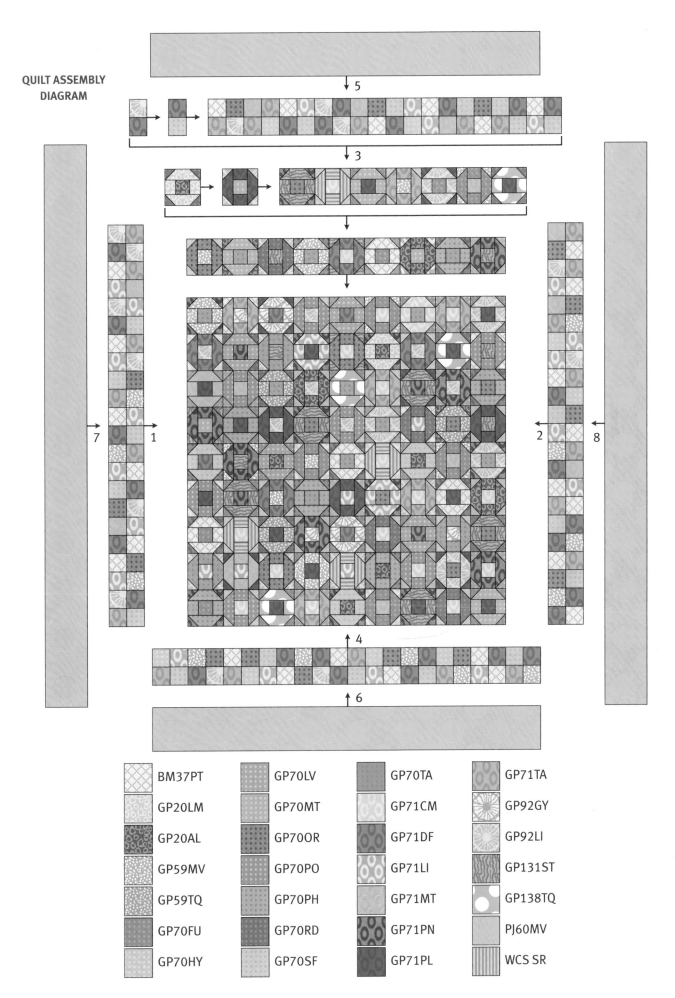

BM37PT	GP70LV	GP70TA	GP71TA
GP20LM	GP70MT	GP71CM	GP92GY
GP20AL	GP70OR	GP71DF	GP92LI
GP59MV	GP70PO	GP71LI	GP131ST
GP59TQ	GP70PH	GP71MT	GP138TQ
GP70FU	GP70RD	GP71PN	PJ60MV
GP70HY	GP70SF	GP71PL	WCS SR

log cabin sampler **

Kaffe Fassett

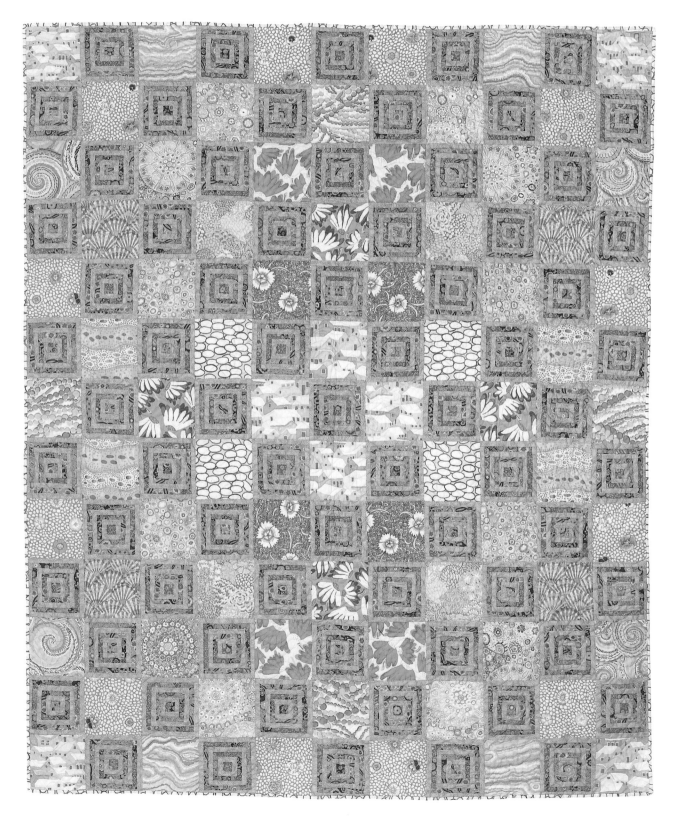

This pretty quilt is made of Log cabin blocks (which finish to 6in (15.25cm) square) alternated in a straight set layout with simple squares (Template A). The 'logs' of the Log Cabin blocks finish at just ½in (1.25cm) wide so Judy chose to use a paper foundation to keep them accurate.

SIZE OF QUILT
The finished quilt will measure approx. 66in x 78in (167.75cm x 198cm).

MATERIALS
Patchwork Fabrics
LAZY DAISY
| Blue | BM44BL | ¼yd (25cm) |
| Yellow | BM44YE | ¼yd (25cm) |

LABELS
| White | BM45WH | ¼yd (25cm) |

VICTORIA
| Citrus | BM46CT | ¼yd (25cm) |

SHANTY TOWN
| Pastel | BM47PT | ½yd (45cm) |

PAPERWEIGHT
| Gold | GP20GD | ¼yd (25cm) |

GUINEA FLOWER
| Grey | GP59GY | ½yd (45cm) |

ABORIGINAL DOTS
| Silver | GP71SV | 3¼yd (3m) |

MILLEFIORE
Grey	GP92GY	¼yd (25cm)
Lilac	GP92LI	¼yd (25cm)
Orange	GP92OR	2¼yd (2.1m)

ORIENTAL TREES
| Yellow | GP129YE | ¼yd (25cm) |

JUPITER
| Pastel | GP131PT | ¼yd (25cm) |

DIANTHUS
| White | GP138WH | ¼yd (25cm) |

CASCADES
| Pastel | GP141PT | ¼yd (25cm) |

PAPER FANS
| Vintage | GP143VN | ¼yd (25cm) |

CURLY BASKETS
| Silver | PJ66SV | ¼yd (25cm) |

Backing Fabric 5yd (4.6m)
We suggest these fabrics for backing
LAKE BLOSSOMS Sky, GP93SK
JOY Mauve, PJ60MV

Binding
LABELS
| White | BM45WH | ⅝yd (60cm) |

Batting
74in x 86in (188cm x 218.5cm)

Quilting thread
Toning machine quilting thread.

Template

A

This project also uses the foundation pattern printed on page 142.

CUTTING OUT
Template A Cut 6½in (16.5cm) strips across the width of the fabric. Each strip will give you 6 squares per full width. Cut 12 in GP59GY, 8 in BM47PT, 4 in BM44BL, BM44YE, BM45WH, BM46CT, GP20GD, GP92GY, GP92LI, GP129YE, GP131PT, GP138WH, GP141PT, GP143VN and PJ66SV. Total 72 squares.
Log Cabin Block Centres Cut 3 strips 1½in (3.75cm) wide across the width of the fabric. Each strip will give you 26 squares per full width. Cut 71 squares 1½in x 1½in (3.75cm x 3.75cm) in GP92OR.

Log Cabin Logs Cut 1in (2.5cm) strips across the width of the fabric in GP92OR and GP71SV. Cut strips a few at a time to keep them pristine for sewing.

Binding Cut 8 strips 2½in (6.5cm) wide across the width of the fabric in BM45WH.

Backing Cut 1 piece 40in x 86in (101.5cm x 218.5cm) and 1 piece 35in x 86in (89cm x 218.5cm) in backing fabric.

FOUNDATION PIECING
For the diagrams RS = Right side, WS = Wrong Side. The foundation papers have a number in each section, this is the order in which the fabric pieces are added. Trace or photocopy 71 copies of the foundation pattern on page 142 (you may wish to make extra copies for practice), low quality photocopy paper works well as it tears easily. The fabrics are placed on the BACK of the paper and the stitching is done from the printed side of the paper. A light box it very helpful when foundation piecing as it allows you to see the printing through the paper, but holding the work up to a window or other light source can work well too.

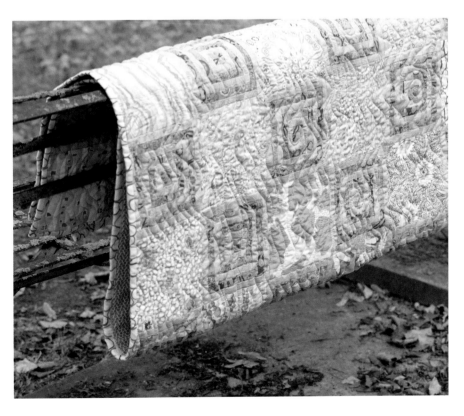

FOUNDATION PIECING DIAGRAMS

Stage 1

face down

Stage 2

sewing line

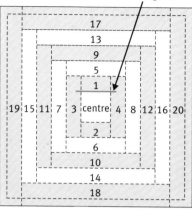

paper face up

Stage 3

paper face down

Stage 4

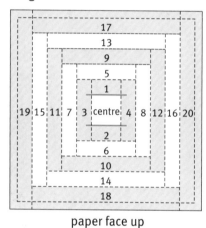

paper face up

Stage 5

paper face down

Stage 6

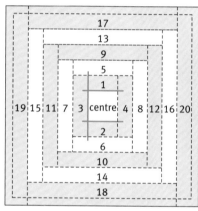

paper face up

Stage 1

The grey areas of the paper foundation indicate the sections where Aboriginal Dots Silver (GP71SV) is used and the white sections Millefiore Orange (GP92OR) is used. Start with your foundation paper face down, Take centre square (GP92OR) and place it evenly to cover the centre of the foundation paper, a dot of glue stick can hold it in place well. Take a strip of GP71SV fabric and cut a section ½in (1.25cm) longer than section 1 on the foundation, in this case it will be 1½in x 1in (3.75cm x 2.5cm). You will be stitching on the dotted line between the centre section and section 1 of the foundation, so make sure the fabrics will align and have a scant ¼in seam allowance once stitched. Pin the strip into place, right sides together, avoiding the stitching line as shown in the foundation piecing stage 1 diagram.

Stage 2

Set your machine to a short stitch, this will perforate the paper and make removal easier later. With the paper upmost stitch on the line between the centre and section 1, as shown in the stage 2 diagram. Always extend your sewing line 2 or 3 stitches beyond the ends of the marked dotted lines, this will ensure the seams are locked into place by subsequent seams.

Stage 3

Turn the paper over and open out the section 1 fabric, press without using steam as it can wrinkle the paper. Take another strip of GP71SV and repeat the process to cover section 2 of the paper foundation as shown in the stage 3 diagram.

Stage 4

Turn the paper again and stitch on the dotted line between the centre and section 2 as shown in the stage 4 diagram.

Stage 5

Turn the paper over and open out the section 2 fabric, press. Cut a section of GP71SV ½in (1.25cm) longer than section 3 on the foundation, this time it will be 2½in x 1in (6.25cm x 2.5cm). Pin into place as shown in the stage 5 diagram.

Stage 6

Turn the paper again and stitch on the dotted line between the centre and section 3 as shown in the stage 6 diagram, you will note that this sewing line locks the ends of the previous lines.

QUILT ASSEMBLY DIAGRAM

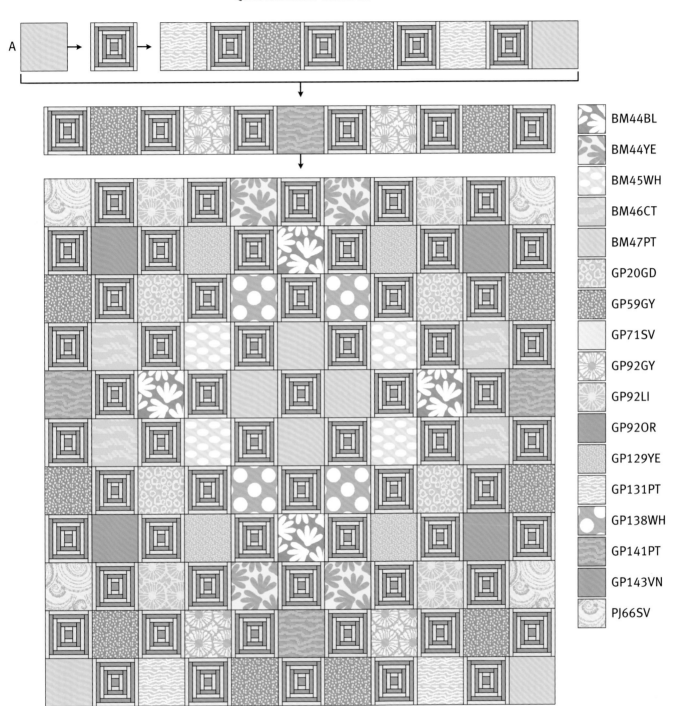

BM44BL
BM44YE
BM45WH
BM46CT
BM47PT
GP20GD
GP59GY
GP71SV
GP92GY
GP92LI
GP92OR
GP129YE
GP131PT
GP138WH
GP141PT
GP143VN
PJ66SV

Keep doing this until all the sections are covered, remembering to change fabrics as you work out towards the edge. Working on several papers at a time can speed up the process, plus working on papers at different stages can be advantageous as smaller offcuts can be used in the centre sections so there is almost no waste. Do not remove the papers yet.

MAKING THE QUILT

Lay out the foundation pieced blocks interspacing with the template A squares as shown in the quilt assembly diagram. Join into 13 rows, then join the rows to complete the quilt centre. Now remove the foundation papers. Patience and a good pair of tweezers can help with this!

FINISHING THE QUILT

Press the quilt top. Seam the backing pieces using a ¼in (6mm) seam allowance to form a piece approx. 74in x 86in (188cm x 218.5cm). Layer the quilt top, batting and backing and baste together (see page 148). Using toning machine quilting thread quilt in a free motion meander pattern throughout the quilt. Trim the quilt edges and attach the binding (see page 149).

rustic checkerboard medallion **

Kaffe Fassett

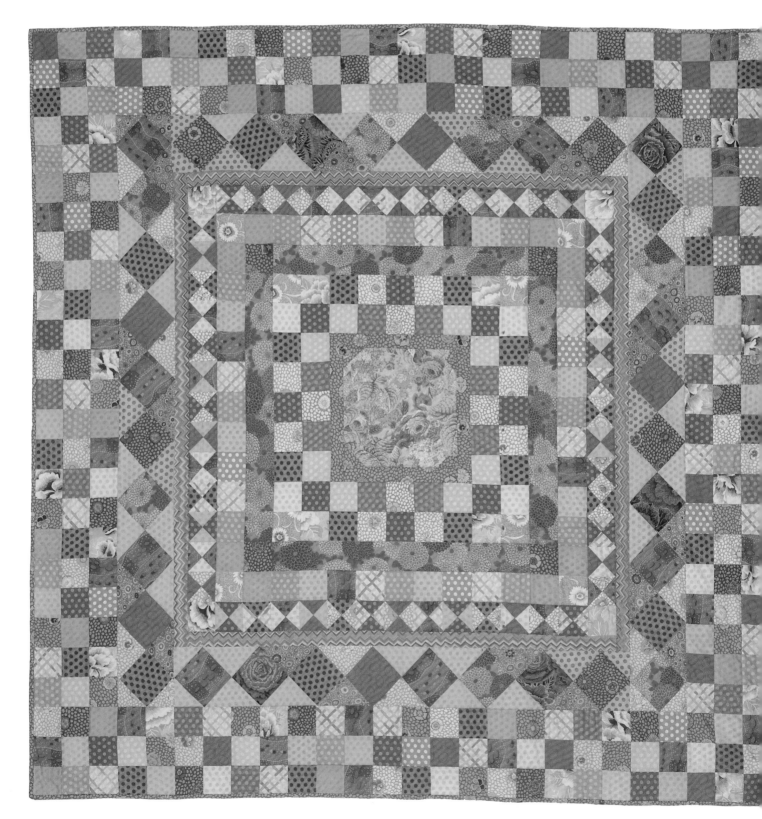

This medallion style quilt is built in a series of borders around a central snowball block. The snowball block is pieced by using a large square (cut to size) and 4 small squares (Template B). The centre is then surrounded with Border 1 which is a simple narrow border. Border 2 consists of a double row of checkerboard squares (Template B). Border 3 is simple with square corner posts (Template B), the same square (Template B) is used to piece Border 4, which is a single row this time. Border 5 is pieced from hourglass blocks which are made using 2 squares of fabric (Template C), these are sewn, cut, then sewn and cut again to yield 2 hourglass blocks. Border 6 is a simple border followed by Border 7 which is pieced using a square (Template D) and 2 triangles (Templates E and F). Finally, Border 8, consists of a triple row of checkerboard squares (Template B).

SIZE OF QUILT
The finished quilt will measure approx.
78in x 78in (198cm x 198cm).

MATERIALS
Patchwork Fabrics
MAD PLAID

Pastel	BM37PT	½yd (45cm)
ZIGZAG		
Pink	BM43PK	⅜yd (35cm)
VICTORIA		
Hot	BM46HT	⅝yd (60cm)
ROMAN GLASS		
Gold	GP01GD	¼yd (25cm)
KIMONO		
Lavender Blue	GP33LB	⅜yd (35cm)
GUINEA FLOWER		
Apricot	GP59AP	½yd (45cm)
Gold	GP59GD	⅝yd (60cm)
Mauve	GP59MV	¼yd (25cm)
Pink	GP59PK	½yd (45cm)
Turquoise	GP59TQ	⅛yd (15cm)
SPOT		
Apple	GP70AL	½yd (45cm)
China Blue	GP70CI	¼yd (25cm)
Duck Egg	GP70DE	⅜yd (35cm)
Fuchsia	GP70FU	⅜yd (35cm)
Gold	GP70GD	¼yd (25cm)
Hydrangea	GP70HY	¼yd (25cm)
Orange	GP70OR	½yd (45cm)
Peach	GP70PH	⅜yd (35cm)
Red	GP70RD	⅜yd (35cm)
Soft Blue	GP70SF	¼yd (25cm)
Yellow	GP70YE	⅜yd (35cm)
ABORIGINAL DOTS		
Purple	GP71PU	½yd (45cm)
DIANTHUS		
Turquoise	GP138TQ	⅛yd (15cm)
BRASSICA		
Red	PJ51RD	¼yd (25cm)
JOY		
Pink	PJ60PK	½yd (45cm)
LILAC		
Yellow	PJ68YE	½yd (45cm)

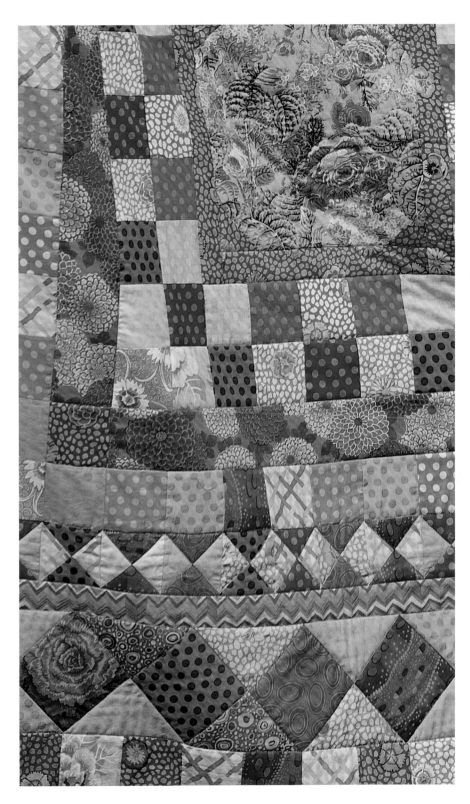

Backing Fabric 5¾yd (5.25m)
We suggest these fabrics for backing
MILLEFIORE Tomato, GP92TM
JOY Pink, PJ60PK

Binding
GUINEA FLOWER
Apricot GP59AP ⅝yd (60cm)

Batting
86in x 86in (218.5cm x 218.5cm)

Quilting thread
Toning machine quilting thread

Templates

B C D

E F

CUTTING OUT

Cut the fabrics in the order stated, reserve leftover strips and trim for later templates to ensure you will have sufficient fabric and prevent waste.
Border 1 Cut 2 strips 2in (5cm) wide across the width of the fabric, cut 2 borders 2in x 12½in (5cm x 31.75cm) and 2 borders 2in x 15½in (5cm x 39.25cm) in GP59AP.
Border 3 Cut 3 strips 3½in (9cm) wide across the width of the fabric, join as necessary and cut 4 borders 3½in x 27½in (9cm x 69.75cm) in PJ60PK.
Border 6 Cut 5 strips 2in (5cm) wide across the width of the fabric, join as necessary and cut 2 borders 2in x 45½in (5cm x 115.5cm) for the quilt top and bottom and 2 borders 2in x 48½in (5cm x 123.25cm) for the quilt sides in BM43PK.
Large Square Cut 1 square 12½in x 12½in (31.75cm x 31.75cm) in PJ68YE.
Template D Cut 4¾in (12cm) strips across the width of the fabric. Each strip will give you 8 squares per full width. Cut 8 in BM46HT, 7 squares in PJ60PK, 6 in GP70OR, 5 in GP59PK, GP71PU and PJ51RD. Total 36 squares.
Template C Cut 4¼in (10.75cm) strips across the width of the fabric. Each strip will give you 9 squares per full width. Cut 7 squares in BM46HT, GP70RD, GP71PU,

6 in BM37PT, GP70SF, 5 in GP59GD, GP70AL, GP70OR and 4 in GP59MV. Total 52 squares.
Template F Cut 3⅞in (9.75cm) strips across the width of the fabric. Cut 6 triangles in GP59GD, 4 in GP70GD 2 in GP01GD, GP70AL and GP70YE. Total 16 triangles.
Template E Cut 3⅝in (9.25cm) strips across the width of the fabric. Each strip will give you 10 triangles per full width. Place the template with the long side along the cut edge of the strip, this will ensure the long side of the triangles will not have a bias edge. Cut 18 in GP01GD, 14 in GP59GD, 13 in GP70AL, 10 in GP70GD and 9 in GP70YE. Total 64 triangles.
Template B Cut 3½in (9cm) strips across the width of the fabric. Each strip will give you 11 squares per full width. Cut 33 squares in BM37PT, 28 in GP33LB, GP70DE, GP70PH, 27 in M46HT, 25 in GP70OR, 24 in GP59AP, GP70FU, 23 in GP59PK, 20 in GP70RD, 18 in GP70HY, GP70YE, 17 in GP70CI, 15 in GP71PU, 14 in GP59GD, GP70AL, 12 in GP59MV, GP70SF, 8 in GP138TQ and 4 in GP59TQ. Total 392 squares.

Binding Cut 8 strips 2½in (6.5cm) wide across the width of the fabric in GP59AP.

Backing Cut 2 pieces 40in x 86in (101.5cm x 218.5cm), 2 pieces 40in x 7in (101.5cm x 17.75cm) and 1 piece 7in x 7in (17.75cm x 17.75cm) in backing fabric.

MAKING THE HOURGLASS BLOCKS

Use a ¼in (6mm) seam allowance throughout, it is essential that the seam allowance is accurate and consistent for these blocks. Refer to quilt assembly diagram 1 for fabric combinations. The method given will make 2 identical hourglass blocks from each pair of squares. Each block will have 2 triangles of each fabric.

Take 2 squares of different fabric, place right sides together matching the edges accurately. Mark a diagonal line from corner to corner with a soft pencil or washable marker, this will be the cutting line. Stitch the squares ¼in (6mm) from both sides of the cutting line as shown in sewing diagram d.

Cut along the marked cutting line to separate the 2 pieced squares, press the seam allowance towards the darker fabric as shown in diagram e.

Take the 2 pieced squares and place them right sides and opposite fabrics together matching the seam lines accurately, the pressing should help the seam allowances to lay smoothly together. Mark a diagonal line from corner to corner at right angles to the previous sewing line as shown in diagram f, this will be the cutting line.

Stitch the squares ¼in (6mm) from both sides of the cutting line as before. Cut along the marked cutting line to separate the 2 hourglass blocks, press the seam allowance to one side as shown in diagram g. Make 52 blocks.

MAKING THE QUILT
Centre Block and Borders 1–5

Use a ¼in (6mm) seam allowance throughout. Refer to the quilt assembly diagrams for fabric placement. Start by making the centre snowball block. Take the large square in PJ68YE and 4 template B squares in GP59AP. Place one small square, right sides together onto each corner of the large square as shown in the snowball block assembly diagram a. Stitch diagonally across the small squares as shown in diagram b. Trim the corners to a ¼in (6mm) seam allowance and press the corners out (diagram c).

Next add border 1, top and bottom first, then the sides as shown in quilt assembly diagram 1.

Border 2 is pieced using template B squares. Make 2 sections of 2 x 5 squares and add to the sides of the quilt and then 2 sections of 2 x 9 squares for the top and bottom.

Add a border 3 strip to each of the quilt sides, then add a template B square the ends of the 2 remaining strips and add to the quilt top and bottom.

Border 4 is pieced, again using template B squares. Make 2 sections of 1 x 11 squares and add to the quilt sides and then 2 sections of 1 x 13 squares for the top and bottom.

SNOWBALL BLOCK ASSEMBLY DIAGRAMS

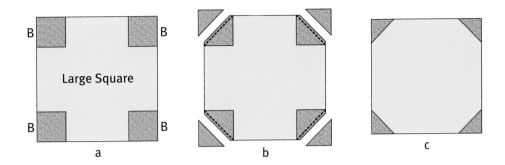

HOURGLASS BLOCK SEWING DIAGRAMS

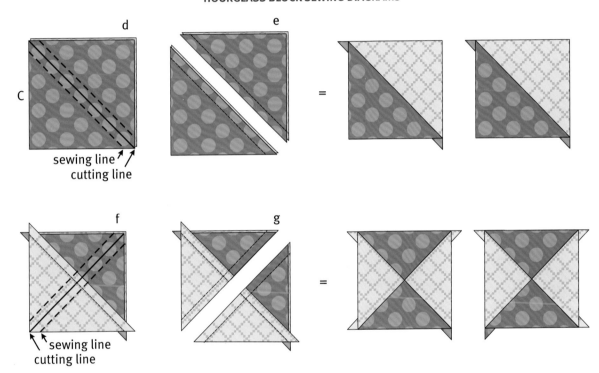

Border 5 is pieced using the hourglass blocks. Join the blocks into 4 borders each of 13 blocks. Add the side borders to the quilt centre. Take 4 template B squares in GP33LB and add one to each end of the remaining borders. Add these borders to the quilt top and bottom as shown in quilt assembly diagram 1.

MAKING THE QUILT
Borders 6–8
Border 6 is added next, top and bottom first, then the sides.

Piece Border 7 using the template D squares and template E and F triangles as shown in quilt assembly diagram 2. The top and bottom borders are added first, then the sides.

Border 8 is pieced using template B squares. Make 2 sections of 3 x 20 squares and add to the sides of the quilt and then 2 sections of 3 x 26 squares for the top and bottom as shown in quilt assembly diagram 2.

FINISHING THE QUILT
Press the quilt top. Seam the backing pieces using a ¼in (6mm) seam allowance to form a piece approx. 86in x 86in (218.5cm x 218.5cm). Layer the quilt top, batting and backing and baste together (see page 148). Stitch in the ditch throughout the quilt using toning machine quilting thread. Trim the quilt edges and attach the binding (see page 149).

QUILT ASSEMBLY DIAGRAM 1

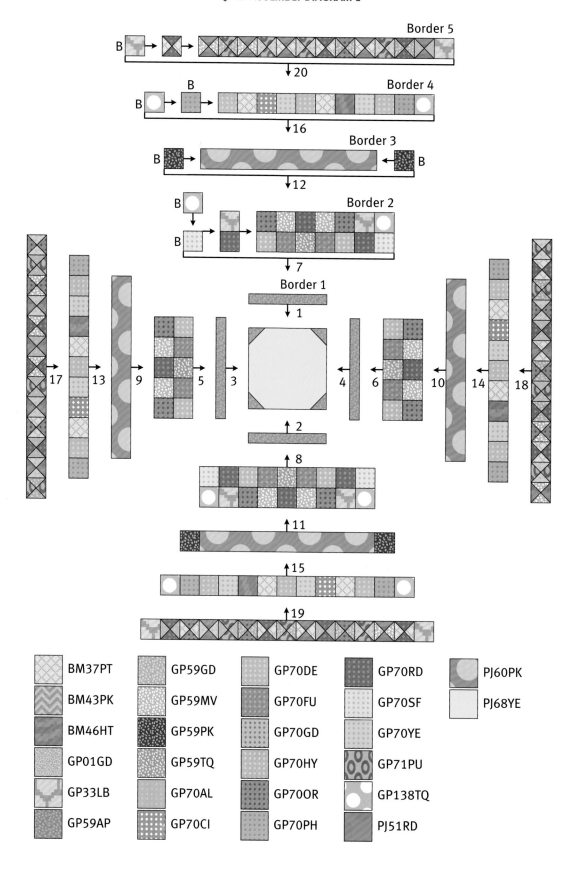

	BM37PT		GP59GD		GP70DE		GP70RD		PJ60PK
	BM43PK		GP59MV		GP70FU		GP70SF		PJ68YE
	BM46HT		GP59PK		GP70GD		GP70YE		
	GP01GD		GP59TQ		GP70HY		GP71PU		
	GP33LB		GP70AL		GP70OR		GP138TQ		
	GP59AP		GP70CI		GP70PH		PJ51RD		

QUILT ASSEMBLY DIAGRAM 2

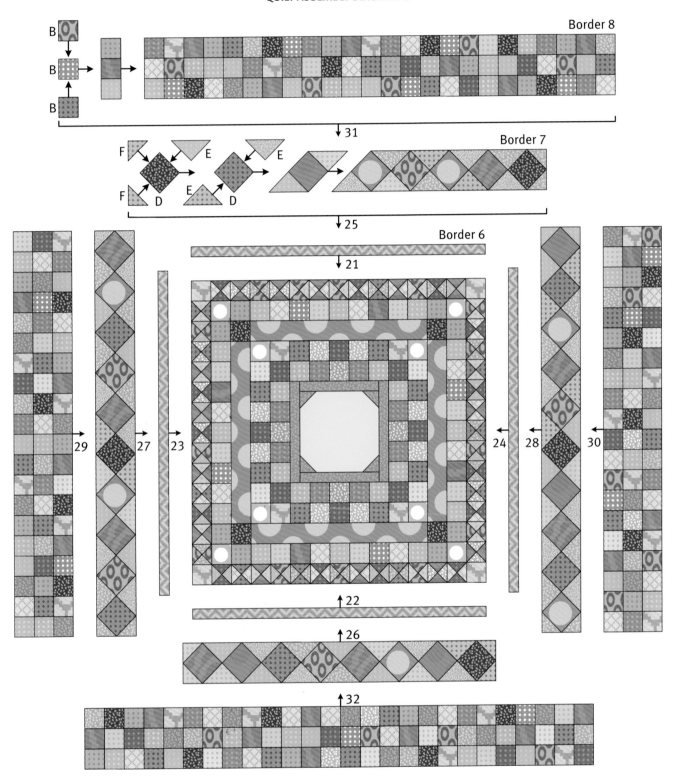

Border 8

B

B

B

↓ 31

F E E

F D E D

Border 7

↓ 25

Border 6

↓ 21

29 27 23

24 28 30

↑ 22

↑ 26

↑ 32

103

trip around the world **

Kaffe Fassett

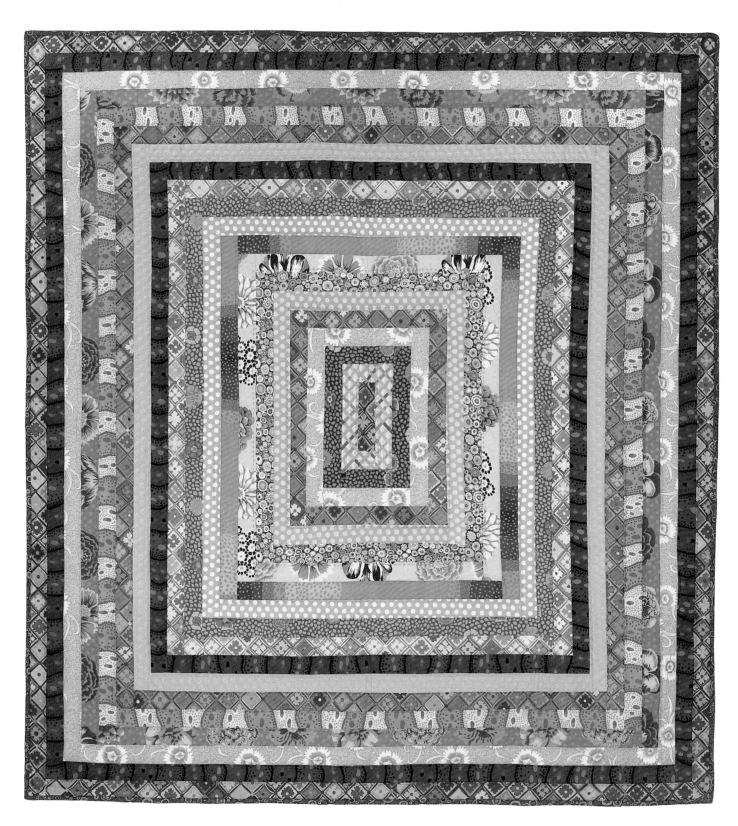

This quilt is constructed around a rectangular centre strip (cut to size). Strips are then added, in 'rounds' to the centre. Each 'round' of strips is cut to size in the same fabric. A total of 19 'rounds' of strips are added to complete the quilt.

SIZE OF QUILT
The finished quilt will measure approx. 58½in x 62½in (148.75cm x 158.75cm).

MATERIALS
Patchwork Fabrics
MAD PLAID
Mauve	BM37MV	⅛yd (15cm)

VICTORIA
Antique	BM46AN	⅜yd (35cm)
Dark	BM46DK	⅝yd (60cm)

PAPERWEIGHT
Pumpkin	GP20PN	¼yd (25cm)

GUINEA FLOWER
Brown	GP59BR	⅛yd (15cm)
Pink	GP59PK	⅜yd (35cm)

SPOT
China Blue	GP70CI	¼yd (25cm)
Lavender	GP70LV	⅛yd (15cm)
Turquoise	GP70TQ	⅜yd (35cm)

BIG BLOOMS
Brown	GP91BR	½yd (45cm)
Duck Egg	GP91DE	¼yd (25cm)

OMBRE
Green	GP117GN	¼yd (25cm)

DIANTHUS
Yellow	GP138YE	½yd (45cm)

ANTWERP FLOWERS
Blue	GP139BL	½yd (45cm)
Multi	GP139MU	⅜yd (35cm)
Red	GP139RD	½yd (45cm)

Backing Fabric 3⅞yd (3.6m)
We suggest these fabrics for backing
MILLEFIORE Brown, GP92BR
BIG BLOOMS Brown, GP91BR

Binding
PAPERWEIGHT
Purple	GP20PU	⅝yd (60cm)

Batting
66in x 70in (167.75cm x 177.75cm)

Quilting thread
Toning perlé embroidery thread.

CUTTING OUT
All strips are cut across the width of the fabric at 2in (5cm) wide. Cut the number of strips stated, join as necessary and cut the specified lengths. Some fabrics are used twice, so reserve leftover strips and use for later rounds.

Centre Strip Cut 1 strip, cut 1 rectangle 2in x 6in (5cm x 15.25cm) in GP139BL. Reserve remaining strip for Round 19.

Round 1 Cut 1 strip, cut 2 squares 2in x 2in (5cm x 5cm) and 2 rectangles 2in x 9in (5cm x 22.75cm) in BM37MV.

Round 2 Cut 1 strip, cut 2 rectangles 2in x 5in (5cm x 12.75cm) and 2 rectangles 2in x 12in (5cm x 30.5cm) in GP59BR.

Round 3 Cut 2 strips, cut 2 rectangles 2in x 8in (5cm x 20.25cm) and 2 rectangles 2in x 15in (5cm x 38cm) in GP138YE. Reserve remaining strip for Round 17.

Round 4 Cut 2 strips, cut 2 rectangles 2in x 11in (5cm x 28cm) and 2 rectangles 2in x 18in (5cm x 45.75cm) in GP139RD. Reserve remaining strip for Round 14.

Round 5 Cut 2 strips, cut 2 rectangles 2in x 14in (5cm x 35.5cm) and 2 rectangles 2in x 21in (5cm x 53.5cm) in GP70LV.

Round 6 Cut 3 strips, cut 2 rectangles 2in x 17in (5cm x 43.25cm) and 2 rectangles 2in x 24in (5cm x 61cm) in GP20PN.

Round 7 Cut 3 strips, cut 2 rectangles 2in x 20in (5cm x 50.75cm) and 2 rectangles 2in x 27in (5cm x 68.5cm) in GP91DE.

Round 8 Cut 3 strips, cut 2 rectangles 2in x 23in (5cm x 58.5cm) and 2 rectangles 2in x 30in (5cm x 76.25cm) in GP117GN.

Round 9 Cut 3 strips, cut 2 rectangles 2in x 26in (5cm x 66cm) and 2 rectangles 2in x 33in (5cm x 83.75cm) in GP70CI.

Round 10 Cut 4 strips, cut 2 rectangles 2in x 29in (5cm x 73.75cm) and 2 rectangles 2in x 36in (5cm x 91.5cm) in GP59PK.

Round 11 Cut 4 strips, cut 2 rectangles 2in x 32in (5cm x 81.25cm) and 2 rectangles 2in x 39in (5cm x 99cm) in GP139MU.

Round 12 Cut 4 strips, cut 2 rectangles 2in x 35in (5cm x 89cm) and 2 rectangles 2in x 42in (5cm x 106.75cm) in BM46DK. Reserve remaining strip for Round 18.

Round 13 Cut 5 strips, cut 2 rectangles 2in x 38in (5cm x 96.5cm) and 2 rectangles 2in x 45in (5cm x 114.25cm) in GP70TQ.

Round 14 Cut 4 strips, cut 2 rectangles 2in x 41in (5cm x 104.25cm) and 2 rectangles 2in x 48in (5cm x 122cm) in GP139RD.

Round 15 Cut 5 strips, cut 2 rectangles 2in x 44in (5cm x 111.75cm) and 2 rectangles 2in x 51in (5cm x 129.5cm) in BM46AN.

Round 16 Cut 6 strips, cut 2 rectangles 2in x 47in (5cm x 119.5cm) and 2 rectangles 2in x 54in (5cm x 137.25cm) in GP91BR.

Round 17 Cut 5 strips, cut 2 rectangles 2in x 50in (5cm x 127cm) and 2 rectangles 2in x 57in (5cm x 144.75cm) in GP138YE.

Round 18 Cut 6 strips, cut 2 rectangles 2in x 53in (5cm x 134.5cm) and 2 rectangles 2in x 60in (5cm x 152.5cm) in BM46DK.

Round 19 Cut 6 strips, cut 2 rectangles 2in x 56in (5cm x 142.25cm) and 2 rectangles 2in x 63in (5cm x 160cm) in GP139BL.

Binding Cut 7 strips 2½in (6.5cm) wide across the width of the fabric in GP20PU.

Backing Cut 1 piece 40in x 66in (101.5cm x 167.75cm) and 1 piece 31in x 66in (78.75cm x 167.75cm) in backing fabric.

Kaffe says:
I suggest cutting the fabric as you need it to keep the strips pristine. I also recommend cutting the strips to size as this will help to keep your patchwork in true as working with narrow strips can be a little tricky.

105

MAKING THE QUILT

Use a ¼in (6mm) seam allowance throughout. Take the centre strip and add a 'round 1' short strip to the top and bottom of the quilt centre as shown in the centre assembly diagram, press carefully away from the centre. Next take the 'round 1' long strips and add to the sides, press carefully to complete round 1. 'Round 2' and all subsequent rounds are added in the same sequence. Add all 19 'rounds' as shown in the quilt assembly diagram.

FINISHING THE QUILT

Press the quilt top. Seam the backing pieces using a ¼in (6mm) seam allowance to form a piece approx. 66in x 70in (167.75cm x 177.75cm). Layer the quilt top, batting and backing and baste together (see page 148). Using toning perlé embroidery thread hand quilt ¼in (6mm) outside each 'round'. Trim the quilt edges and attach the binding (see page 149).

CENTRE ASSEMBLY DIAGRAM

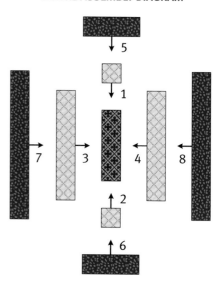

QUILT ASSEMBLY DIAGRAM

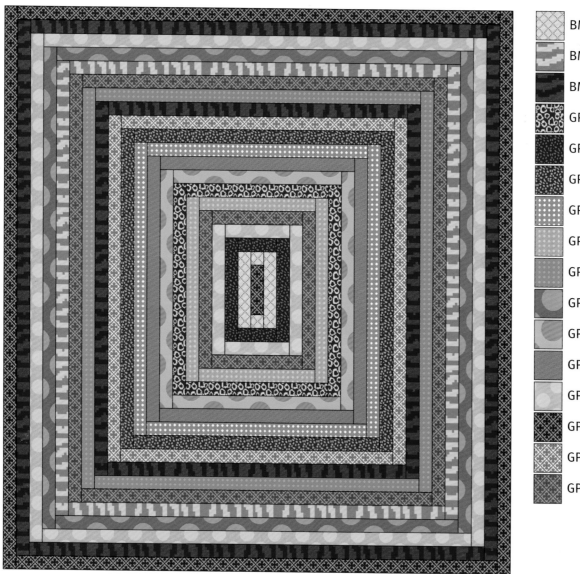

BM37MV

BM46AN

BM46DK

GP20PN

GP59BR

GP59PK

GP70CI

GP70LV

GP70TQ

GP91BR

GP91DE

GP117GN

GP138YE

GP139BL

GP139MU

GP139RD

bright squares *

Kaffe Fassett

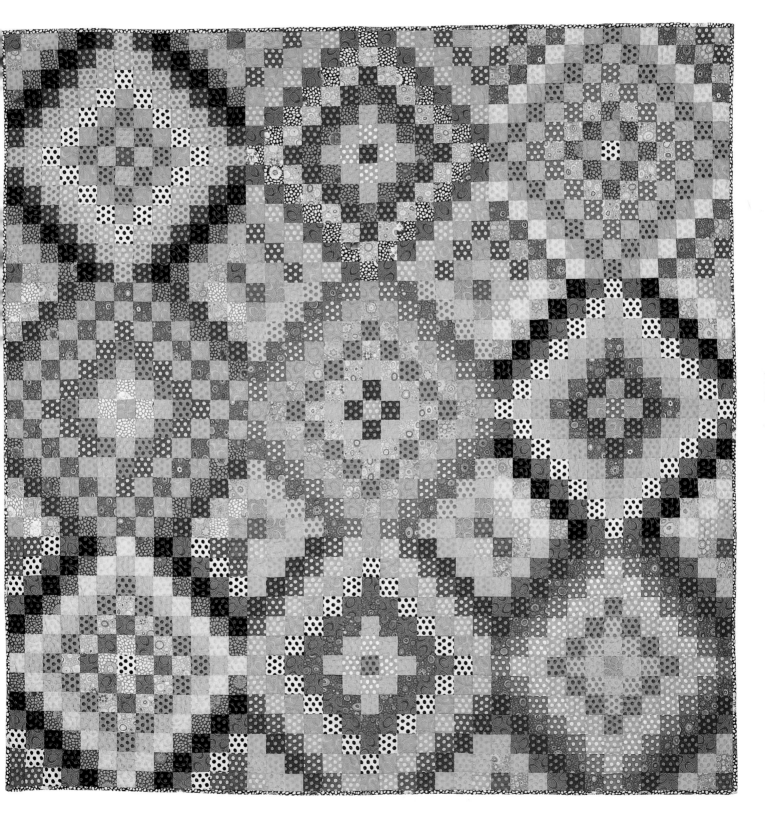

The layout of this quilt tricks the eye into thinking it is much more complex than it really is! It is made using a single square (Template M) pieced into blocks which are simply straight set. The only challenge is keeping track of the fabrics. We have separated the blocks completely in the quilt assembly diagram to help with this.

SIZE OF QUILT
The finished quilt will measure approx. 78in x 78in (198cm x 198cm).

MATERIALS
Patchwork Fabrics
ROMAN GLASS

Pink	GP01PK	⅜yd (35cm)
Red	GP01RD	⅝yd (60cm)

GUINEA FLOWER

Pink	GP59PK	½yd (45cm)
Turquoise	GP59TQ	⅛yd (15cm)
White	GP59WH	¼yd (25cm)

SPOT

Black	GP70BK	⅜yd (35cm)
China Blue	GP70CI	¼yd (25cm)
Gold	GP70GD	¼yd (25cm)
Green	GP70GN	½yd (45cm)
Grape	GP70GP	⅜yd (35cm)
Lavender	GP70LV	⅝yd (60cm)
Magenta	GP70MG	⅛yd (15cm)
Peach	GP70PH	⅜yd (35cm)
Royal	GP70RY	⅝yd (60cm)
Tomato	GP70TM	½yd (45cm)
Turquoise	GP70TQ	¾yd (70cm)
White	GP70WH	½yd (45cm)
Yellow	GP70YE	⅜yd (35cm)

ABORIGINAL DOTS

Cantaloupe	GP71CA	¼yd (25cm)
Delft	GP71DF	⅝yd (60cm)
Lilac	GP71LI	⅛yd (15cm)
Ochre	GP71OC	⅝yd (60cm)

MILLEFIORE

Green	GP92GN	½yd (45cm)

Backing Fabric 5¾yd (5.3m)
We suggest these fabrics for backing
BIG BLOOMS Duck Egg, GP91DE
DREAM Pastel, GP148PT

Binding
GUINEA FLOWER

White	GP59WH	⅝yd (60cm)

Batting
86in x 86in (218.5cm x 218.5cm)

Quilting thread
Toning machine quilting thread.

Templates

M

CUTTING OUT
Template M Cut 2½in (6.25cm) strips across the width of the fabric, each strip will give you 16 squares per full strip. Cut 137 in GP70TQ, 108 in GP01RD, GP71DF, 105 in GP70RY, 101 in GP71OC, 97 in GP70LV, 89 in GP70GN, 80 in GP59PK, 76 in GP92GN, 74 in GP70WH, 65 in GP70TM, 64 in GP70PH, 63 in GP70GP, 60 in GP70BK, 56 in GP01PK, GP70YE, 48 in GP70GD, 40 in GP71CA, 28 in GP70CI, 24 in GP59WH, 16 in GP59TQ, 13 in GP70MG and GP71LI. Total 1521 squares.

Binding Cut 8 strips 2½in (6.5cm) wide across the width of the fabric in GP59WH.

Backing Cut 2 pieces 40in x 86in (101.5cm x 218.5cm), 2 pieces 40in x 7in (101.5 x 17.75cm) and 1 piece 7in x 7in (17.75cm x 17.75cm) in backing fabric.

MAKING THE BLOCKS
Use a ¼in (6mm) seam allowance throughout. Refer to the quilt assembly diagram for fabric placement. Lay out all the squares for the first block, a design wall is helpful for this. Piece the squares into 13 rows. Press the seam allowances in opposite directions for each row and join the rows to complete the block as shown in block assembly diagram a. Make 9 blocks.

M

a

MAKING THE QUILT
Join the blocks into 3 rows, then join the rows to complete the quilt.

FINISHING THE QUILT
Press the quilt top. Seam the backing pieces using a ¼in (6mm) seam allowance to form a piece approx. 86in x 86in (218.5cm x 218.5cm). Layer the quilt top, batting and backing and baste together (see page 148). Using toning machine quilting thread free motion quilt in a twirly leaf pattern throughout the quilt. Trim the quilt edges and attach the binding (see page 149).

Pauline says:
Consistent pressing of a quilt like this the key to success. Pressing seams in opposite directions will allow the quilt to lay flat and will help when matching the seams. Be aware of the direction the seam allowances are pressed for adjacent blocks and plan as you go.

QUILT ASSEMBLY DIAGRAM

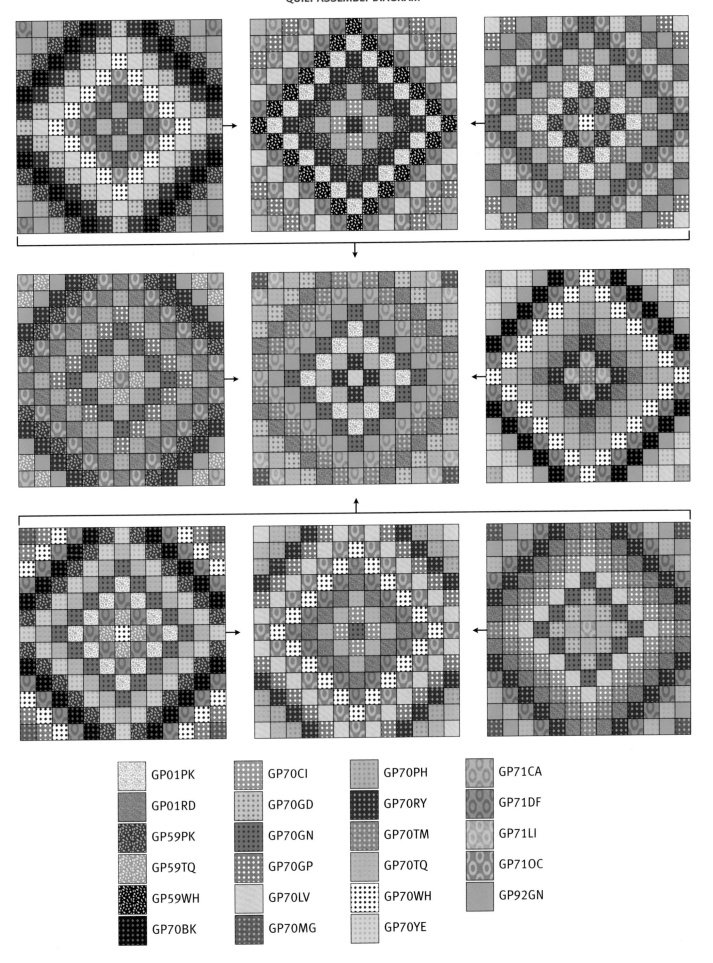

GP01PK	GP70CI	GP70PH	GP71CA
GP01RD	GP70GD	GP70RY	GP71DF
GP59PK	GP70GN	GP70TM	GP71LI
GP59TQ	GP70GP	GP70TQ	GP71OC
GP59WH	GP70LV	GP70WH	GP92GN
GP70BK	GP70MG	GP70YE	

diamond jubilee ***

Kaffe Fassett

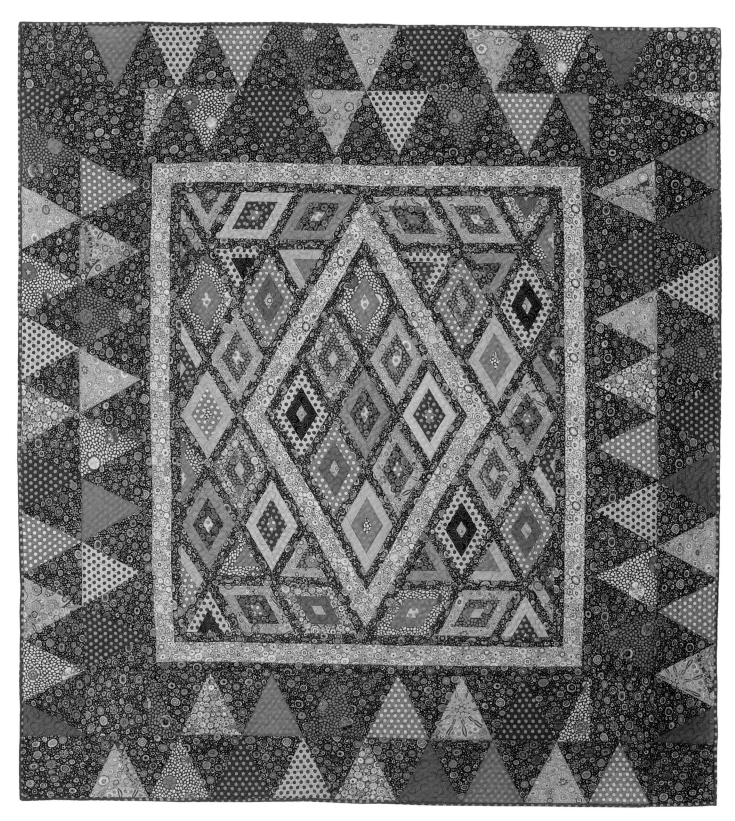

This quilt is built in a series of layers around the centre which is made with 9 foundation pieced diamond blocks set 'on point' to make a large diamond. This central diamond is surrounded with a series of 3 simple borders (Borders 1, 2 and 3, cut to size). The next layer is made up of more foundation pieced diamond blocks, along with foundation pieced triangle blocks and half diamond blocks which are used in various orientations depending on position. This takes the quilt centre to a rectangular shape which is surrounded with a series of 3 more simple borders (Border 4, 5 and 6, cut to size). Borders 7 and 8 are pieced using a triangle (Template X) and are trimmed to fit, these borders also have square corner posts (cut to size).

SIZE OF QUILT
The finished quilt will measure approx. 76½in x 83in (194.24cm x 210.75cm).

MATERIALS
Patchwork and Border Fabrics
ROMAN GLASS

Byzantine	GP01BY	4½yd (4.1m)
Gold	GP01GD	⅝yd (60cm)

PAPERWEIGHT

Pumpkin	GP20PN	½yd (45cm)
Sludge	GP20SL	⅝yd (60cm)
Gypsy	GP20GS	⅜yd (35cm)

GUINEA FLOWER

Brown	GP59BR	½yd (45cm)
Yellow	GP59YE	½yd (45cm)

SPOT

Gold	GP70GD	⅛yd (15cm)
Grey	GP70GY	½yd (45cm)
Ice	GP70IC	¼yd (25cm)
Tobacco	GP70TO	½yd (45cm)
Tomato	GP70TM	½yd (45cm)
Royal	GP70RY	½yd (45cm)

ABORIGINAL DOTS

Chocolate	GP71CO	⅛yd (15cm)
Ochre	GP71OC	⅜yd (35cm)
Pumpkin	GP71PN	⅜yd (35cm)
Purple	GP71PU	¼yd (25cm)

MILLEFIORE

Orange	GP92OR	½yd (45cm)

Backing Fabric 5⅞yd (5.4m)
We suggest these fabrics for backing
MILLEFIORE Brown, GP92BR
GUINEA FLOWER Purple, GP59PU

Binding
SPOT

Royal	GP70RY	¾yd (70cm)

Batting
84in x 91in (213.25cm x 231.25cm)

Quilting thread
Toning machine quilting thread

Templates

X

This project also uses the foundation patterns printed on pages 143, 144 and 145.

CUTTING OUT
Cut the fabrics in the order stated, reserve leftover fabrics for foundation piecing to ensure you will have sufficient fabric and prevent waste.
Template X Cut 7⅞in (20cm) strips across the width of the fabric, each strip will give you 9 triangles per full width. Cut 72 in GP01BY, 9 in GP70RY, 8 in GP59BR, GP59YE, GP70TM, GP92OR, 7 in GP70GY, 6 in GP01GD, GP01PN, GP70TO and GP71PN. Total 144 triangles.
Border 7 and 8 Corner Posts Cut 8 squares 7½in x 7½in (19cm x 19cm) in GP01BY.

Borders 1, 3 and 4 Cut 10 strips 1in (2.5cm) wide across the width of the fabric in GP01BY. Join the strips as necessary and cut borders as follows.
Border 1 Cut 2 borders 1in x 22½in (2.5cm x 57.25cm) and 2 borders 1in x 23¾in (2.5cm x 60.5cm) in GP01BY. These are cut over length and will be trimmed to shape and length later.
Border 3 Cut 2 borders 1in x 28½in (2.5cm x 72.5cm) and 2 borders 1in x 29½in (2.5cm x 75cm) in GP01BY. These are cut over length and will be trimmed to shape and length later.
Border 4 Cut 2 borders 1in x 48½in (2.5cm x 123.25cm) for the quilt sides and 2 borders 1in x 43in (2.5cm x 109.25cm) for the quilt top and bottom in GP01BY.

Border 6 Cut 6 strips 1½in (3.75cm) wide across the width of the fabric in GP01BY. Join the strips as necessary and cut 2 borders 1½in x 53½in (3.75cm x 136cm) for the quilt sides and 2 borders 1½in x 49in (3.75cm x 124.5cm) for the quilt sides.

Borders 2 and 5 Cut 8 strips 2½in (6.25cm) wide across the width of the fabric in GP20SL. Join the strips as necessary and cut borders as follows.
Border 2 Cut 2 borders 2½in x 24½in (6.25cm x 62.25cm) and 2 borders 2½in x 29¼in (6.25cm x 74.25cm) in GP20SL. These are cut over length and will be trimmed to shape and length later.
Border 5 Cut 2 borders 2½in x 49½in (6.25cm x 125.75cm) for the quilt sides and 2 borders 2½in x 47in (6.25cm x 119.5cm) for the quilt top and bottom in GP20SL.

Foundation Piecing Select and cut strips for a few blocks at a time by referring to the quilt assembly diagrams. For the inner sections of the foundation patterns (sections 1–9 of the diamond pattern, sections 1–5 of the triangle pattern and sections 1–4 of the half diamond pattern) start by cutting 1¾in (4.5cm) wide strips across the width of the fabric. Once you have practiced and made a few blocks you may wish to reduce this to 1½in (3.75cm) wide strips. For the outer sections of the foundation patterns (sections 10–13 of the diamond pattern, sections 6–8 of the triangle pattern and sections 5–7 of the half diamond pattern) cut 1½in (3.75cm) wide strips across the width of the fabric in GP01BY.

Binding Cut 9 strips 2½in (6.5cm) wide across the width of the fabric in GP70RY.

Backing Cut 2 pieces 40in x 84in (101.5cm x 213.25cm), 2 pieces 40in x 12in (101.5cm x 30.5cm) and 1 piece 12in x 5in (30.5cm x 12.75cm) in backing fabric.

FOUNDATION PIECING DIAGRAMS

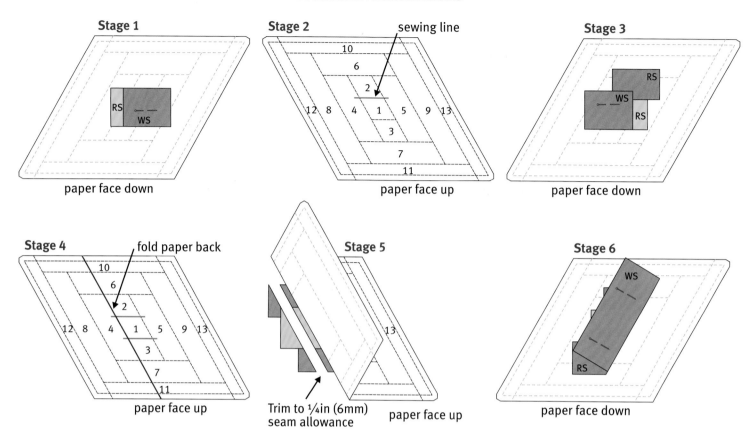

Stage 1 — paper face down

Stage 2 — sewing line — paper face up

Stage 3 — paper face down

Stage 4 — fold paper back — paper face up

Stage 5 — Trim to ¼in (6mm) seam allowance — paper face up

Stage 6 — paper face down

FOUNDATION PIECING THE BLOCKS

For the diagrams RS = Right side, WS = Wrong Side. The foundation papers have a number in each section, this is the order in which the fabric pieces are added. Trace or photocopy 31 copies of the diamond foundation pattern on page 143, 12 copies of the triangle foundation pattern on page 144 and 8 copies of the half diamond foundation pattern on page 145, (you may wish to make extra copies for practice), low quality photocopy paper works well as it tears easily. Cut out the foundation patterns on the solid outer line. The fabrics are placed on the BACK of the paper and the stitching is done from the printed side of the paper. A light box it very helpful when foundation piecing as it allows you to see the printing through the paper, but holding the work up to a window or other light source can work well too. Refer to the quilt assembly diagrams for fabric placement.

Stage 1

Start with your diamond foundation paper face down, Take a strip and cut a piece to completely cover section 1 of the foundation plus a seam allowance of ¼in (6mm). You don't need to cut it into a diamond shape, this will happen as you piece and trim. Place the strip evenly to cover section 1 of the centre of the foundation paper, a dot of glue stick can hold it in place well. Take a strip of the next fabric and cut a piece the same size as the first piece, place it right sides together with the first piece, but offset to the side so that when it is opened out it will completely cover section 2 of the foundation with a ¼in (6mm) all around. You will be stitching on the dotted line between section 1 and section 2 of the foundation. Pin the strip into place avoiding the stitching line as shown in the foundation piecing stage 1 diagram.

Stage 2

Set your machine to a short stitch, this will perforate the paper well and make removal easier later. With the paper face up stitch on the line between section 1 and section 2, shown as a red line on the stage 2 diagram. Always extend your sewing line 2 or 3 stitches beyond the ends of the marked dotted lines, this will ensure the seams are locked into place by subsequent seams.

Stage 3

Turn the paper over and open out the section 2 fabric, press without using steam as it can wrinkle the paper. Take another strip of the same fabric and repeat the process to cover section 3 of the paper foundation as shown in the stage 3 diagram.

Stage 4

Turn the paper again and stitch on the dotted line between the section 1 and section 3 as shown in the stage 4

QUILT ASSEMBLY DIAGRAM 1

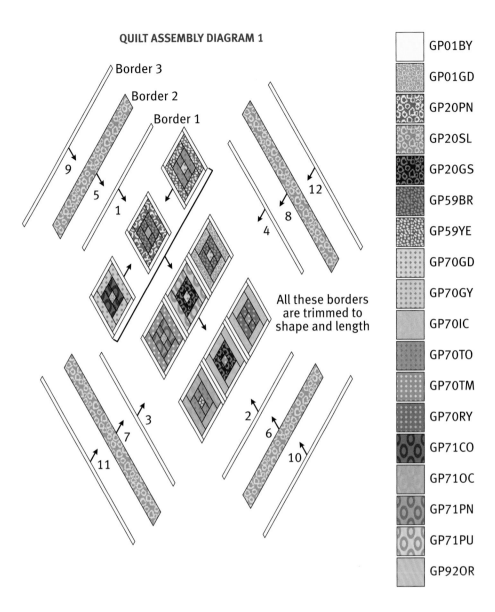

Border 3

Border 2

Border 1

All these borders are trimmed to shape and length

	GP01BY
	GP01GD
	GP20PN
	GP20SL
	GP20GS
	GP59BR
	GP59YE
	GP70GD
	GP70GY
	GP70IC
	GP70TO
	GP70TM
	GP70RY
	GP71CO
	GP71OC
	GP71PN
	GP71PU
	GP92OR

diagram. Open out the section 3 fabric and press. Now fold the paper on the line between sections 1, 2 and 3 and section 4, shown as a blue line on the stage 4 diagram. You will need to rip the paper a little where you have previously stitched to achieve this, but don't worry, it will not affect the finished block.

Stage 5
Very carefully trim the pieced fabrics to a ¼in (6mm) seam allowance as shown in the stage 5 diagram.

Stage 6
Flatten the paper and turn it face down. Cut a strip of fabric to cover section 4, again making sure it will completely cover section 4 plus ¼in (6mm) seam

allowance once stitched, (it will be considerably bigger than the first 3 sections). Pin into place as shown in the stage 5 diagram. Turn the paper and stitch on the line between sections 1, 2 and 3 and section 4. You will notice that this sewing line locks the ends of the previous lines.

Keep doing this until all the sections are covered, remembering to change fabrics as you work out towards the edge. The outer sections are always pieced in fabric GP01BY and finish narrower than the inner sections. When stitching is complete trim the outer edge to fit the paper exactly. Working on several papers at a time can speed up the process, do not remove the papers yet.

MAKING THE QUILT CENTRE
Use a ¼in (6mm) seam allowance throughout. Take 9 foundation pieced diamond blocks for the quilt centre. Join into 3 rows of 3 blocks, then join the rows to complete the centre section. Take the shorter border 1 strips. Position the strips carefully on opposite sides of the quilt centre section so that when they are stitched they can be opened out and trimmed flush with the raw edge of the centre at both ends. Take the longer border 1 strips and add to the other 2 sides and trim in the same manner. Add borders 2 and 3 and trim in the same way as shown in quilt assembly diagram 1.

QUILT ASSEMBLY DIAGRAM 2

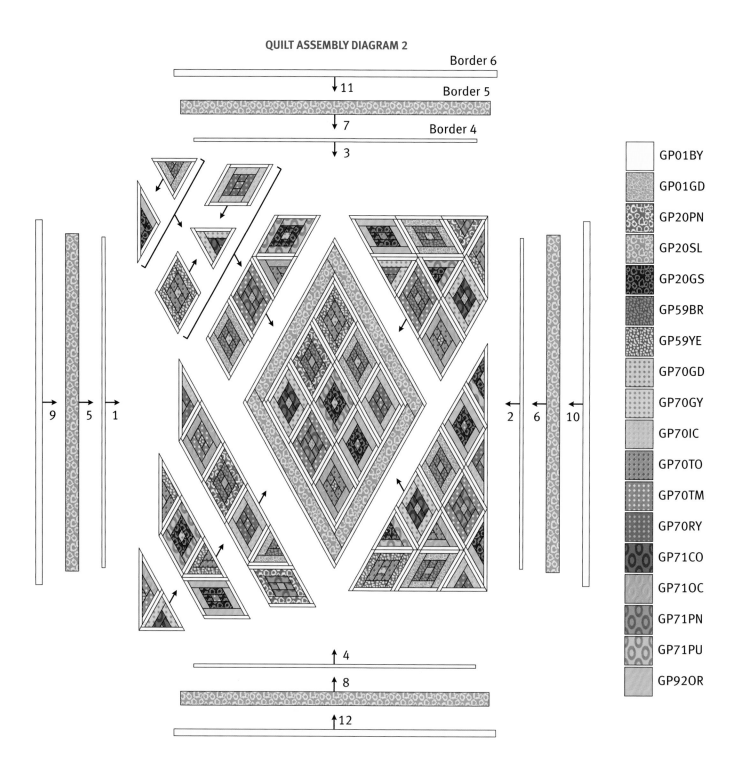

Border 6

11

Border 5

7

Border 4

3

9 5 1

2 6 10

4

8

12

GP01BY
GP01GD
GP20PN
GP20SL
GP20GS
GP59BR
GP59YE
GP70GD
GP70GY
GP70IC
GP70TO
GP70TM
GP70RY
GP71CO
GP71OC
GP71PN
GP71PU
GP92OR

Arrange the foundation pieced diamond, triangle and half triangle blocks as shown in quilt assembly diagram 2. Assemble the blocks into rows as shown, then into 4 sections. The sections are added in the sequence, top left, top right, bottom left, bottom right. Add border 4, sides first, then top and bottom. Add borders 5 and 6 in the same manner. Now remove the foundation papers. Patience and a good pair of tweezers can help with this!

MAKING THE OUTER BORDERS
Borders 7 and 8 are pieced using template X triangles. For border 7 piece 2 borders of 17 triangles for the quilt sides. Trim evenly to fit the quilt centre exactly but don't add them to the quilt yet as you need to trim the top and bottom borders to fit the quilt centre before the side borders are stitched into place. Make 2 borders of 15 triangles for the quilt top and bottom, trim to fit the quilt centre

exactly as before, add a corner post to each end of the top and bottom borders. Add border 7 to the quilt centre, sides first then top and bottom. Border 8 is made and trimmed in the same way as border 7, this time with 21 triangles for the sides and 19 for the top and bottom. Add border 8 to the quilt centre, sides first then top and bottom to complete the quilt.

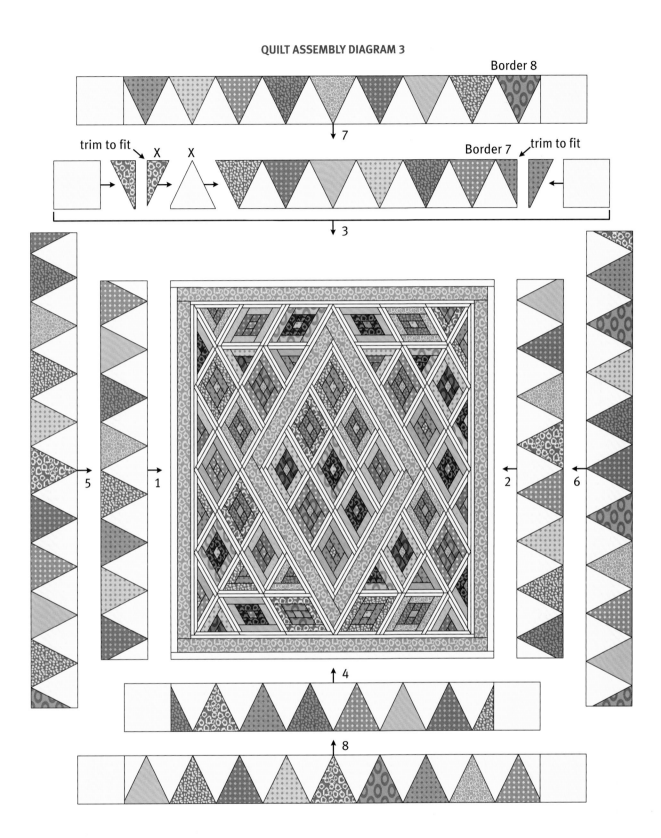

FINISHING THE QUILT

Press the quilt top. Seam the backing pieces using a ¼in (6mm) seam allowance to form a piece approx. 84in x 91in (213.25cm x 231.25cm). Layer the quilt top, batting and backing and baste together (see page 148). Free motion quilt in a meander pattern across the whole quilt using toning machine quilting thread. Trim the quilt edges and attach the binding (see page 149).

snowball crisscross **

Kaffe Fassett

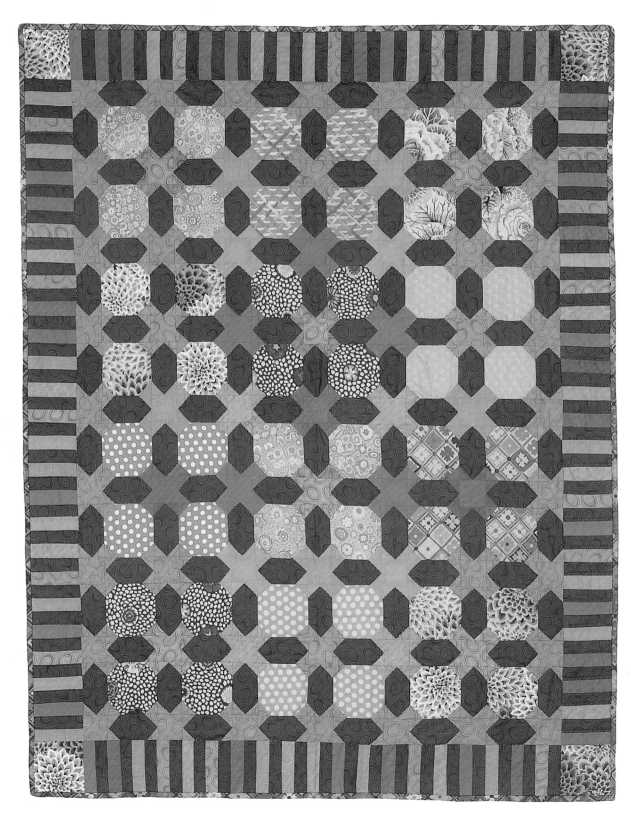

This quilt is made up of 2 block types, the first is a traditional snowball, made using a large square (Template N) and 4 small squares (Template O), the small squares are placed over the corners of the large square and stitched diagonally. They are then trimmed and flipped back to replace the corners of the large square. The second block is an elongated hexagon along with 4 triangles. The blocks are pieced using a rectangle (Template P) and 4 squares (Template O). This is pieced in the same way as the snowball block, this time the squares are placed over the corners of the rectangle and stitched diagonally. They are then trimmed and flipped back to replace the corners of the rectangle. The 2 block types are combined in straight rows with another square (Template M) which produces the striking X shapes in the design. The quilt centre is surrounded with a border pieced using a rectangle (Template Q) and a square (Template N) for the corner posts.

SIZE OF QUILT
The finished quilt will measure approx.
46in x 58in (116.75cm x 147.25cm).

MATERIALS
Patchwork and Border Fabrics
MAD PLAID
| Candy | BM37CD | ¼yd (25cm) |

DAHLIA BLOOMS
| Succulent | GP54SC | ⅜yd (35cm) |

GUINEA FLOWER
| Yellow | GP59YE | ¼yd (25cm) |

SPOT
Lavender	GP70LV	¼yd (25cm)
Teal	GP70TE	¼yd (25cm)
Turquoise	GP70TQ	¼yd (25cm)

ABORIGINAL DOTS
Charcoal	GP71CC	1⅝yd (1.5m)
Delft	GP71DF	⅜yd (35cm)
Ochre	GP71OC	¼yd (25cm)
Ocean	GP71ON	¼yd (25cm)
Taupe	GP71TA	⅝yd (60cm)

MILLEFIORE
| Green | GP92GN | ¼yd (25cm) |

ANTWERP FLOWERS
| Green | GP139GN | ¼yd (25cm) |

BRASSICA
| Green | PJ51GN | ¼yd (25cm) |

SHOT COTTON
Chartreuse	SC12	¼yd (25cm)
Tobacco	SC18	¼yd (25cm)
Lilac	SC36	⅜yd (35cm)
Galvanized	SC87	⅜yd (35cm)
Sprout	SC94	¼yd (25cm)

Backing Fabric 3⅜yd (3.1m)
We suggest these fabrics for backing
DAHLIA BLOOMS Succulent, GP54SC
SPOT Teal, GP70TE

Binding
ANTWERP FLOWERS
| Red | GP139RD | ½yd (45cm) |

Batting
54in x 66in (137.25cm x 167.75cm)

Quilting thread
Toning perlé embroidery threads.

Templates

CUTTING OUT
Please cut the patch shapes in the order specified. Reserve leftover fabric strips for following templates and trim as necessary.
Template N Cut 4½in (11.5cm) strips across the width of the fabric. Each strip will give you 8 squares per full width. Cut 12 squares in GP54SC, 8 in GP59YE, GP92GN, 4 in BM37CD, GP70LV, GP70TE, GP70TQ, GP139GN and PJ51GN. Total 52 squares.
Template M Cut 2½in (6.25cm) strips across the width of the fabric. Each strip will give you 16 squares per full width. Cut 32 squares in GP71TA, 6 in GP71DF, 5 in SC36, SC87, 4 in GP71OC, GP71ON, SC94, 2 in SC12 and 1 in SC18. Total 63 squares.
Template P Cut 2½in (6.25cm) strips across the width of the fabric. Each strip will give you 8 rectangles per full width. Cut rectangles 110 in GP71CC.
Template Q Cut 1½in (3.75cm) strips across the width of the fabric. Each strip will give you 8 rectangles per full width. Cut 88 rectangles in GP71CC, 17 in SC87, 14 in SC36, 11 in GP71OC, SC18, 10 in GP71DF, SC94, 9 in GP71ON and 6 in SC12. Total 176 rectangles.
Template O Cut 1½in (3.75cm) strips across the width of the fabric. Each strip will give you 26 squares per full width. Cut 260 squares in GP71TA, 72 in GP71DF, 60 in SC36, SC87, 48 in GP71OC, GP71ON, SC94, 24 in SC12 and 12 in SC18. Total 632 squares.

Binding Cut 6 strips 2½in (6.5cm) wide across the width of the fabric in GP139RD.

Backing Cut 1 piece 40in x 54in (101.5cm x 137.25cm) and 1 piece 27in x 54in (68.5cm x 137.25cm) in backing fabric.

MAKING THE BLOCKS
Use a ¼in (6mm) seam allowance throughout. Refer to the quilt assembly diagram for fabric placement. To make an elongated hexagon block take one rectangle (template P) and four small squares (template O). Place 2 squares, right sides together onto 2 opposite corners of the rectangle, matching the edges carefully as shown in block assembly diagram a. Stitch diagonally across the squares and trim the corners to a ¼in (6mm) seam allowance as shown in diagram b. Press the corners out (diagram c). Next place the remaining 2 small squares onto the other 2 corners of the rectangle, again matching the edges carefully as shown in block assembly diagram d. Stitch diagonally across the squares and trim the corners to a ¼in (6mm) seam allowance as before (diagram e). Finally press the corners out to complete the block as shown in diagram f. Make 110 blocks.

To make the Snowball blocks take one large square (template N) and four small squares (template O). Place one small

BLOCK ASSEMBLY DIAGRAMS

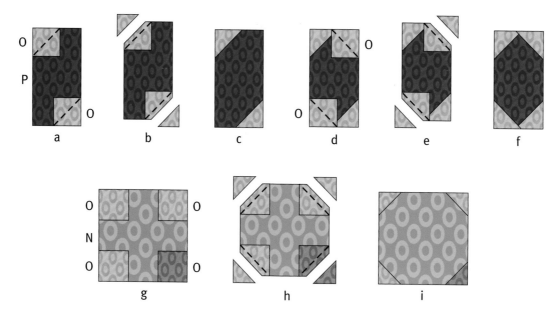

a b c d e f

g h i

square, right sides together onto each corner of the large square, matching the edges carefully as shown in block assembly diagram g. Stitch diagonally across the small squares as shown in diagram h. Trim the corners to a ¼in (6mm) seam allowance and press the corners out (diagram i). Make 48 snowball blocks.

MAKING THE QUILT CENTRE
Lay out the blocks and template M squares as shown in the quilt assembly diagram. Join into 17 rows. Join the rows to complete the quilt centre.

MAKING THE BORDERS
Piece the borders as shown in the quilt assembly diagram. There are 50 template Q rectangles in each side border and 38 rectangles in the top and bottom borders. Add a template N corner post to each end of the top and bottom borders. Add the side borders to the quilt centre, then to top and bottom borders to complete the quilt top.

FINISHING THE QUILT
Press the quilt top. Seam the backing pieces using a ¼in (6mm) seam allowance to form a piece approx. 57in x 71in (144.75cm x 180.25cm). Layer the quilt top, batting and backing and baste together (see page 148). Using toning perlé embroidery threads quilt in the ditch to outline the X shapes as shown in the quilting diagram. Trim the quilt edges and attach the binding (see page 149).

QUILTING DIAGRAM

QUILT ASSEMBLY DIAGRAM

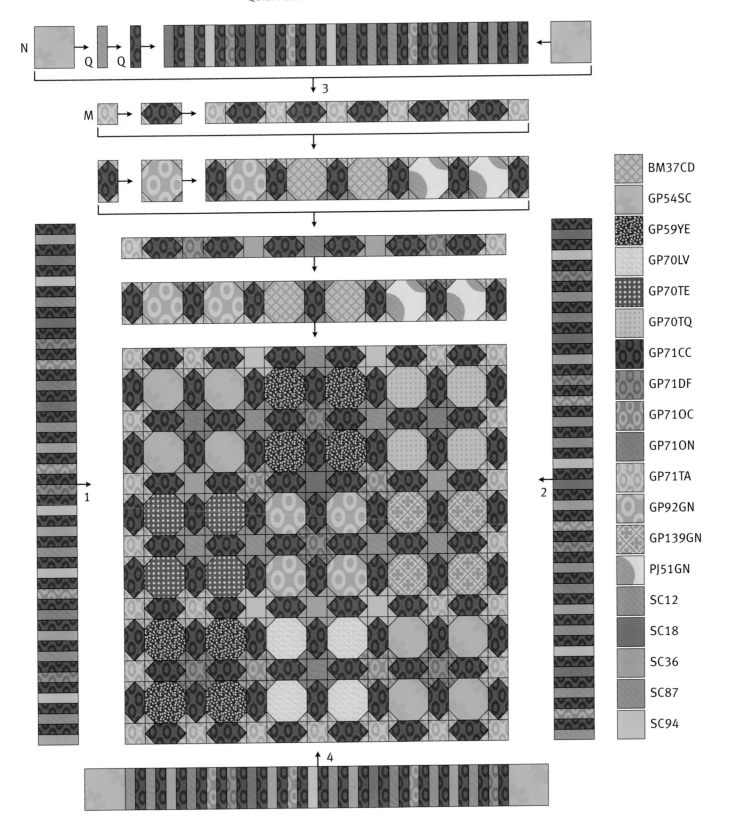

N

Q

Q

M

1

2

3

4

BM37CD

GP54SC

GP59YE

GP70LV

GP70TE

GP70TQ

GP71CC

GP71DF

GP71OC

GP71ON

GP71TA

GP92GN

GP139GN

PJ51GN

SC12

SC18

SC36

SC87

SC94

citrus zigzag ribbon **

Kaffe Fassett, colourway by Corienne Kramer

This version of the Zigzag Ribbon quilt is made in the same way as the Candy Zigzag Ribbon. Corienne chose to use more fabrics in a bright zingy palette for her colourway. We have listed the fabrics and quantities that Corienne used, but this is a starting point and we hope you will be inspired to choose your own selection.

SIZE OF QUILT
The finished quilt will measure approx. 72in x 72in (183cm x 183cm).

MATERIALS
Centre Block, Strip Set and Border Fabrics

MAD PLAID
Pastel	BM37PT	¼yd (25cm)

ZIGZAG
Pink	BM43PK	¾yd (70cm)

ROMAN GLASS
Leafy	GP01LF	⅜yd (35cm)
Pastel	GP01PT	¼yd (25cm)

PAPERWEIGHT
Pink	GP20PK	¼yd (25cm)

DAHLIA BLOOMS
Spring	GP54SP	¼yd (25cm)

GUINEA FLOWER
Mauve	GP59MV	¼yd (25cm)

SPOT
Gold	GP70GD	¼yd (25cm)
Grape	GP70GP	⅜yd (35cm)
Periwinkle	GP70PE	¼yd (25cm)
Pond	GP70PO	¼yd (25cm)
Yellow	GP70YE	¼yd (25cm)

ABORIGINAL DOTS
Gold	GP71GD	¼yd (25cm)

MILLEFIORE
Green	GP92GN	¾yd (70cm)
Lilac	GP92LI	¼yd (25cm)

LAKE BLOSSOMS
Yellow	GP93YE	¼yd (25cm)

OMBRE
Pink	GP117PK	½yd (45cm)

JUPITER
Purple	GP131PU	¼yd (25cm)
Yellow	GP131YE	⅜yd (35cm)

FLAME STRIPE
Yellow	GP134YE	¼yd (25cm)

PAPER FANS
Yellow	GP143YE	⅝yd (60cm)

BRASSICA
Yellow	PJ51YE	¼yd (25cm)

FEATHERS
Yellow	PJ55YE	⅜yd (35cm)

JOY
Yellow	PJ60YE	¼yd (25cm)

LILAC
Yellow	PJ68YE	¼yd (25cm)

WOVEN BROAD STRIPE
Watermelon	WBS WL	¼yd (25cm)

QUILT ASSEMBLY DIAGRAM 1

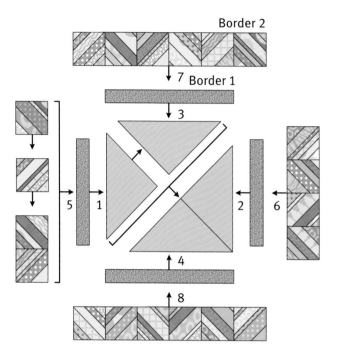

Border 2

7 Border 1

3

5 1 2 6

4

8

Backing Fabric 4¾yd (4.35m)
We suggest these fabrics for backing
LILAC Yellow, PJ68YE
DAHLIA BLOOMS Spring, GP54SP

Binding
ABORIGINAL DOTS
Gold GP71GD ⅝yd (60cm)

Batting
80in x 80in (203.25cm x 203.25cm)

Quilting thread
Toning machine quilting thread

Templates
See Candy Zigzag Ribbon

CUTTING OUT
Cut the fabric in the order stated to
prevent waste. Make templates using
template plastic to make cutting the strip
sets easier. All the fabrics are used in the
Strip Sets except BM43PK which is only
used for Border 5.
Triangle Make a template by cutting
a 12¼in (31cm) square of paper and
cutting it in half diagonally, this makes
the Triangle template. Cut 2 strips

8¾in (22.25cm) across the width of the
fabric in GP143YE. Carefully fussy cut 4
identical triangles using the photograph
as a guide.
Border 1 Cut 2 strips 2½in (6.25cm)
wide across the width of the fabric, cut 2
borders 2½in x 16½in (6.25cm x 42cm)
and 2 borders 2½in x 20½in (6.25cm x
52cm) in GP117PK.
Border 3 Cut 4 strips 3in (7.5cm) wide
across the width of the fabric, cut 2
borders 3in x 30½in (7.5cm x 77.5cm)
and 2 borders 3in x 35½in (7.5cm x
90.25cm) in GP92GN.
Border 5 Cut 6 strips 4in (10.25cm) wide
across the width of the fabric, join as
necessary and cut 2 borders 4in x 49½in
(10.25cm x 125.75cm) and 2 borders
4in x 56½in (10.25cm x 143.5cm) in
BM43PK.
Strip Sets The strip set fabrics are
cut across the full width of the fabric
at various widths ranging from 1in
(2.5cm) up to 2¾in (7cm) in ¼in (6mm)
increments.

Binding Cut 8 strips 2½in (6.5cm) wide
across the width of the fabric in GP71GD.

Backing Cut 2 pieces 40in x 80in
(101.5cm x 203.25cm) in backing fabric.

MAKING THE PIECED BLOCKS
See Candy Zigzag Ribbon Instructions.

MAKING THE QUILT
See Candy Zigzag Ribbon Instructions.
Please note that the blocks are pieced in
a different orientation in Border 2 for this
version.

FINISHING THE QUILT
Press the quilt top. Seam the backing
pieces using a ¼in (6mm) seam
allowance to form a piece approx. 80in x
80in (203.25cm x 203.25cm). Layer the
quilt top, batting and backing and baste
together (see page 148). Machine quilt
using toning machine quilting thread.
Quilt in the ditch and then in the pieced
blocks quilt wavy lines across each seam,
free motion quilt the centre and borders
following the fabric designs. Trim the
quilt edges and attach the binding (see
page 149).

QUILT ASSEMBLY DIAGRAM 2

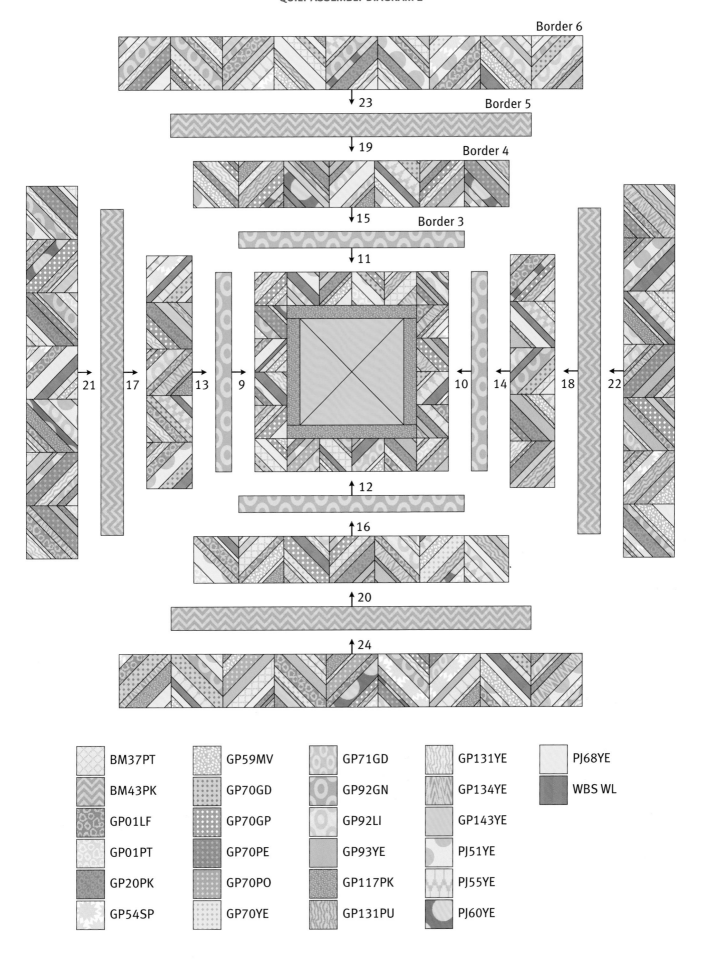

Border 6

Border 5

Border 4

Border 3

BM37PT
BM43PK
GP01LF
GP01PT
GP20PK
GP54SP

GP59MV
GP70GD
GP70GP
GP70PE
GP70PO
GP70YE

GP71GD
GP92GN
GP92LI
GP93YE
GP117PK
GP131PU

GP131YE
GP134YE
GP143YE
PJ51YE
PJ55YE
PJ60YE

PJ68YE
WBS WL

purple checkerboard medallion **

Kaffe Fassett, colourway by Liza Prior Lucy

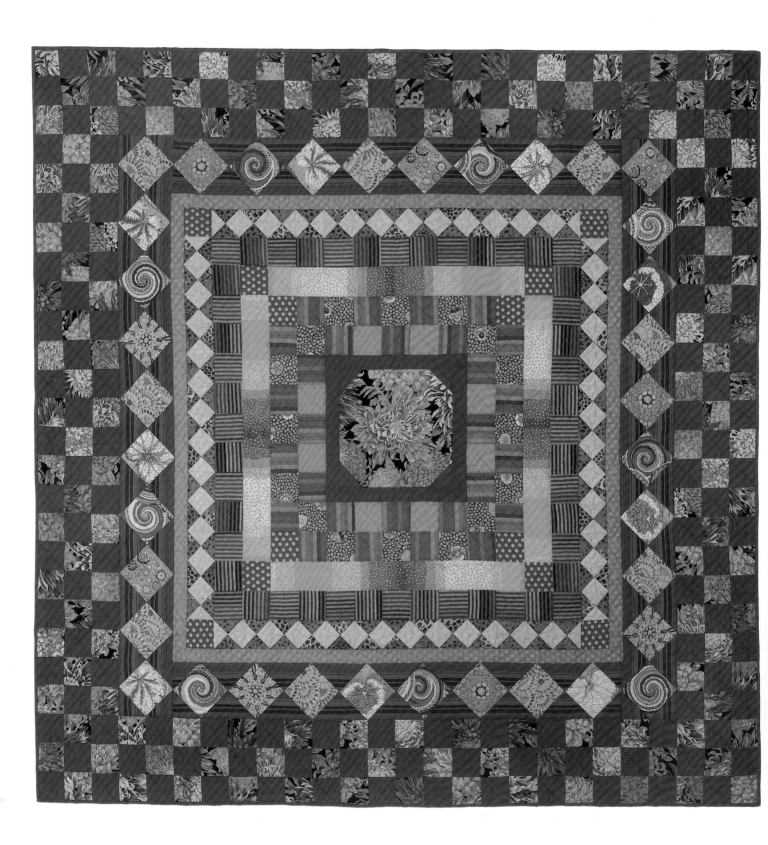

This version of the Checkerboard Medallion quilt is made in the same way as the Rustic Checkerboard Medallion. Liza chose fewer fabrics in a dark, rich palette of purples, russets and greens for her striking colourway. Several of the fabrics in this quilt were fussy cut, we have allowed extra fabric to accommodate this.

SIZE OF QUILT
The finished quilt will measure approx. 78in x 78in (198cm x 198cm).

MATERIALS
Patchwork Fabrics
DAHLIA BLOOMS		
Fig	GP54FI	½yd (45cm)
GUINEA FLOWER		
Brown	GP59BR	¼yd (25cm)
SPOT		
Royal	GP70RY	¼yd (25cm)
Tobacco	GP70TO	½yd (45cm)
ABORIGINAL DOTS		
Ochre	GP71OC	½yd (45cm)
MILLEFIORE		
Brown	GP92BR*	⅜yd (35cm)
OMBRE		
Green	GP117GN*	½yd (45cm)
PAPER FANS		
Ochre	GP143OC*	⅜yd (35cm)
JAPANESE CHRYSANTHEMUM		
Red	PJ41RD*	1⅝yd (1.5m)
CURLY BASKETS		
Brown	PJ66BR*	⅜yd (35cm)
BIG LEAF		
Ochre	PJ70OC*	⅜yd (35cm)
SHOT COTTON		
Grape	SC47	1½yd (1.4m)
WOVEN CATERPILLAR STRIPE		
Dusk	WCS DU	⅜yd (35cm)
Earth	WCS ER	⅜yd (35cm)
WOVEN EXOTIC STRIPE		
Parma	WES PM*	1yd (90cm)
WOVEN NARROW STRIPE		
Earth	WNS ER	⅜yd (35cm)

*Fussy cut, extra fabric allowed.

Backing Fabric 5¾yd (5.25m)
We suggest these fabrics for backing
BELLE EPOCH Dark, GP133DK
MILLEFIORE Brown, GP92BR

Binding
SHOT COTTON
Grape SC47 ⅝yd (60cm)

Batting
86in x 86in (218.5cm x 218.5cm)

Quilting thread
Toning machine quilting thread

Templates
See Rustic Checkerboard Medallion

CUTTING OUT
Cut the fabrics in the order stated to prevent waste. Several of the fabrics are fussy cut for this quilt.

Border 1 Cut 2 strips 2in (5cm) wide across the width of the fabric, cut 2 borders 2in x 12½in (5cm x 31.75cm) and 2 borders 2in x 15½in (5cm x 39.25cm) in SC47.

Border 3 Cut 4 strips 3½in (9cm) wide across the width of the fabric in GP117GN, fussy cut 4 borders 3½in x 27½in (9cm x 69.75cm) with the green section of the fabric centred, see the photograph for help with this.

Border 6 Cut 5 strips 2in (5cm) wide across the width of the fabric, join as necessary and cut 2 borders 2in x 45½in (5cm x 115.5cm) for the quilt top and bottom and 2 borders 2in x 48½in (5cm x 123.25cm) for the quilt sides in GP70TO.

Large Square Fussy cut 1 square 12½in x 12½in (31.75cm x 31.75cm) in PJ41RD centring on a large bloom refer to the photograph for help with this. Reserve the leftover fabric for template B.

Template D Fussy cut 4¾in x 4¾in (12cm x 12cm) squares centring on the designs in the fabrics. Cut 9 in GP92BR, GP143OC, PJ66BR and PJ70OC. Total 36 squares.

Template C Cut 4¼in (10.75cm) strips across the width of the fabric. Each strip will give you 9 squares per full width. Cut 26 in GP54FI and GP71OC. Total 52 squares.

Templates E and F These triangles are all cut in WES PM down the length of the fabric and we have provided a cutting layout. Pick one stripe repeat and make sure you can get a full 8 sets across the width of the fabric before you start. Cut 64 Template E triangles and 16 template F triangles as shown in the cutting layout for fabric WES PM. Separate the triangles into 2 sets which will be used in border 7. One set for the inside edge of the border and the other for the outside edge, refer to the photograph for help with this.

Template B Cut 3½in (9cm) strips across the width of the fabric. Each strip will give you 11 squares per full width. Cut 142 squares in SC47, 138 in PJ41RD, 28 in WNS ER, 24 in WCS DU, WCS ER, 16 in GP59BR, 12 in GP70RY and 8 in GP70TO. Total 392 squares.

CUTTING LAYOUT FOR FABRIC WES PM

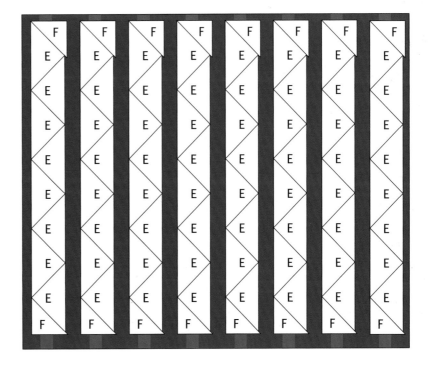

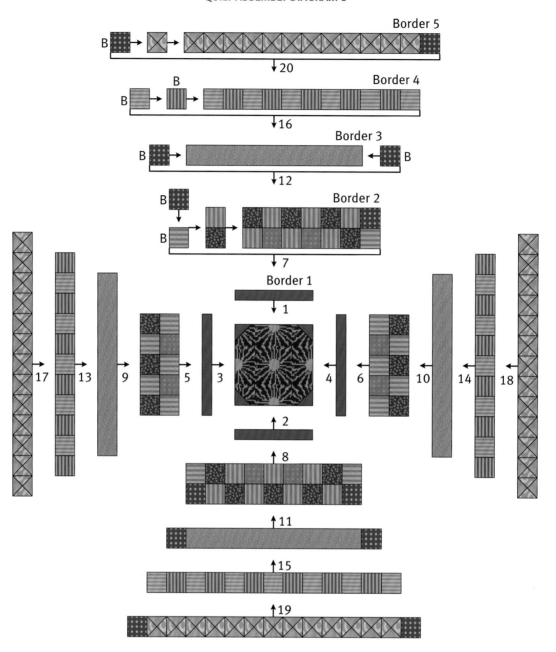

Binding Cut 8 strips 2½in (6.5cm) wide across the width of the fabric in SC47.

Backing Cut 2 pieces 40in x 86in (101.5cm x 218.5cm), 2 pieces 40in x 7in (101.5cm x 17.75cm) and 1 piece 7in x 7in (17.75cm x 17.75cm) in backing fabric.

MAKING THE HOURGLASS BLOCKS
See Rustic Checkerboard Medallion Instructions.

MAKING THE QUILT
See Rustic Checkerboard Medallion Instructions.

FINISHING THE QUILT
Press the quilt top. Seam the backing pieces using a ¼in (6mm) seam allowance to form a piece approx. 86in x 86in (218.5cm x 218.5cm). Layer the quilt top, batting and backing and baste together (see page 148). Working from the centre out using toning machine

quilting thread free motion quilt the centre snowball block following the floral design in the fabric. In borders 1, 3 and 6 stitch a twisted ribbon design. Cross hatch Borders 2, 4 and 8 through every square. For Border 5 stitch a twisted star in each yellow square and Border 6 free motion quilt following the designs in the fabrics. Trim the quilt edges and attach the binding (see page 149).

QUILT ASSEMBLY DIAGRAM 2

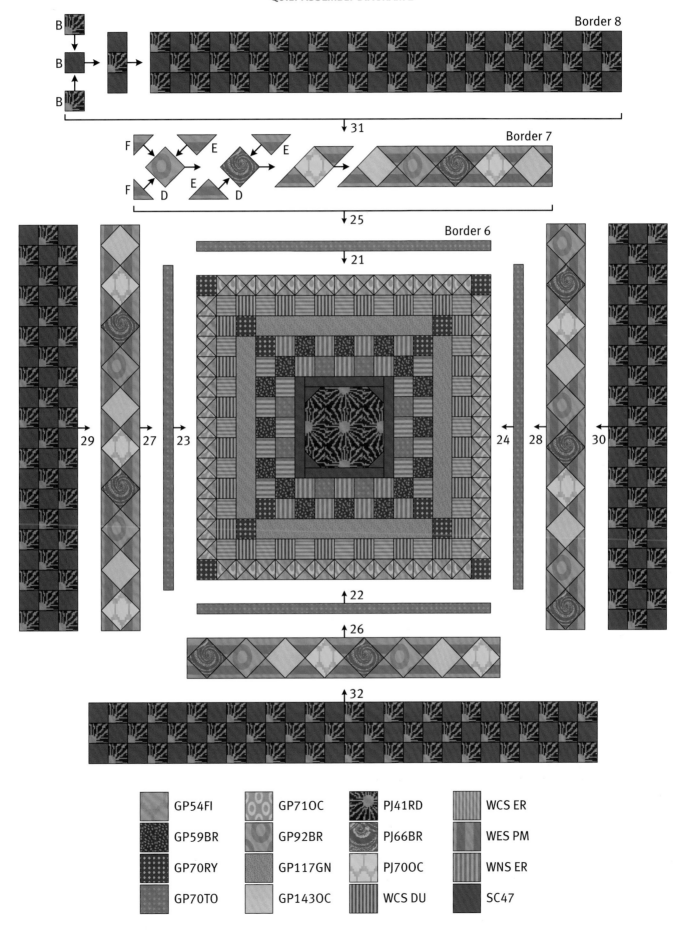

Border 8

Border 7

Border 6

B
B
B

F E E
F E
D E D

31

25

21

29 27 23 24 28 30

22

26

32

	GP54FI		GP71OC		PJ41RD		WCS ER
	GP59BR		GP92BR		PJ66BR		WES PM
	GP70RY		GP117GN		PJ70OC		WNS ER
	GP70TO		GP143OC		WCS DU		SC47

earthy herringbone stripes **

Kaffe Fassett, colourway by Judy Baldwin

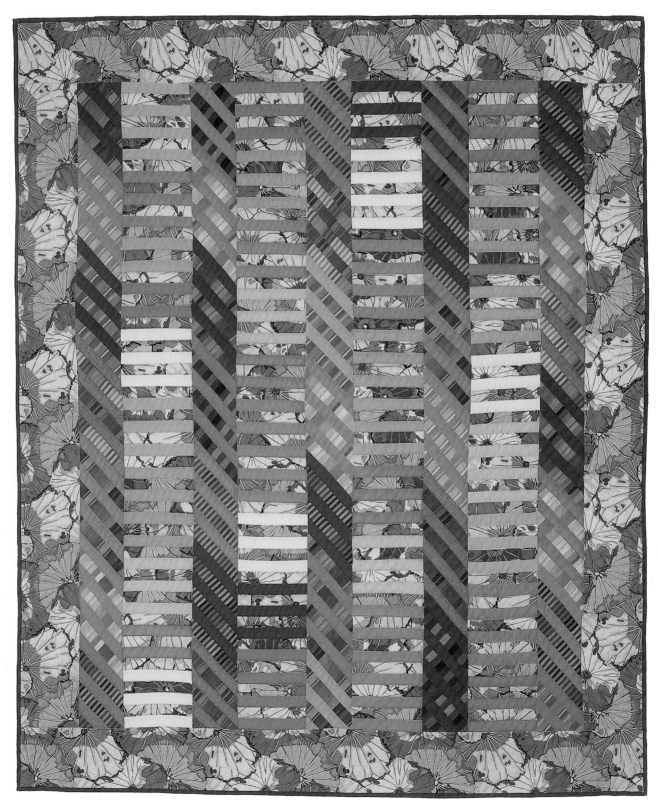

This quilt is pieced in columns in the same way as Sunshine Herringbone Stripes. Judy decided to use Lotus Leaf Antique for alternate strips in the straight columns and for the border which creates an interesting view, a bit like looking at the jungle through a louvred panel.

SIZE OF QUILT
The finished quilt will measure approx. 55 in x 68 in (139.75cm x 172.75cm).

MATERIALS
Patchwork and Border Fabrics
LOTUS LEAF

Antique	GP29AN	2yd (1.85m)

SHOT COTTON

Ginger	SC01	¼yd (25cm)
Thunder	SC06	¼yd (25cm)
Persimmon	SC07	¼yd (25cm)
Lavender	SC14	¼yd (25cm)
Tobacco	SC18	¼yd (25cm)
Ecru	SC24	¼yd (25cm)
Apple	SC39	¼yd (25cm)
Grape	SC47	¼yd (25cm)
Sky	SC62	⅛yd (15cm)
Blueberry	SC88	¼yd (25cm)
Eucalyptus	SC90	¼yd (25cm)
Pea Soup	SC91	⅜yd (35cm)

WOVEN ALTERNATING STRIPE

Grass	WAS GS	⅛yd (15cm)
Lavender	WAS LV	⅛yd (15cm)

WOVEN BROAD STRIPE

Dark	WBS DK	¼yd (25cm)

WOVEN CATERPILLAR STRIPE

Blue	WCS BL	⅛yd (15cm)
Dusk	WCS DU	¼yd (25cm)
Earth	WCS ER	⅛yd (15cm)

WOVEN EXOTIC STRIPE

Mallard	WES ML	⅛yd (15cm)
Parma	WES PM	⅛yd (15cm)
Purple	WES PU	¼yd (25cm)

WOVEN ROMAN STRIPE

Arizona	WRS AR	¼yd (25cm)
Shadow	WRS SD	⅛yd (15cm)

Backing Fabric 3¾yd (3.4m)
We suggest these fabrics for backing
CURLY BASKETS Antique, PJ66AN
MILLEFIORE Orange, GP92OR

Binding
SHOT COTTON

Bordeaux	SC54	⅝yd (60cm)

Batting
63in x 76in (160cm x 193cm).

Quilting thread
Toning machine quilting thread.

You will also need
A roll of thin drawing paper from which to cut 5 rectangles 4½in x 57½in (11.5cm x 146cm) for foundations.

Templates
See Sunshine Herringbone Stripes

CUTTING OUT
Cut the fabric in the order stated. When cutting the borders cut only the border shapes stated leaving the remaining fabric uncut as it is used for the straight columns.

Borders Down the length of the fabric cut 2 borders 6in x 57½in (15.25cm x 146cm) for the quilt sides and 2 borders 6in x 55½in (15.25cm x 141cm) for the quilt top and bottom in GP29AN. Reserve the remaining fabric for the straight columns.

Template L Cut 1 in SC01, SC06, SC47, SC90 and SC91. Total 5 Triangles.

Diagonal Columns Cut 1½in (3.75cm) strips across the width of the fabric, each strip will give you 5 rectangles per full width. Cut 1½in x 8in (3.75cm x 20.25cm) rectangles. Cut 17 in SC90, SC91, 16 in SC47, 15 in WCS DU, WRS AR, 13 in SC88, WES PU, 12 in SC01, SC06, 11 in WBS DK, 9 in SC07, WCS ER, WRS SD, 8 in WAS LV, WCS BL, 7 in WES ML, WES PM, 6 in WAS GS, 3 in SC14 and SC18. Total 210 rectangles.

Straight Columns Cut 1½in (3.75cm) strips across the width of the fabric, each strip will give you 6 rectangles per full width. Cut 1½in x 6½in (3.75cm x 16.5cm) rectangles. Cut 112 in GP29AN, 16 in SC39, 15 in SC91, 14 in SC07, SC18, 13 in SC24, 10 in SC01, SC62, SC88, 8 in SC14 and 6 in SC47. Total 228 rectangles.

Binding Cut 7 strips 2½in (6.5cm) across the width of the fabric in SC54.

Backing Cut 1 piece 40in x 76in (101.5cm x 193cm) and 1 piece 37in x 76in (94cm x 193cm) in backing fabric.

MAKING THE DIAGONAL COLUMNS
See Sunshine Herringbone Stripes instructions

MAKING THE QUILT
See Sunshine Herringbone Stripes instructions

FINISHING THE QUILT
See Sunshine Herringbone Stripes instructions. For this version quilt in the ditch throughout the central columns using toning machine quilting thread. In the border free motion quilt following the designs in the fabric.

QUILT ASSEMBLY DIAGRAM

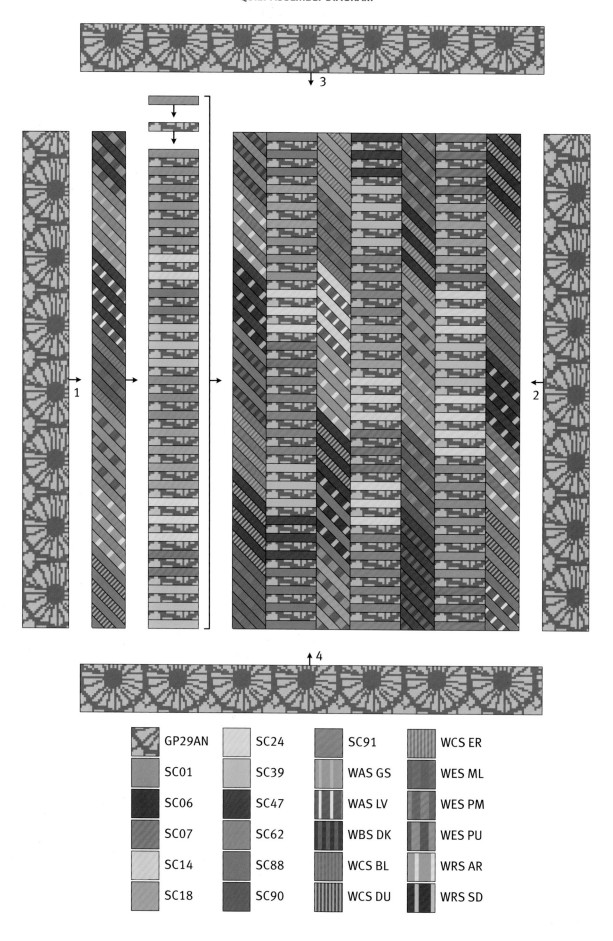

	GP29AN		SC24		SC91		WCS ER
	SC01		SC39		WAS GS		WES ML
	SC06		SC47		WAS LV		WES PM
	SC07		SC62		WBS DK		WES PU
	SC14		SC88		WCS BL		WRS AR
	SC18		SC90		WCS DU		WRS SD

cool wheels ***

Kaffe Fassett, colourway by Pauline Smith

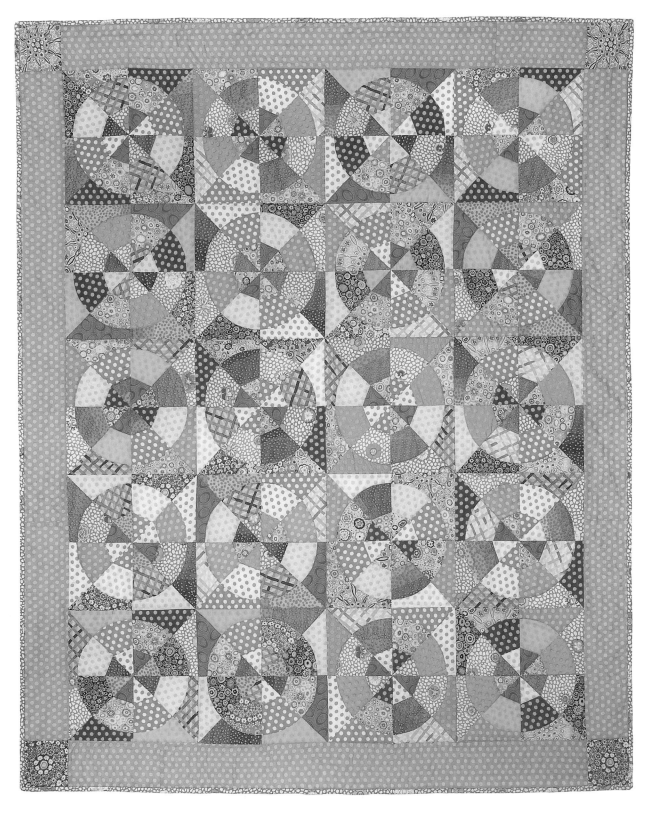

This version of the Wheels quilt is made in the same way as Hot Wheels, this time using cool colours. Pauline used Ombre in pink very effectively in the quilt, separating the colours into Cerise and Orange to use mainly in the dark sections of the blocks and Green/Pink in the light sections. We have allowed a generous quantity of this fabric but please cut carefully!

SIZE OF QUILT
The finished quilt will measure approx. 59in x 71½in (149.75cm x 181.5cm)

MATERIALS
Patchwork and Border Fabrics
MAD PLAID

Mauve	BM37MV	⅜yd (35cm)
Pastel	BM37PT	¼yd (25cm

PAPERWEIGHT

Gold	GP20GD	½yd (45cm)
Grey	GP20GY	¼yd (25cm)

GUINEA FLOWER

Mauve	GP59MV	⅜yd (35cm)
Turquoise	GP59TQ	⅜yd (35cm)

SPOT

Apple	GP70AL	¼yd (25cm)
China Blue	GP70CI	½yd (45cm)
Duck Egg	GP70DE	1⅜yd (1.25m)
Magnolia	GP70MN	¼yd (25cm)
Periwinkle	GP70PE	⅜yd (35cm)
Pond	GP70PO	⅛yd (15cm)
Soft Blue	GP70SF	½yd (45cm)
Sky	GP70SK	⅜yd (35cm)
Turquoise	GP70TQ	¼yd (25cm)

ABORIGINAL DOTS

Ocean	GP71ON	⅜yd (35cm)

MILLEFIORE

Lilac	GP92LI	⅜yd (35cm)
Pastel	GP92PT	⅜yd (35cm)

OMBRE

Pink	GP117PK	¾yd (70cm)

Backing Fabric 4yd (3.7m)
We suggest these fabrics for backing
MAD PLAID Mauve, BM37MV
DREAM Blue, GP148BL

Binding
GUINEA FLOWER

Turquoise	GP59TQ	⅝yd (60cm)

Batting
67in x 79in (170.25cm x 200.5cm)

Quilting thread
Toning machine quilting thread

Templates
See Hot Wheels

CUTTING OUT
Cut the fabric in the order stated, trim and use leftover strips for later templates. Cutting layouts are provided for all the templates to show how to get the maximum pieces per full row in the instructions for Hot Wheels on page 67. The Ombre, Pink GP117PK fabric is separated into 3 colourways, Cerise and Orange are used mainly in the dark sections of the blocks, Green/Pink is used in the light sections. We have specified the 3 colourways separately in the cutting instructions.

Borders Cut 6 strips 5in (12.75cm) wide across the width of the fabric in GP70DE, Join as necessary and cut 2 borders 5in x 63in (12.75cm x 160cm) for the quilt sides and 2 borders 5in x 50½in (12.75cm x 128.25cm) for the quilt top and bottom.

Border Corner Posts Fussy cut 4 squares 5in x 5in (12.75cm x 12.75cm) in GP92PT centring on the circular motifs as shown in the photograph.

Template R Cut 3½in (9cm) strips across the width of the fabric. Each strip will give you 10 patches per full row, see the cutting layout for template R. 18 in GP20GD, GP70CI, 14 in GP70SF, 12 in GP59MV, GP70TQ, 10 in BM37MV, GP59TQ, GP70DE, GP117PK–Orange, 8 in GP20GY, GP70AL, 6 in GP70PE, GP70SK, 4 in BM37PT, GP92LI, GP117PK–Cerise, 2 in GP70MN, GP92PT and GP117PK–Green/Pink. Total 160 patches.

Template T & Reverse T Be sure to open out the fabric strips when cutting Template T and Reverse T patches! If you leave them folded and cut 2 layers you will end up with the wrong shapes. Cut 3¼in (8.25cm) strips across the width of the fabric. Each strip will give you 7 patches per full row, see the cutting layout for template T & Reverse T. With the template right side up cut 10 in GP70DE, GP70PE, GP71ON, GP92PT, 8 in BM37MV, GP20GY, GP70CI, GP117PK–Cerise, 6 in GP70PO and 2 in GP117PK–Orange. Total 80 patches.

Now reverse the template by flipping it over and with the wrong side up cut 10 in BM37PT, GP59MV, GP92LI, 8 in GP20GD, GP70AL, GP70SF, GP70SK, 6 in GP59TQ, GP117PK–Green/Pink, 4 in GP70MN and 2 in GP117PK–Orange. Total 80 Patches.
Template S Cut 3¼in (8.25cm) strips across the width of the fabric. Each strip will give you 28 patches per full row, see the cutting layout for template S. Cut 26 in GP71ON, 18 in GP20GD, GP70SK, 14 in GP117PK–Cerise, 12 in GP59TQ, 10 in GP70PE, GP70MN, GP117PK–Green/Pink, 8 in GP70CI, GP117PK–Orange, 6 in BM37MV, GP92LI, 4 in GP70SF, 2 in GP59MV, GP70AL, GP70DE, GP70TQ and GP92PT. Total 160 triangles.

Binding Cut 7 strips 2½in (6.5cm) wide across the width of the fabric in GP59TQ.

Backing Cut 2 pieces 40in x 67in (101.5cm x 170.25cm) in backing fabric.

MAKING THE BLOCKS
See Hot Wheels instructions. None of the fabrics were used wrong side facing in this version.

MAKING THE QUILT
See Hot Wheels instructions.

FINISHING THE QUILT
See Hot Wheels instructions.

QUILT ASSEMBLY DIAGRAM

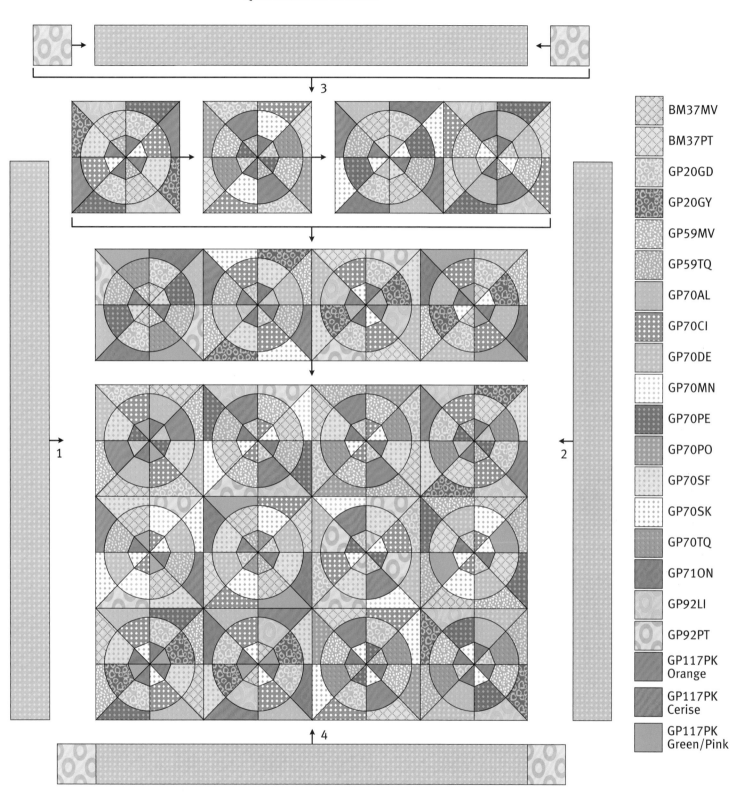

BM37MV
BM37PT
GP20GD
GP20GY
GP59MV
GP59TQ
GP70AL
GP70CI
GP70DE
GP70MN
GP70PE
GP70PO
GP70SF
GP70SK
GP70TQ
GP71ON
GP92LI
GP92PT
GP117PK Orange
GP117PK Cerise
GP117PK Green/Pink

mellow wagga wagga *

Kaffe Fassett, colourway by Brandon Mably

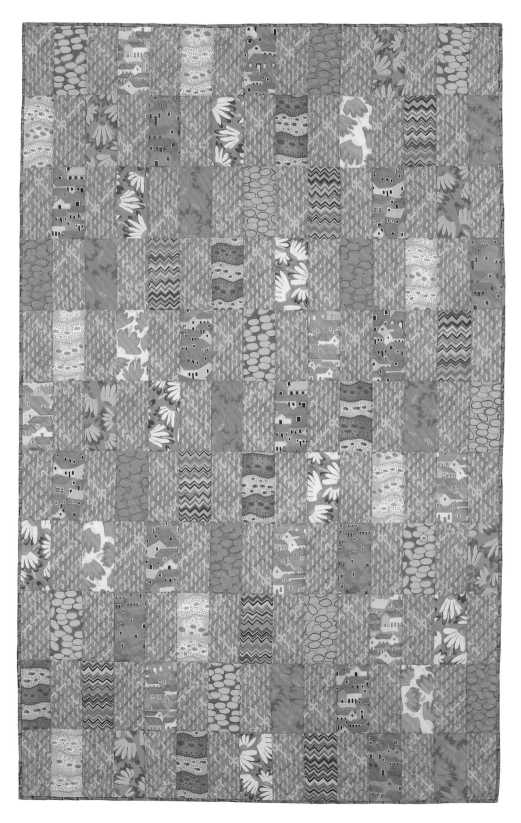

This version of the Wagga Wagga quilt is made using the same method as Dark Wagga Wagga. Brandon chose to alternate one fabric throughout his quilt and did not add buttons.

SIZE OF QUILT
The finished quilt will measure approx. 52½in x 82½in (133.25cm x 209.5cm).

MATERIALS
Patchwork Fabrics
MAD PLAID

Candy	BM37CY	2⅛yd (2m)
ZIGZAG		
Multi	BM43MU	¼yd (25cm)
LAZY DAISY		
Blue	BM44BL	¼yd (25cm)
Emerald	BM44EM	¼yd (25cm)
Pink	BM44PK	¼yd (25cm)
Yellow	BM44YE	⅛yd (15cm)
LABELS		
Cool	BM45CL	¼yd (25cm)
Hot	BM45HT	¼yd (25cm)
Ochre	BM45OC	⅛yd (15cm)
VICTORIA		
Antique	BM46AN	¼yd (25cm)
Citrus	BM46CT	¼yd (25cm)
SHANTY TOWN		
Bright	BM47BT	¼yd (25cm)
Ochre	BM47OC	¼yd (25cm)
Red	BM47RD	⅛yd (15cm)

Backing Fabric 5¼yd (4.8m)
We suggest these fabrics for backing
VICTORIA Hot, BM46HT
SHANTY TOWN Red, BM47RD

Binding
ZIGZAG
Warm BM43WM ⅝yd (60cm)

Batting
60in x 90in (152.5cm x 228.5cm)

Quilting thread
Toning machine quilting thread.

Templates
See Dark Wagga Wagga.

CUTTING OUT
Template G Cut 4in (10.25cm) strips across the width of the fabric, each strip will give you 5 rectangles per full width. Cut 83 rectangles in BM37CY,

9 in BM47BT, 8 in BM43MU, BM44BL, 7 in BM44PK, BM46CT, BM47OC, 6 in BM44EM, BM45CL, BM45HT, BM46AN, 5 in BM47RD, 4 in BM44YE and 3 in BM45OC. Total 165 rectangles.

Binding Cut 7 strips 2½in (6.5cm) wide across the width of the fabric in BM43WM.

Backing Cut 1 piece 40in x 90in (101.5cm x 228.5cm) and 1 piece 21in x 90in (53.25cm x 228.5cm) in backing fabric.

MAKING THE QUILT
See Dark Wagga Wagga instructions.

FINISHING THE QUILT
See Dark Wagga Wagga instructions. For this version stitch in the ditch throughout the quilt using toning machine quilting thread.

QUILT ASSEMBLY DIAGRAM

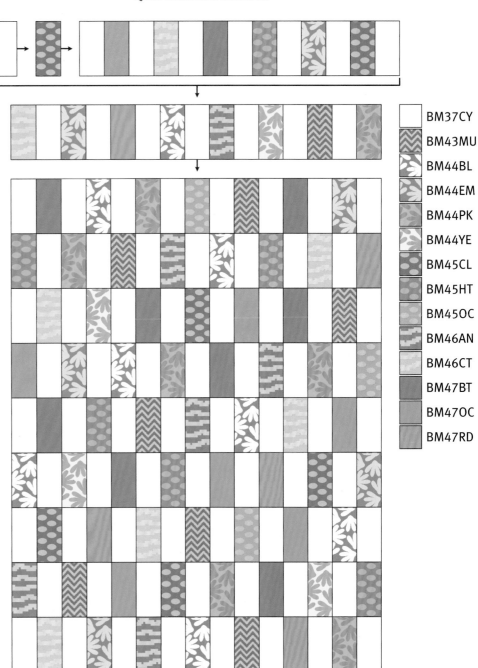

BM37CY	
BM43MU	
BM44BL	
BM44EM	
BM44PK	
BM44YE	
BM45CL	
BM45HT	
BM45OC	
BM46AN	
BM46CT	
BM47BT	
BM47OC	
BM47RD	

templates

Please refer to the individual instructions for the templates required for each quilt as some templates are used in several projects. The arrows on the templates should be lined up with the straight grain of the fabric, which runs either along the selvedge or at 90 degrees to the selvedge. Following the marked grain lines is important to prevent patches having bias edges along block and quilt edges which can cause distortion. In some quilts the arrows also denote stripe direction.

G
WAGGA WAGGA

A
LOG CABIN SAMPLER

CHECKERBOARD
MEDALLION

C

CHECKERBOARD
MEDALLION

D

CHECKERBOARD
MEDALLION

B

HERRINGBONE
STRIPES

L

M

BRIGHT SQUARES,
PASTEL DONUT
& SNOWBALL
CRISSCROSS

F

CHECKERBOARD
MEDALLION

U
PASTEL DONUT

E
CHECKERBOARD
MEDALLION

H
UNSET STRIPES

W
PASTEL DONUT

V
PASTEL DONUT

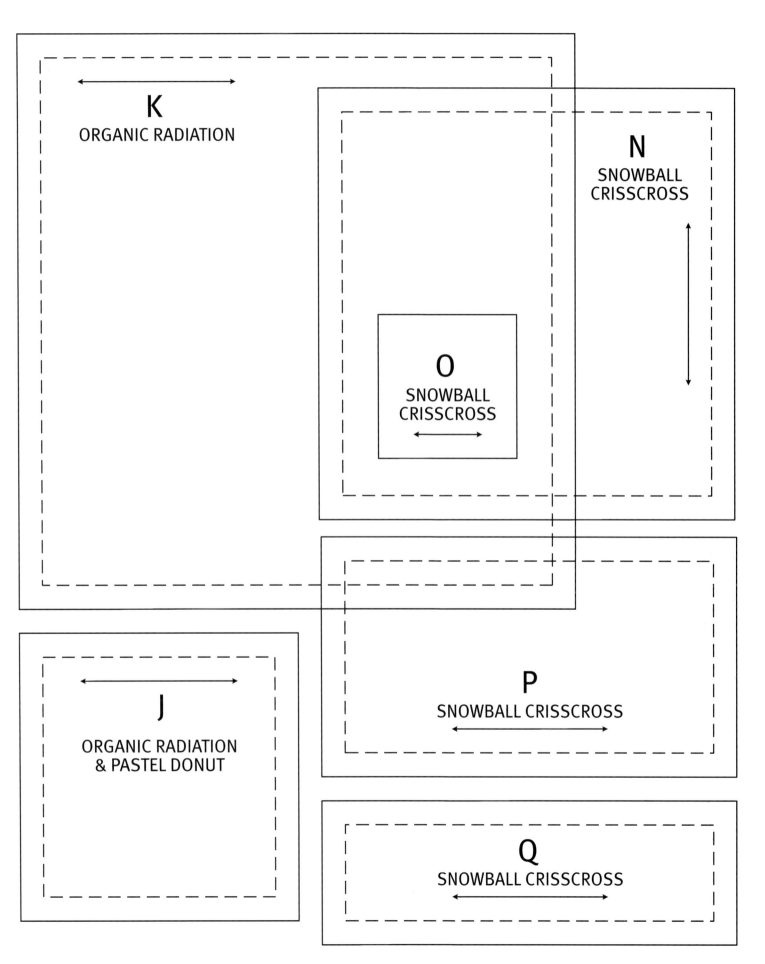

K
ORGANIC RADIATION

N
SNOWBALL
CRISSCROSS

O
SNOWBALL
CRISSCROSS

J
ORGANIC RADIATION
& PASTEL DONUT

P
SNOWBALL CRISSCROSS

Q
SNOWBALL CRISSCROSS

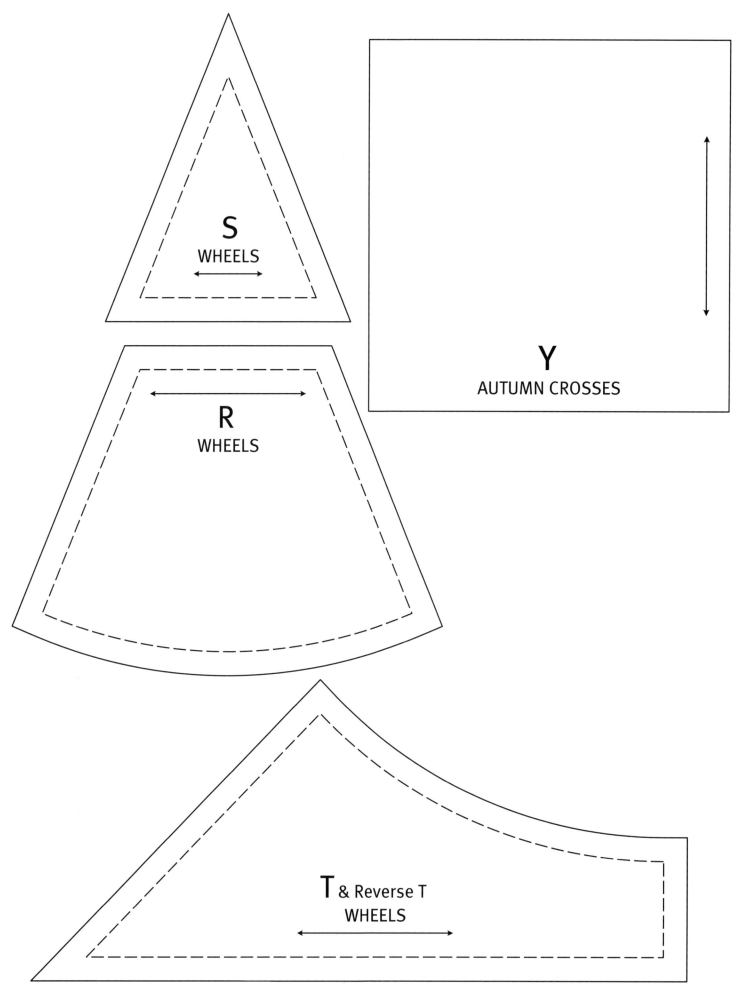

S
WHEELS

Y
AUTUMN CROSSES

R
WHEELS

T & Reverse T
WHEELS

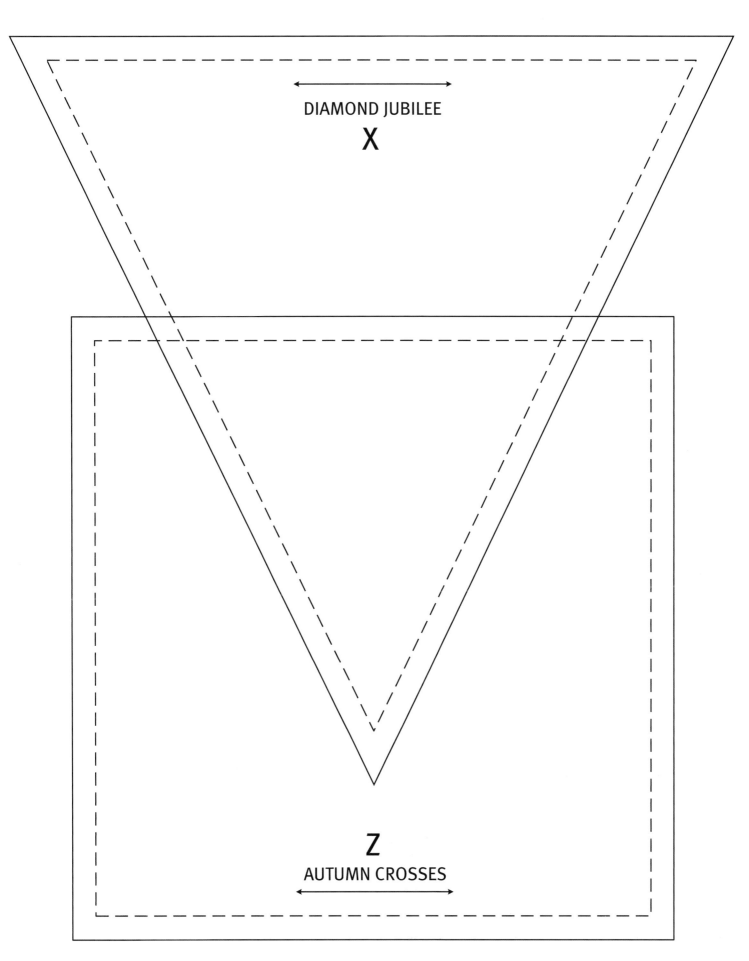

DIAMOND JUBILEE

X

Z

AUTUMN CROSSES

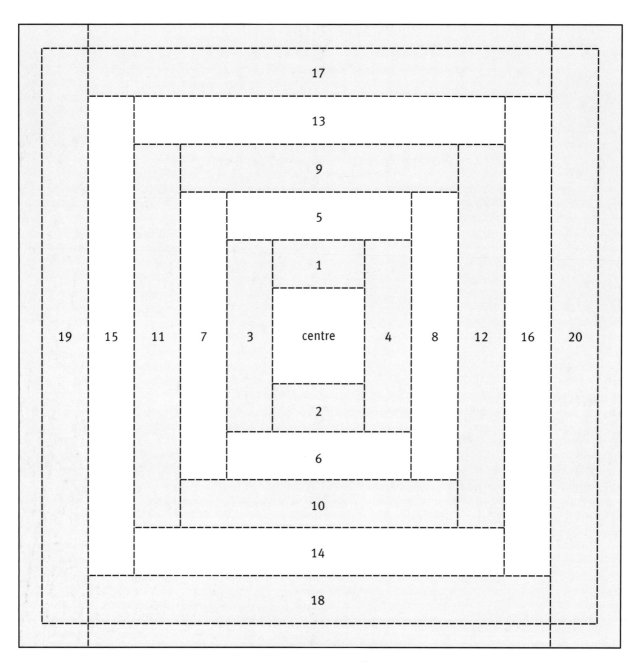

LOG CABIN SAMPLER
FOUNDATION PATTERN

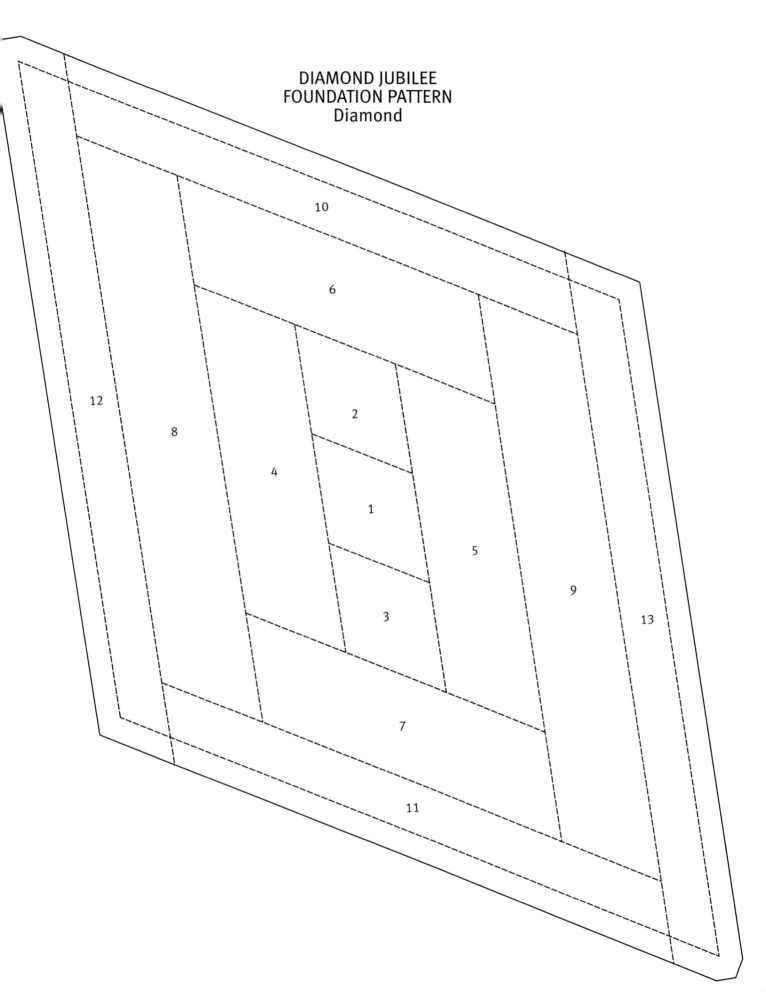

DIAMOND JUBILEE
FOUNDATION PATTERN
Diamond

DIAMOND JUBILEE
FOUNDATION PATTERN
Triangle

DIAMOND JUBILEE
FOUNDATION PATTERN
Half Diamond

5

3

1

7

2

4

6

patchwork know-how

These instructions are intended for the novice quilt maker, providing the basic information needed to make the projects in this book, along with some useful tips.

EXPERIENCE RATINGS
* Easy, straightforward, suitable for a beginner.
** Suitable for the average patchwork and quilter.
*** For the more experienced patchwork and quilter.

ABOUT THE FABRICS
The fabrics used for the quilts in this book are from Kaffe Fassett Collective. The first two letters of the fabric codes denote the designer:
GP is the code for the Kaffe Fassett collection
PJ is the code for the Philip Jacobs collection
BM is the code for the Brandon Mably collection.

PREPARING THE FABRIC
Prewash all new fabrics before you begin, to ensure that there will be no uneven shrinkage and no bleeding of colours when the finished quilt is laundered. Press the fabric whilst it is still damp to return crispness to it. All fabric requirements in this book are calculated on a 40in (101.5cm) usable fabric width, to allow for shrinkage and selvedge removal.

MAKING TEMPLATES
Transparent template plastic is the best material to use: it is durable and allows you to see the fabric and select certain motifs. You can also use thin stiff cardboard.

Templates for machine piecing
1 Trace off the actual–sized template provided either directly on to template plastic, or tracing paper, and then on to thin cardboard. Use a ruler to help you trace off the straight cutting line, dotted seam line and grain lines.

Some of the templates in this book were too large to print complete. Transfer the template onto the fold of a large sheet of paper, cut out and open out for the full template.
2 Cut out the traced off template using a craft knife, a ruler and a self–healing cutting mat.
3 Punch holes in the corners of the template, at each point on the seam line, using a hole punch.

Templates for hand piecing
• Make a template as for machine piecing, but do not trace off the cutting line. Use the dotted seam line as the outer edge of the template.

• This template allows you to draw the seam lines directly on to the fabric. The seam allowances can then be cut by eye around the patch.

CUTTING THE FABRIC
On the individual instructions for each project, you will find a summary of all the patch shapes used.

Always mark and cut out any border and binding strips first, followed by the largest patch shapes and finally the smallest ones, to make the most efficient use of your fabric. The border and binding strips are best cut using a rotary cutter.

Rotary cutting
Rotary cut strips are usually cut across the fabric from selvedge to selvedge, but some projects may vary, so please read through all the instructions before you start cutting the fabrics.

1 Before beginning to cut, press out any folds or creases in the fabric. If you are cutting a large piece of fabric, you will need to fold it several times to fit the cutting mat. When there is only a single fold, place the fold facing you. If the fabric is too wide to be folded only once, fold it concertina-style until it fits your mat. A small rotary cutter with a sharp blade will cut up to six layers of fabric; a large cutter up to eight layers.

2 To ensure that your cut strips are straight and even, the folds must be placed exactly parallel to the straight edges of the fabric and along a line on the cutting mat.

3 Place a plastic ruler over the raw edge of the fabric, overlapping it about ½in (1.25cm). Make sure that the ruler is at right angles to both the straight edges and the fold to ensure that you cut along the straight grain. Press down on the ruler and wheel the cutter away from you along the edge of the ruler.

4 Open out the fabric to check the edge. Don't worry if it's not perfectly straight – a little wiggle will not show when the quilt is stitched together. Re-fold fabric, then place the ruler over the trimmed edge, aligning the edge with the markings on the ruler that match the correct strip width. Cut strip along the edge of the ruler.

USING TEMPLATES
The most efficient way to cut out templates is by first rotary cutting a strip of fabric to the width stated for your template, and then marking off your templates along the strip, edge to edge at the required angle. This method leaves hardly any waste and gives a random effect to your patches.

A less efficient method is to 'fussy cut' them, where the templates are cut individually by placing them on particular motifs or stripes, to create special effects. Although this method is more wasteful, it yields very interesting results.

1 Place the template face down, on the wrong side of the fabric, with the grain-line arrow following the straight grain of the fabric, if indicated. Be careful though – check with your individual instructions, as some instructions may ask you to cut patches on varying grains.

2 Hold the template firmly in place and draw around it with a sharp pencil or crayon, marking in the corner dots or seam lines. To save fabric, position patches close together or even touching. Don't worry if outlines positioned on the straight grain when drawn on striped fabrics do not always match the stripes when cut – this will add a degree of visual excitement to the patchwork!

3 Once you've drawn all the pieces needed, you are ready to cut the fabric, with either a rotary cutter and ruler or a pair of sharp sewing scissors.

BASIC HAND AND MACHINE PIECING
Patches can be stitched together by hand or machine. Machine stitching is quicker, but hand assembly allows you to carry your patches around with you and work on them in every spare moment. The choice is yours. For techniques that are new to you, practise on scrap pieces of fabric until you feel confident.

Machine piecing

Follow the quilt instructions for the order in which to piece the individual patchwork blocks and then assemble the blocks together in rows.

1 Seam lines are not marked on the fabric for simple shapes, so stitch ¼in (6mm) seams using the machine needle plate, a ¼in (6mm) wide machine foot, or tape stuck to the machine as a guide. Pin two patches with right sides together, matching edges.

For some shapes, particularly diamonds you need to match the sewing lines, not the fabric edges. Place 2 diamonds right sides together but offset so that the sewing lines intersect at the correct position. Use pins to secure for sewing.

Set your machine at 10–12 stitches per inch (2.5cm) and stitch seams from edge to edge, removing pins as you feed the fabric through the machine.

2 Press the seams of each patchwork block to one side before attempting to join it to another block. When joining diamond shaped blocks you will need to offset the blocks in the same way as diamond shaped patches, matching the sewing lines, not the fabric edges.

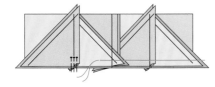

3 When joining rows of blocks, make sure that adjacent seam allowances are pressed in opposite directions to reduce bulk and make matching easier. Pin pieces together directly through the stitch line and to the right and left of the seam. Remove pins as you sew. Continue pressing seams to one side as you work.

Hand piecing

1 Pin two patches with right sides together, so that the marked seam lines are facing outwards.

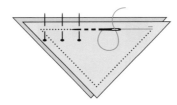

2 Using a single strand of strong thread, secure the corner of a seam line with a couple of back stitches.

3 Sew running stitches along the marked line, working 8–10 stitches per inch (2.5cm) and ending at the opposite seam line corner with a few back stitches. When hand piecing never stitch over the seam allowances.

4 Press the seams to one side, as shown in machine piecing (Step 2).

MACHINE APPLIQUÉ WITH ADHESIVE WEB

To make appliqué very easy you can use adhesive web (which comes attached to a paper backing sheet) to bond the motifs to the background fabric. There are two types of web available: the first keeps the pieces in place while they are stitched, the second permanently attaches the pieces so that no sewing is required. Follow steps 1 and 2 for the non-sew type and steps 1–3 for the type that requires sewing.

1 Trace the reversed appliqué design onto the paper side of the adhesive web leaving a ¼in (6mm) gap between all the shapes. Roughly cut out the motifs ⅛in (3mm) outside your drawn line.

2 Bond the motifs to the reverse of your chosen fabrics. Cut out on the drawn line with very sharp scissors. Remove the backing paper by scoring the centre of the motif carefully with a scissor point and peeling the paper away from the centre out (to prevent damage to the edges). Place the motifs onto the background, noting any which may be layered. Cover with a clean cloth and bond with a hot iron (check instructions for temperature setting as adhesive web can vary depending on the manufacturer).

3 Using a contrasting or toning coloured thread in your machine, work small close zigzag stitches (or a blanket stitch if your machine has one) around the edge of the

motifs; the majority of the stitching should sit on the appliqué shape. When stitching up to points stop with the machine needle in the down position, lift the foot of your machine, pivot the work, lower the foot and continue to stitch. Make sure all the raw edges are stitched.

HAND APPLIQUÉ

Good preparation is essential for speedy and accurate hand appliqué. The finger-pressing method is suitable for needle-turning application, used for simple shapes like leaves and flowers. Using a card template is the best method for bold simple motifs such as circles.

Finger–pressing method

1 To make your template, transfer the appliqué design using carbon paper on to stiff card, and cut out the template. Trace around the outline of your appliquéd shape on to the right side of your fabric using a well sharpened pencil. Cut out shapes, adding by eye a ¼in (6mm) seam allowance all around.

2 Hold shape right side up and fold under the seam, turning along your drawn line, pinch to form a crease. Dampening the fabric makes this very easy. When using shapes with 'points' such as leaves, turn in the seam allowance at the 'point' first, as shown in the diagram. Then continue all round the shape. If your shapes have sharp curves, you can snip the seam allowance to ease the curve. Take care not to stretch the appliqué shapes as you work.

Card template method

1 Cut out appliqué shapes as shown in step 1 of finger-pressing. Make a circular template from thin cardboard, without seam allowances.

2 Using a matching thread, work a row of running stitches close to the edge of the fabric circle. Place a thin cardboard template in the centre of the fabric circle on the wrong side of the fabric.

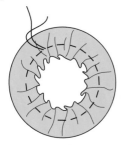

3 Carefully pull up the running stitches to gather up the edge of the fabric circle around the cardboard template. Press, so that no puckers or tucks appear on the right side. Then, carefully pop out the cardboard template without distorting the fabric shape.

Straight stems

Place fabric face down and simply press over the ¼in (6mm) seam allowance along each edge. You don't need to finish the ends of stems that are layered under other appliqué shapes. Where the end of the stem is visible, simply tuck under the end and finish neatly.

Needle-turning application

Take the appliqué shape and pin in position. Stroke the seam allowance under with the tip of the needle as far as the creased pencil line, and hold securely in place with your thumb. Using a matching thread, bring the needle up from the back of the block into the edge of the shape and proceed to blind-hem in place. (This stitch allows the motifs to appear to be held on invisibly.) To do this, bring the thread out from below through the folded edge of the motif, never on the top. The stitches must be small, even and close together to prevent the seam allowance from unfolding and from frayed edges appearing. Try to avoid pulling the stitches too tight, as this will cause the motifs to pucker up. Work around the whole shape, stroking under each small section before sewing.

QUILTING

When you have finished piecing your patchwork and added any borders, press it carefully. It is now ready for quilting.

Marking quilting designs and motifs

Many tools are available for marking quilting patterns, check the manufacturer's instructions for use and test on scraps of fabric from your project. Use an acrylic ruler for marking straight lines.

Stencils

Some designs require stencils, these can be made at home, by transferring the designs on to template plastic, or stiff cardboard. The design is then cut away in the form of long dashes, to act as guides for both internal and external lines. These stencils are a quick method for producing an identical set of repeated designs.

Preparing the backing and batting

• Remove the selvedges and piece together the backing fabric to form a backing at least 4in (10cm) larger all round than the patchwork top.

• Choose a fairly thin batting, preferably pure cotton, to give your quilt a flat appearance. If your batting has been rolled up, unroll it and let it rest before cutting it to the same size as the backing.

• For a large quilt it may be necessary to join two pieces of batting to fit. Lay the pieces of batting on a flat surface so that they overlap by around 8in (20cm). Cut a curved line through both layers.

overlap wadding

• Carefully peel away the two narrow pieces and discard. Butt the curved cut edges back together. Stitch the two pieces together using a large herringbone stitch.

1 On the floor or on a large work surface, lay out the backing with wrong side uppermost. Use weights along the edges to keep it taut.

2 Lay the batting on the backing and smooth it out gently. Next lay the patchwork top, right side up, on top of the batting and smooth gently until there are no wrinkles. Pin at the corners and at the midpoints of each side, close to the edges.

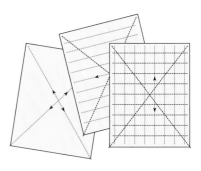

3 Beginning at the centre, baste diagonal lines outwards to the corners, making your stitches about 3in (7.5cm) long. Then, again starting at the centre, baste horizontal and vertical lines out to the edges. Continue basting until you have basted a grid of lines about 4in (10cm) apart over the entire quilt.

4 For speed, when machine quilting, some quilters prefer to baste their quilt sandwich layers together using rust-proof safety pins, spaced at 4in (10cm) intervals over the entire quilt.

HAND QUILTING

This is best done with the quilt mounted on a quilting frame or hoop, but as long as you have basted the quilt well, a frame is not essential. With the quilt top facing upwards, begin at the centre of the quilt and make even running stitches following the design. It is more important to make even stitches on both sides of the quilt than to make small ones. Start and finish your stitching with back stitches and bury the ends of your threads in the batting.

MACHINE QUILTING

• For a flat looking quilt, always use a walking foot on your machine for stitching straight lines, and a darning foot for free–motion quilting.

• It is best to start your quilting at the centre of the quilt and work out towards the borders, doing the straight quilting lines first (stitch-in-the-ditch) followed by the free-motion quilting.

• When free motion-quilting stitch in a loose meandering style as shown in the diagrams. Do not stitch too closely as this will make the quilt feel stiff when finished. If you wish you can include floral themes or follow shapes on the printed fabrics for added interest.

• Make it easier for yourself by handling the quilt properly. Roll up the excess quilt neatly to fit under your sewing machine arm, and use a table or chair to help support the weight of the quilt that hangs down the other side.

FINISHING

Preparing to bind the edges

Once you have quilted or tied your quilt sandwich together, remove all the basting stitches. Then, baste around the outer edge of the quilt ¼in (6mm) from the edge of the top patchwork layer. Trim the back and batting to the edge of the patchwork and straighten the edge of the patchwork if necessary.

Making the binding

1 Cut bias or straight grain strips the width required for your binding, making sure the grain-line is running the correct way on your straight grain strips. Cut enough strips until you have the required length to go around the edge of your quilt.

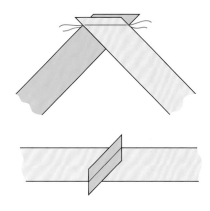

2 To join strips together, the two ends that are to be joined must be cut at a 45 degree angle, as above. Stitch right sides together, trim turnings and press seam open.

Binding the edges

1 Cut the starting end of binding strip at a 45 degree angle, fold a ¼in (6mm) turning to wrong side along cut edge and press in place. With wrong sides together, fold strip in half lengthways, keeping raw edges level, and press.

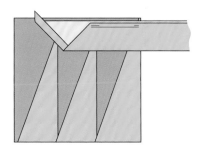

2 Starting at the centre of one of the long edges, place the doubled binding on to the right side of the quilt keeping raw edges level. Stitch the binding in place starting ¼in (6mm) in from the diagonal folded edge. Reverse stitch to secure, and work ¼in (6mm) in from edge of the quilt towards first corner of quilt. Stop ¼in (6mm) in from corner and work a few reverse stitches.

3 Fold the loose end of the binding up, making a 45 degree angle (see A). Keeping the diagonal fold in place, fold the binding back down, aligning the raw edges with the next side of the quilt. Starting at the point where the last stitch ended, stitch down the next side (see B).

4 Continue to stitch the binding in place around all the quilt edges in this way, tucking the finishing end of the binding inside the diagonal starting section.

5 Turn the folded edge of the binding on to the back of the quilt. Hand stitch the folded edge in place just covering binding machine stitches, and folding a mitre at each corner

glossary of terms

Adhesive or fusible web This comes attached to a paper backing sheet and is used to bond appliqué motifs to a background fabric. There are 2 types of web available, the first keeps the pieces in place whilst they are stitched, the second permanently attaches the pieces so that no sewing is required.

Appliqué The technique of stitching fabric shapes on to a background to create a design. It can be applied either by hand or machine with a decorative embroidery stitch, such as buttonhole, or satin stitch.

Backing The bottom layer of a quilt sandwich. It is made of fabric pieced to the size of the quilt top with the addition of about 4in (10.25cm) all around to allow for quilting take-up.

Basting or tacking This is a means of holding two fabric layers or the layers of a quilt sandwich together temporarily with large hand stitches, or pins.

Batting or wadding This is the middle layer, or padding in a quilt. It can be made of cotton, wool, silk or synthetic fibres.

Bias The diagonal grain of a fabric. This is the direction which has the most give or stretch, making it ideal for bindings, especially on curved edges.

Binding A narrow strip of fabric used to finish off the edges of quilts or projects; it can be cut on the straight grain of a fabric or on the bias.

Block A single design unit that when stitched together with other blocks create the quilt top. It is most often a square, hexagon, or rectangle, but it can be any shape. It can be pieced or plain.

Border A frame of fabric stitched to the outer edges of the quilt top. Borders can be narrow or wide, pieced or plain. As well as making the quilt larger, they unify the overall design and draw attention to the central area.

Chalk pencils Available in various colours, they are used for marking lines, or spots on fabric.

Cutting mat Designed for use with a rotary cutter, it is made from a special 'self–healing' material that keeps your cutting blade sharp. Cutting mats come in various sizes and are usually marked with a grid to help you line up the edges of fabric and cut out larger pieces.

Design wall Used for laying out fabric patches before sewing. A large wall or folding board covered with flannel fabric or cotton batting in a neutral shade (dull beige or grey work well) will hold fabric in place so that an overall view can be taken of the placement.

Free-motion quilting Curved wavy quilting lines stitched in a random manner. Stitching diagrams are often given for you to follow as a loose guide.

Fussy cutting This is when a template is placed on a particular motif, or stripe, to obtain interesting effects. This method is not as efficient as strip cutting, but yields very interesting results.

Grain The direction in which the threads run in a woven fabric. In a vertical direction it is called the lengthwise grain, which has very little stretch. The horizontal direction, or crosswise grain is slightly stretchy, but diagonally the fabric has a lot of stretch. This grain is called the bias. Wherever possible the grain of a fabric should run in the same direction on a quilt block and borders.

Grain lines These are arrows printed on templates which should be aligned with the fabric grain.

Inset seams or setting-in A patchwork technique whereby one patch (or block) is stitched into a 'V' shape formed by the joining of two other patches (or blocks).

Patch A small shaped piece of fabric used in the making of a patchwork pattern.

Patchwork The technique of stitching small pieces of fabric (patches) together to create a larger piece of fabric, usually forming a design.

Pieced quilt A quilt composed of patches.

Quilting Traditionally done by hand with running stitches, but for speed modern quilts are often stitched by machine. The stitches are sewn through the top, wadding and backing to hold the three layers together. Quilting stitches are usually worked in some form of design, but they can be random.

Quilting hoop Consists of two wooden circular or oval rings with a screw adjuster on the outer ring. It stabilises the quilt layers, helping to create an even tension.

Reducing Glass Used for viewing the complete composition of a quilt at a glance. It works like a magnifier in reverse. A useful tool for checking fabric placement before piecing a quilt.

Rotary cutter A sharp circular blade attached to a handle for quick, accurate cutting. It is a device that can be used to cut several layers of fabric at one time. It must be used in conjunction with a 'self–healing' cutting mat and a thick plastic ruler.

Rotary ruler A thick, clear plastic ruler marked with lines in imperial or metric measurements. Sometimes they also have diagonal lines indicating 45 and 60 degree angles. A rotary ruler is used as a guide when cutting out fabric pieces using a rotary cutter.

Sashing A piece or pieced sections of fabric interspaced between blocks.

Sashing posts When blocks have sashing between them the corner squares are known as sashing posts.

Selvedges Also known as selvages, these are the firmly woven edges down each side of a fabric length. Selvedges should be trimmed off before cutting out your fabric, as they are more liable to shrink when the fabric is washed.

Stitch-in-the-ditch or Ditch quilting Also known as quilting-in-the-ditch. The quilting stitches are worked along the actual seam lines, to give a pieced quilt texture.

Template A pattern piece used as a guide for marking and cutting out fabric patches, or marking a quilting, or appliqué design. Usually made from plastic or strong card that can be reused many times. Templates for cutting fabric usually have marked grain lines which should be aligned with the fabric grain.

Threads One hundred percent cotton or cotton–covered polyester is best for hand and machine piecing. Choose a colour that matches your fabric. When sewing different colours and patterns together, choose a medium to light neutral colour, such as grey or ecru. Specialist quilting threads are available for hand and machine quilting.

Walking foot or Quilting foot This is a sewing machine foot with dual feed control. It is very helpful when quilting, as the fabric layers are fed evenly from the top and below, reducing the risk of slippage and puckering.

Yo-Yos A circle of fabric double the size of the finished puff is gathered up into a rosette shape.

ACKNOWLEDGMENTS
Alan Baxter for his wonderful location; Frank Emonds, and
Chris and Denny Gudgin; and The York Quilt Museum and
their staff.

The fabric collection can be viewed online at
www.coatscrafts.co.uk *and* **www.westminsterfabrics.com**

Rowan 100% cotton premium thread, Anchor embroidery thread, and Prym sewing aids, distributed by
Coats Crafts UK, Green Lane Mill, Holmfirth, West Yorkshire, HD9 2DX.
Tel: +44 (0) 1484 681881 • Fax: +44 (0) 1484 687920

Rowan 100% cotton premium thread and Anchor embroidery thread distributed in the USA by
Westminster Fibers, 3430 Toringdon Way, Charlotte, North Carolina 28277.
Tel: 704 329 5800 • Fax: 704 329 5027

Prym productions distributed in the USA by
Prym-Dritz Corp, 950 Brisack Road, Spartanburg, SC 29303.
Tel: +1 864 576 5050 • Fax: +1 864 587 3353
email: pdmar@teleplex.net

Rowan/Coats Crafts UK, Green Lane Mill, Holmfirth,
West Yorkshire HD9 2DX, England.
Tel: +44 (0) 1484 681881 • Email: ccuk.sales@coats.com
www.coatscrafts.co.uk • www.knitrowan.co.uk

Westminster Lifestyle Fabrics, 3430 Toringdon Way, Suite 301,
Charlotte, NC, U.S.A
Tel: 704-329-5800 • Email: fabric@westminsterfibers.com
www.westminsterfabrics.com

distributors and stockists

Distributors of Rowan fabrics

AUSTRALIA
Triway Logistics c/o XLN Fabrics
2/21 Binney Rd, Kings Park
NSW 2148
www.xln.com.au

AUSTRIA
Coats Harlander Ges.m.b.H.
+00800-26 27-2800
coats.harlander@coats.com

BENELUX
Coats N.V.
Coats B.V.
c/o Coats GmbH
België, Belgique: +32 (0) 800-77892
Nederland: +31 (0) 800-0226648
Luxembourg: +49 (0) 7644-802 222
sales.coatsninove@coats.com

BULGARIA, GREECE, CYPRUS
Coats Bulgaria EOOD
+359-2-976-77-49
officebg@coats.com

CZECH REPUBLIC
Coats Czecho s.r.o.
+00421-2-32303119
galanterie@coats.com

ESTONIA
Coats Eesti AS
+372 6306 250
coats@coats.ee

FINLAND
Coats Opti Crafts Oy
+358-9-274871
coatsopti.sales@coats.com

FRANCE
3bcom
35 avenue de Larrieu
31094 Toulouse cedex01
Tel. +33 562 202 096
Commercial@3b-com.com

Milpoint
Zaes du moulin rouge
24120 Terrasson
Tel +33 553 517 420
Fax +33 553 517 429
contact@milpoint.fr
milpoint.fr

Coats France
Division Arts du Fil
c/o Coats GMbH
+(0) 810-06-00-02
artsdufil@coats.com

GERMANY
Coats GmbH
+49 (0) 7644-802 222
Kenzingen.Vertrieb@Coats.com

HUNGARY, SLOVENIA, CROATIA, NORTH SERBIA
Coats Crafts Hungary Kft.
+36 82 504 393

ITALY
Coats Cucirini Sri
+39-02-63-615-210
servizio.clienti@coats.com

JAPAN
Kinkame Shigyo Co, Ltd
1-2-15, Higashi-Nihonbashi
Chuo-Ku
Tokyo, 103-0004
www.kinkame.com.jp

Kiyohara
4-5-2 Minamikyuhoji-Machi
Chou-Ku 541-8506

LATVIA
Coats Latvija SIA
+371-67625031
info.latvia@coats.com

LITHUANIA
Coats Lietuva UAB
+3705-2730972
info@coats.lt

NEW ZEALAND
Fabco Ltd
43 Lee Martin Road
RD3, Hamilton, 3283
www.fabco.co.nz

POLAND
Coats Polska Sp. z.o.o.
+48-42-254 0 400
coats@coats.com.pl

PORTUGAL
Companhia de Linha
Coats & Clark, SA
+00-351-223-770-700

RUSSIA
Jota + K
Moscow
Phone: 007-499 -504-15-84
www.tkani-lifestyle.ru

SLOVAK REPUBLIC
Coats s.r.o.
+00421-2-63532314
galanteria@coats.com

SINGAPORE
Quilts n Calicoes
163 Tanglin Rd,
03-13, Tanglin Mall,
Singapore 247933
www.quiltsncalicoes.com

SPAIN
Coats Fabra. SAU
+34 93 290 8500
Atencion.clientesc@coats.com

SWEDEN, NORWAY, DENMARK
Coats GMBH
+49 (0) 7644-802-222
kenzingen.vertrieb@coats.com

Industrial Textiles A/S
+45-48-17-20-55
mail@indutex.dk

SWITZERLAND
Coats Stroppel AG
+00800-26272800
coats.stroppel@coats.com

TAIWAN
Long Teh Trading Co Ltd
No.71, Hebei W. St
Tai Chung City
Taiwan (ROC) 40669

TURKEY
Coats Crafts
+90 216 425 8810

UNITED KINGDOM
Coats Crafts UK
+44 (0) 1484 681881
ccuk.sales@coats.com
www.webshop.coats.com

USA
Westminster Fibers, 8 Shelter
Drive, Greer, South Carolina,
29650
Tel: (800) 445-9276
info@westminsterfibers.com
www.westminsterfibers.com

For stockists in all other
countries please contact
Rowan for details